Gift of

The John W. Bowman Family
in memory of
TIMOTHY DILLON BOWMAN

THE ART OF ISLAM

THE ART OF ISLAM

Nurhan Atasoy
Afif Bahnassi
Michael Rogers

Unesco Collection of Representative Works:
Art Album Series

Unesco

Flammarion

ISBN: 2-08-013510-4

Design by Thomas Gravemaker
Composed by Coupé S.A., Sautron
Map by Carto-plan
Printed by Imprimerie Clerc, Saint-Amand Montrond
Bound by Reliure Brun, Malesherbes

Page 6
The Dome of the Rock
691-692
Jerusalem
Detail of the arcades.

Table of Contents

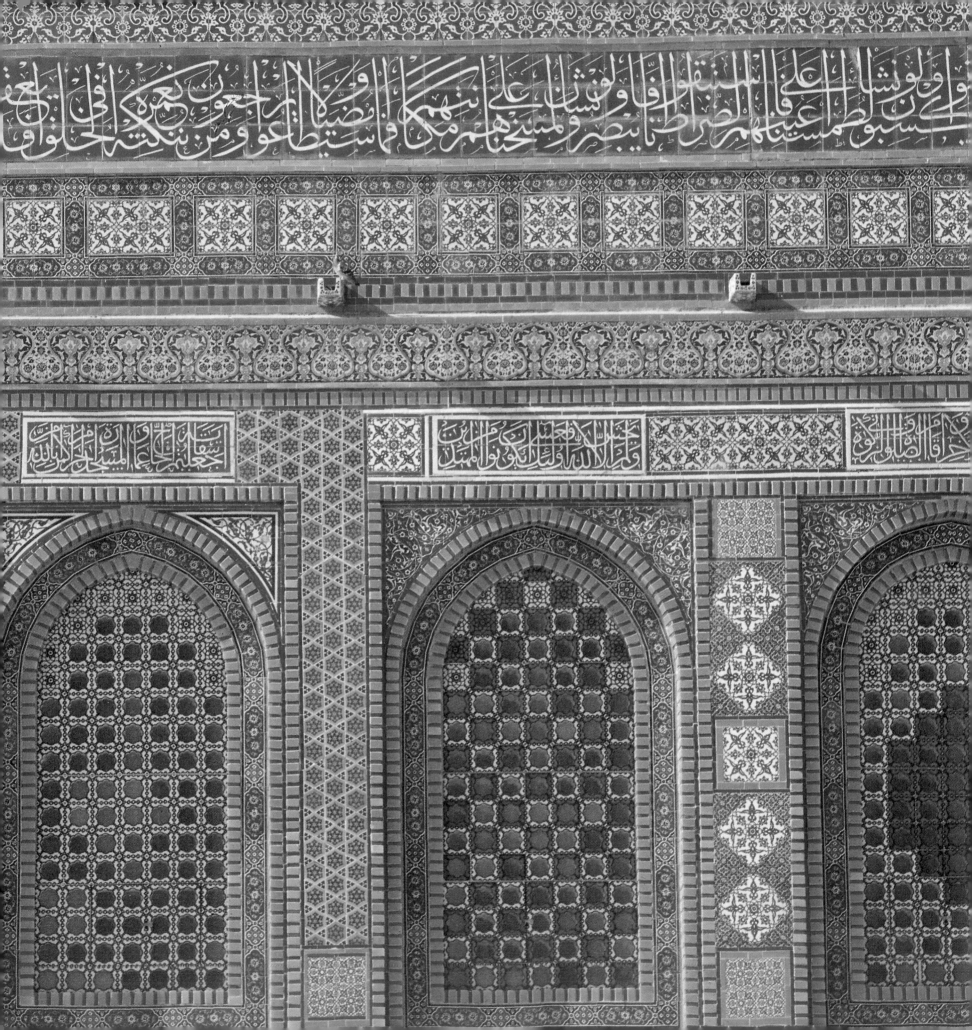

Introduction

The hegira, or hijra, commemorates the journey of the Prophet Muhammad from Mecca to Medina. It corresponds to the year AD 622 and forms the starting point of the Muslim calendar. Within a decade of the Prophet's message, Islam had spread throughout the Arabian peninsula. With the religious faith came new social and political attitudes, and a culture which soon united the Near East, much of Asia, Africa and Spain. This culture gradually assimilated the traditions of the states and peoples it absorbed and transformed the various artistic styles of each region into a style of its own.

The Holy Koran formed the basis of the Islamic culture in every sense. Revealed in the Arabic language, it was not only a spiritual guide for all Muslim peoples, but also provided them with a legal, social and cultural foundation. Arabic, the medium of the sacred message, became the official language and appeared on buildings, textiles, pottery, wood and stone carving, metalwork and jewellery. Fine script, or calligraphy, was also developed for its own sake into one of the highest forms of Islamic art and is found in many different styles.

Since Islam has not encouraged the representation of the human figure in art, a unified decorative style evolved which was spread throughout the Islamic world by craftsmen travelling from one country to another. Often enormous distances were covered: for example, Central Asian artistic themes came to Anatolia via Iran through Turkish tribal migrations and with the Mongol armies.

From the beginning the mosque formed the heart of the Islamic city. It was the prime institution of Islam, constituting a further unifying cultural factor throughout the Islamic world.

Mosques differ according to period and area, but in their different ways reflect the unity of the Muslim world, not just as a place of prayer, but also as a centre of life around which cities developed. The mosque is not merely a gathering place for the faithful before and after the prayer ceremony, it is the dominant feature of the Islamic city. Examples of art forms in many different media can be found there: ceramics, tiles, calligraphy, glassware, textiles, carpets, stone and wood carvings, metalwork, stucco and the arts of the book.

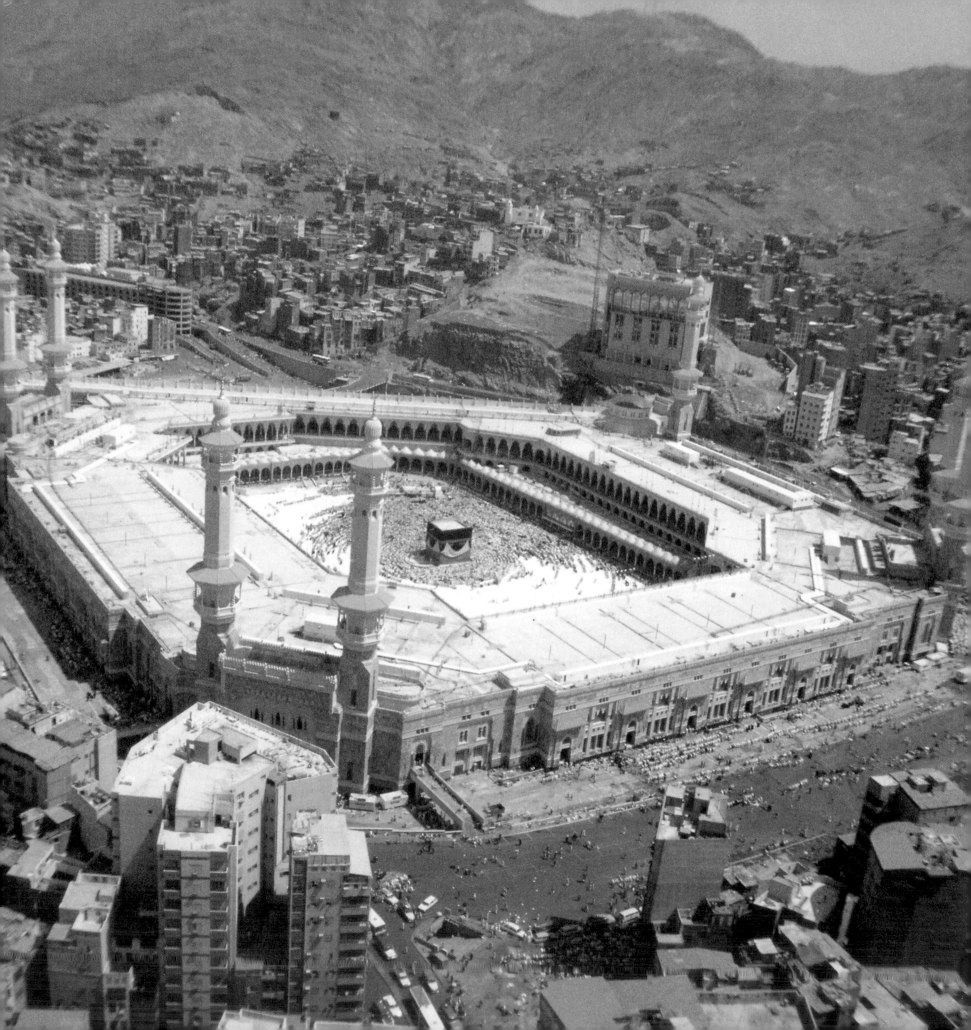

Architecture in its Environment

Mecca, Mosque of the Haram

The sanctuary at Mecca is a vast arcaded enclosure with the Kaaba at the centre. The Kaaba, a cube-like construction which houses the black Stone towards which Muslims turn in prayer, is surrounded by a paved path along which pilgrims perform their ritual circumambulation. The courtyard also contains the well of Zamzam, the domed shrine of Abraham/ Ibrâhîm, an ancient colonnade and a great open-air *minbar* from which sermons are delivered on important Muslim religious occasions. The surrounding arcades, which took their present form in the 16th century, have recently been entirely rebuilt.

Pilgrimage scroll
1436
British Library, London

Attesting that a woman, Amîna bint Husayn, visited the shrines of the Hejaz, the western part of Saudi Arabia, this scroll contains detailed representations of the Haram at Mecca, the stations of the pilgrimage outside it, and the shrine at Medina, including the tomb of the Prophet Muhammad and its enclosure.

Umayyad Mosque
Damascus, Syrian Arab Republic
Early 8th century

The Great Mosque of the Umayyad Caliph al-Walîd was built on the site of the temple of Jupiter Damascenus, close to the main Roman street which crossed the city. The Umayyad building has undergone constant restorations but its basic plan has not been altered.

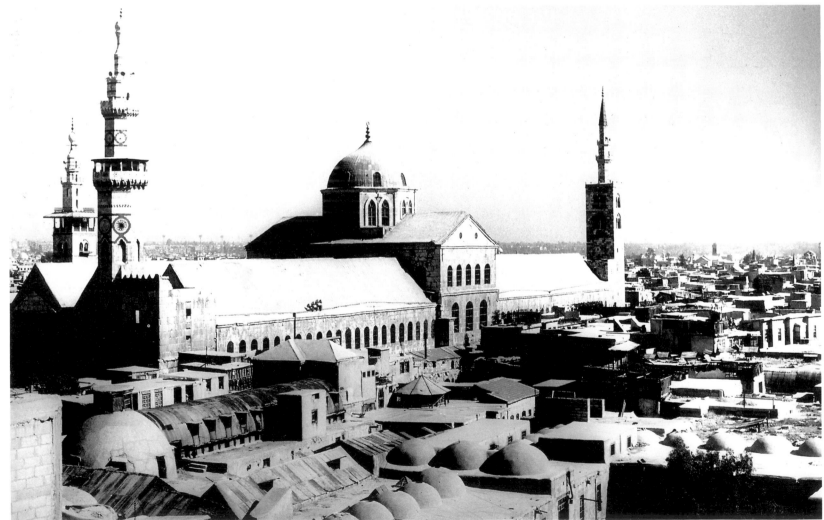

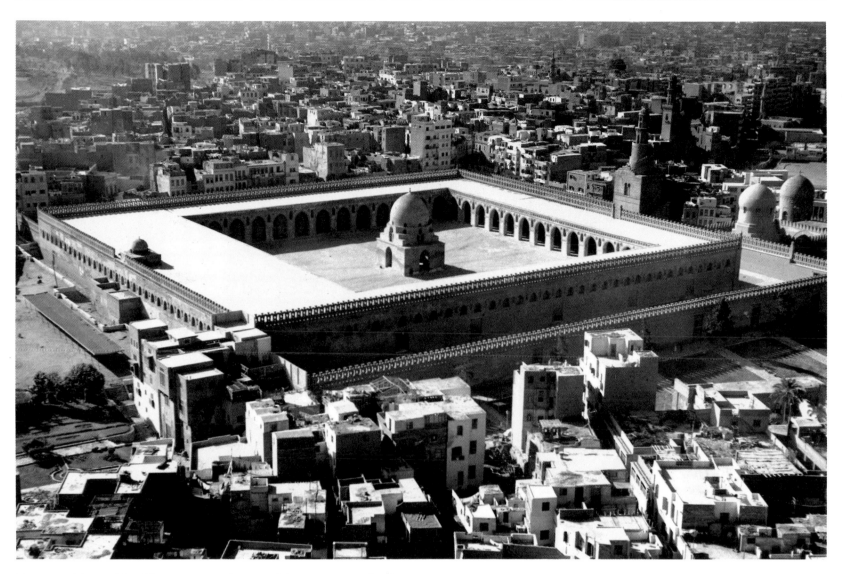

Mosque of Ahmad ibn Tûlûn
Cairo, Egypt
Founded 876

The mosque, founded by Ahmad Ibn Tûlûn, was built in conjunction with a palace at the centre of his city. The pointed arch was used extensively to support the roof and stucco wall coverings which decorated the mosque. Following the foundation of Cairo in 969, the urban centre moved north. Although the buildings around the mosque are relatively modern, the markets until recent years reached right up to the walls of the outer enclosure.

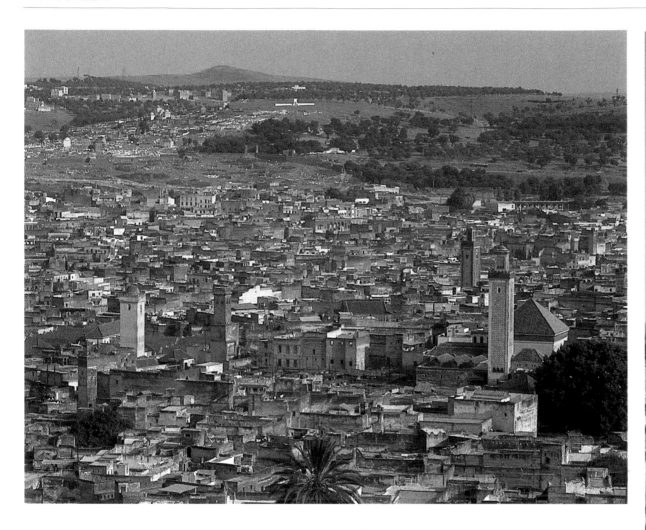

The Mediaeval Quarters
Fez, Morocco
c. 800

Founded by an 'Alid ruler, the city attracted immigrants from Andalusia and North Africa. Two of its mosques are 9th-century foundations, and in the following six centuries it was richly endowed with teaching institutions *(madrasas)* located near the tombs of holy men *(Zawiyas)*.

Süleymaniye
Istanbul, Turkey
1550-57

Built on a raised terrace overlooking the Golden Horn over the gardens of the old palace, the mosque is at the centre of a complex of buildings, which includes four *madrasas* (for the education of the upper echelons of the Ottoman bureaucracy), a hospital and medical school, a bath, a public soup kitchen and shops. Behind the mosque is a cemetery with the tombs of Süleyman the Magnificent and his wife Roxelane (or Hürrem Sultan).

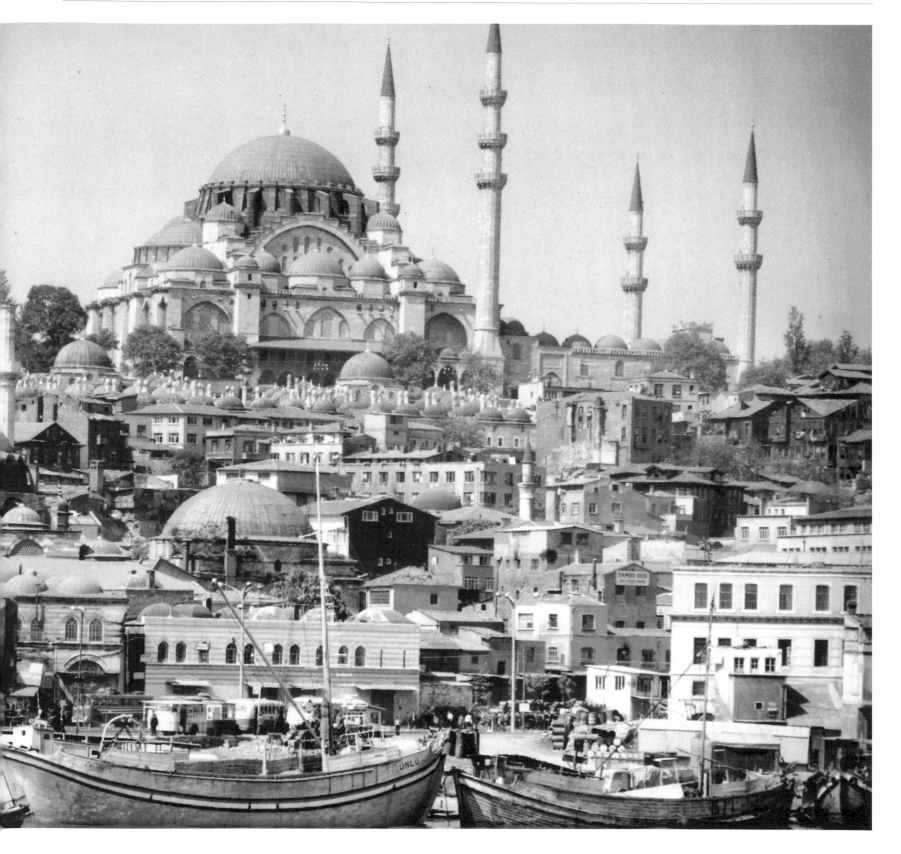

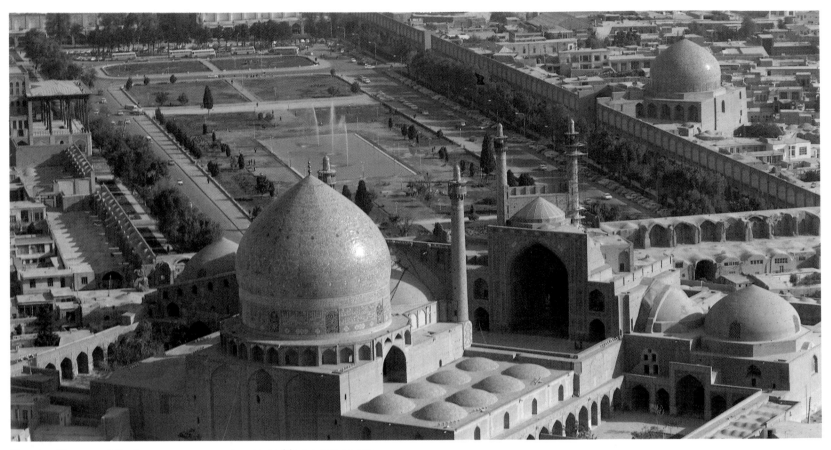

Maydan Square of the Imam
(formerly maydan of Shah 'Abbas)
Isfahan, Islamic Republic of Iran
17th century

Following the transfer of his
capital from Qazwin to Isfahan in
the early 17th century, Shah
'Abbas I had large areas laid out
as gardens and promenades, and
a vast rectangular space oriented
roughly north-south was
surrounded by bazaars and luxury
shops. A monumental entrance,
giving on to the bazaars, marked
one end of the square while the

entrance to his own mosque,
begun in 1612, decorated the
other. On the western side, the
high grandstand of 'Ali Qapu,
flimsily built but luxuriously
decorated, was intended for
watching polo matches in the
Maydan below.
On the east side was the Masjid
of Shaykh Lutfallâh. The planning
was somewhat improvised and
much of the building was
completed by the successors
of Shah 'Abbas after his death
in 1628.

Palace and mosque of Ishak Pasha
Doğubayazit, Turkey
Late 18th century

Constructed to be inaccessible in
a mountainous area commanding
the northwest Persian frontier,
this building was the refuge of a
Cildirogeullari lord who lived by
plundering caravans and
imprisoning travellers for ransom.
The self-sufficient fortress was
built with elaborately decorated
stone. It comprised a palace,
kitchens, a bath, a mosque and
vaulted prisons, all in a hybrid
style combining elements of
Seljuk, Caucasian and Neapolitan
baroque art.

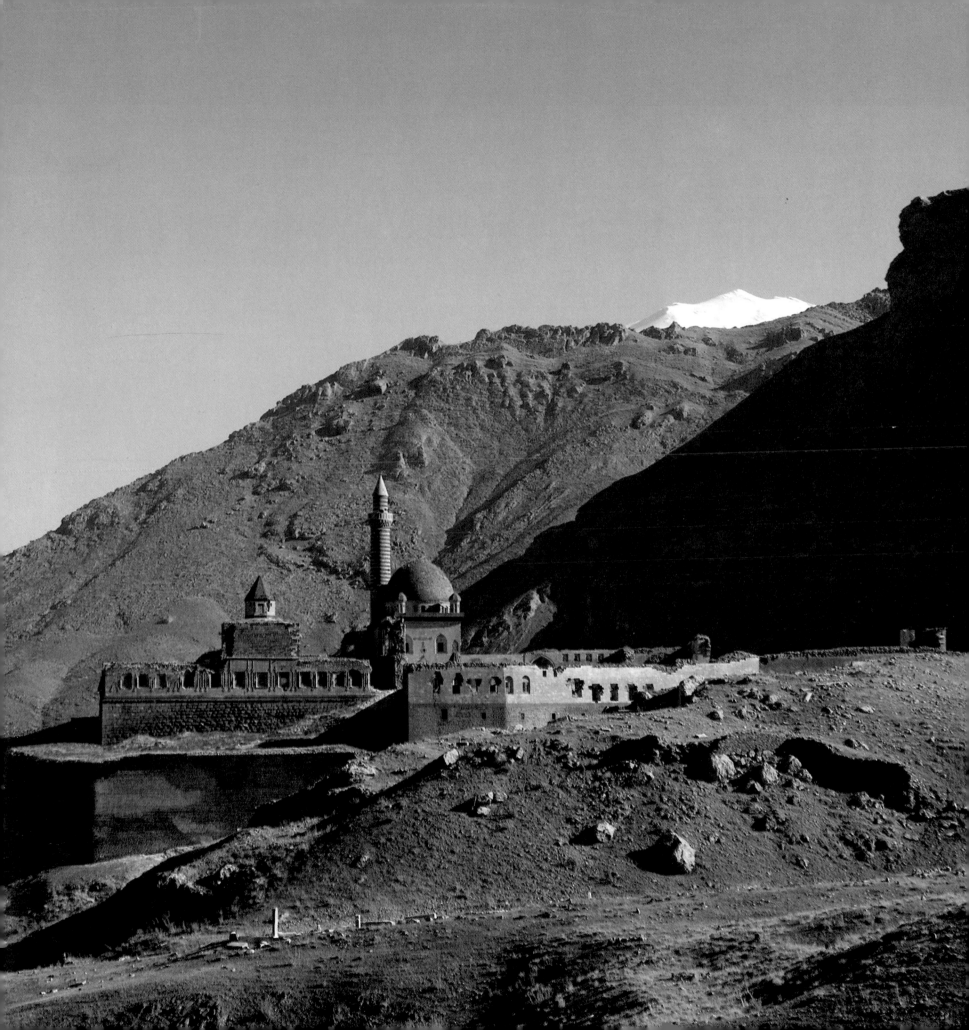

The Red Fort, Taj Mahal and surroundings
Agra, India

The Red Fort housed a series of palaces belonging to the Mughal emperors Akbar (circa 1570), Jahângîr (circa 1604) and Shah Jahân (circa 1627), which combined Muslim and Hindu architectural elements. Custom and lack of space dictated that funerary architecture should be built outside the walls; the most sumptuous of these, the white marble Taj Mahal (1632-54) erected by Shah Jahân, was built on a plinth at the centre of a garden with canals and pools, in an *enceinte* with monumental gateways, audience halls and a mosque.

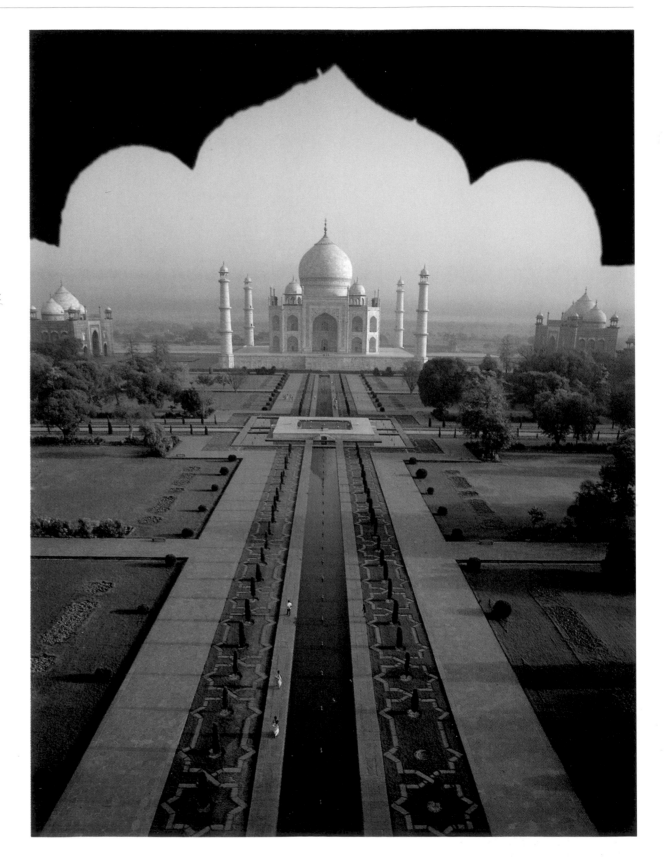

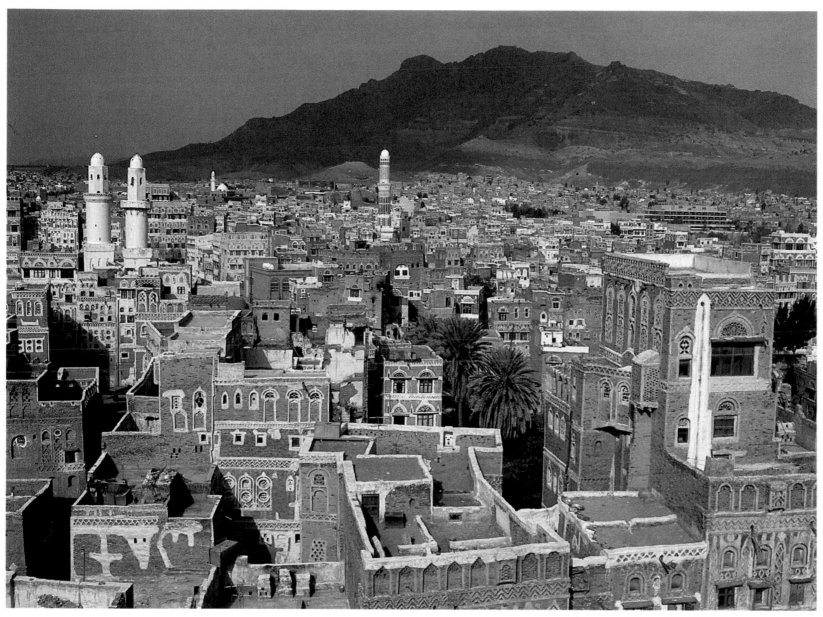

View of San'ā, Yemen

Owing to the mountainous terrain of northern Yemen, buildings are multi-storeyed to maximize the use of ground space available for construction. Typically, the walls are thick, the buildings taper at the top because of their height, and the upper storeys are decorated profusely, possibly in an effort to compensate for the narrowness of the façades.

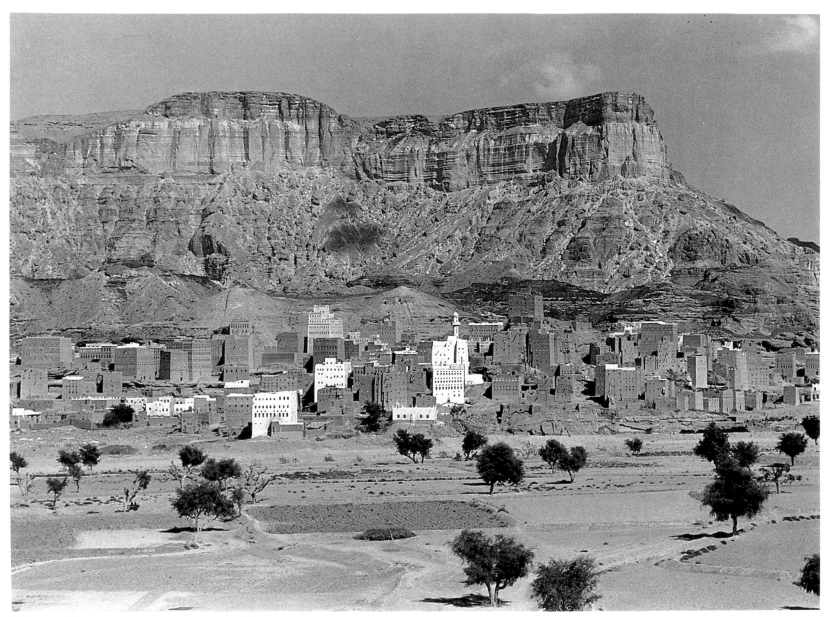

Village architecture
Wadi Hadramawt, Yemen

The slightly tapering multi-
storeyed architecture typical of
the Hadramawt harmonizes with
the sharply eroded mountain
landscape. Most of the buildings
are plastered with mud, but a few
are painted completely in white,
which relieves the monotony and
stresses the architectural
rhythms.

unusual?

View of Ghardaia, Algeria

The low, flat-roofed houses climb
up the hillside in terraces. In stark
and deliberate contrast, the
minarets rise high above their
horizontally organized
surroundings.

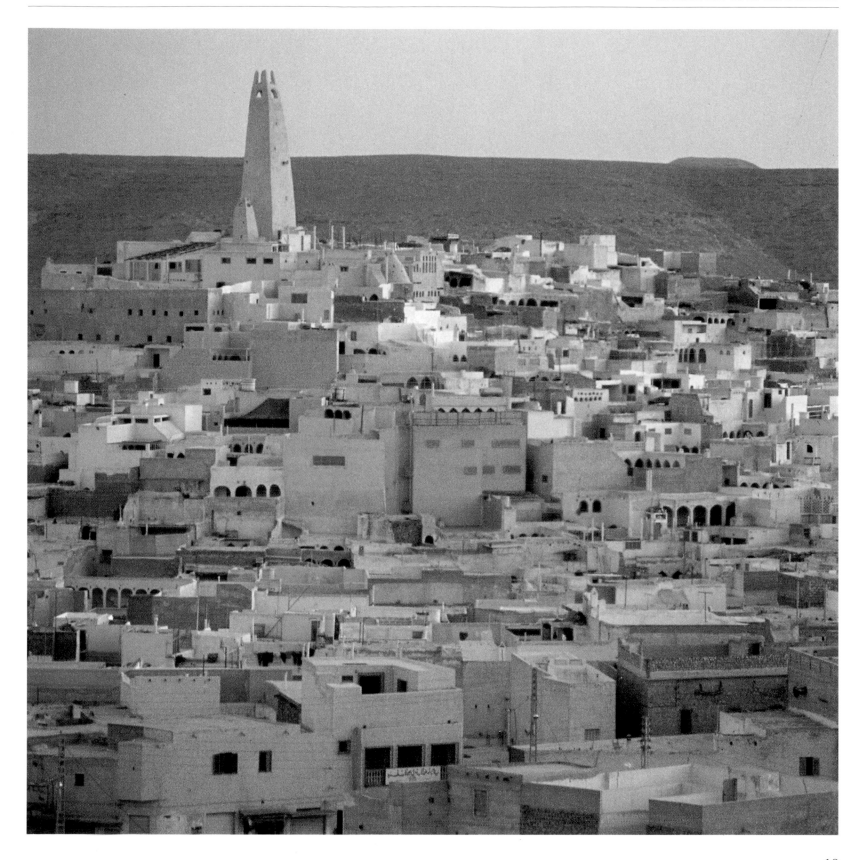

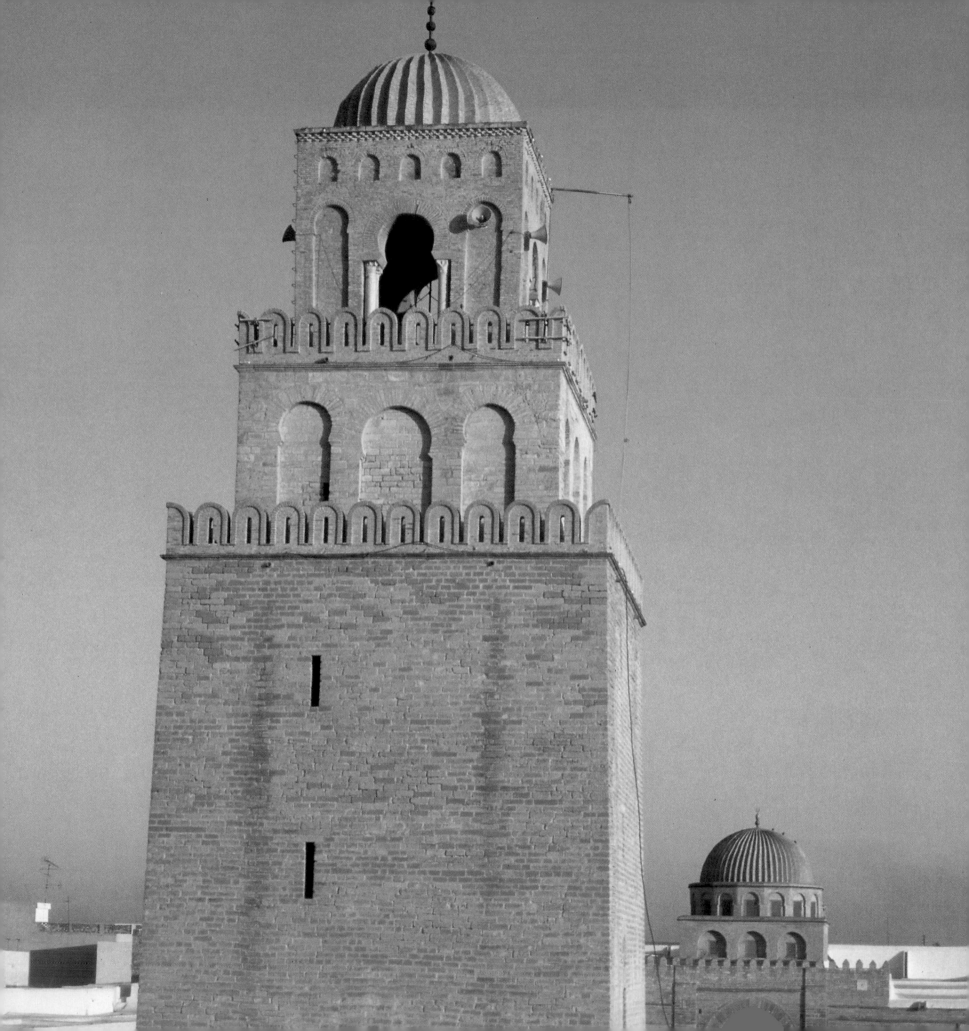

Major Elements of Islamic Architecture

Minarets

The intricately decorated tower-like structures, often of fine masonry, from which the call to prayer is given, have become a symbol of Islam. Yet early extant minarets are few; there was no standard model. Many great buildings had no minarets at all, and although by the year AD 1000 mosques were regularly built with minarets, they exhibited numerous local variations in material and decoration, and often were attached to shrines, mausoleums, *khanqahs* (dervish monasteries) and *madrasas* as well as to mosques. Sometimes they were commemorative, like the Qutb Minar at Delhi, which commemorates the Ghurid conquest of India in the late 12th century, or the successive minarets added to the mosques of Al-Azhar (Cairo) or to the Umayyad Mosque in Damascus. By the 15th century, particularly in Central Asia and in Mughal India, the symmetry of the plan dictated the multiplication of minarets above a porch or flanking a façade (where they may also actually buttress it). Aesthetic considerations of balance probably account for the six minarets of the mosque of Sultan Ahmed in Istanbul, although their number also contributes to the grandeur of the building. Such structures are not well adapted to the call to prayer, and minarets therefore were seen primarily as conspicuous indications from afar of the existence of a religious foundation.

Great Mosque, minaret
Qayrawan, Tunisia

The only likely remains of the Umayyad Mosque, which was almost entirely rebuilt in 836, is the three-tiered minaret, one of the earliest in Islam, and a three-tiered structure whose topmost storey is made of 13th-century brick. Minarets were often left standing simply because they were too difficult to demolish.

21

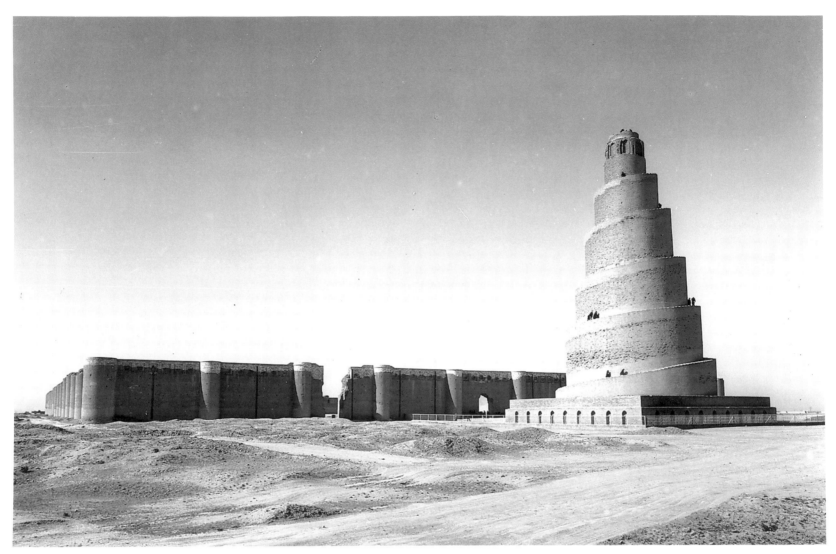

Great Mosque, minaret
Samarra, Iraq
848-52

The free-standing minaret, set on
a square plinth and located on the
same axis as the *mihrab*, is
composed of an anti-clockwise
spiral tower. A platform, which
evidently bore a small wooden
pavilion, crowned it. This minaret
served as the model for that of
Abû Dulaf at Samarra (860-61)
and very probably for that of Ibn
Tûlûn in Cairo, although its original
structure has not survived.

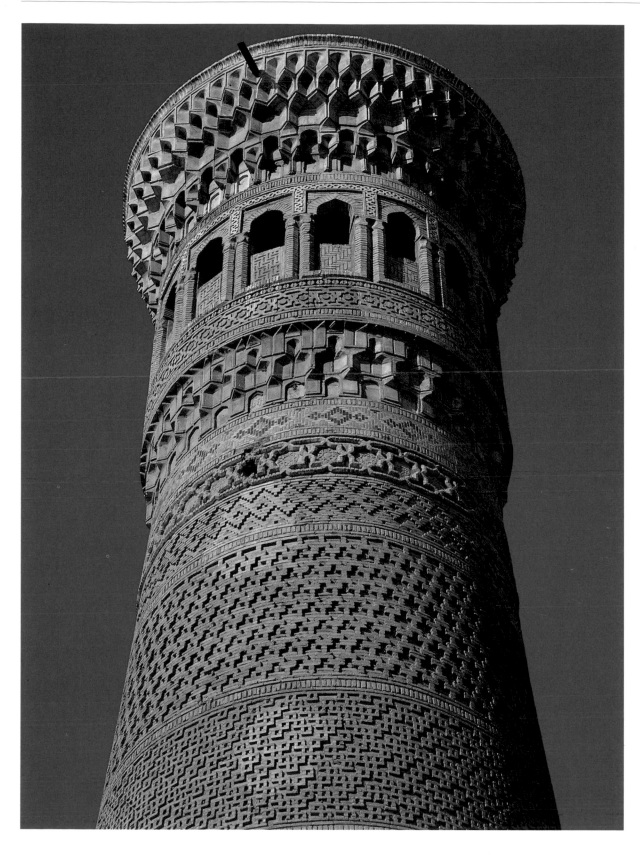

Kalyan Mosque, minaret
Bukhara, USSR
Early 12th century

The tapering brick minaret, 46 metres high, is decorated with geometric bands of brick strapwork. The profile suggests that the builder had not forgotten his training in mud-brick architecture.

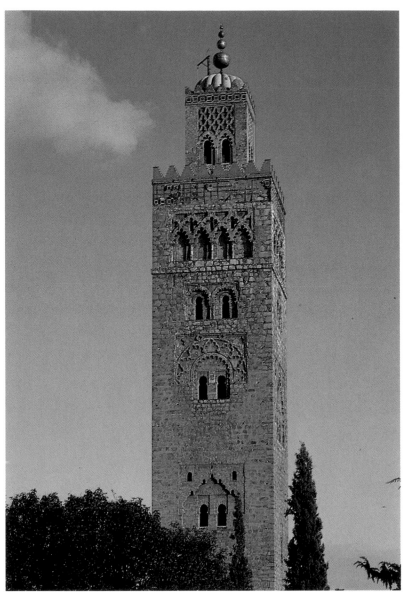

Great Mosque (the Kutubiyya),
minaret
Marrakesh, Morocco
12th century

The minaret follows the classical
Andalusian-Maghribi tradition – it
is square and crowned with a
smaller pavilion. On the exterior
the windows are set in decorative
niches, some of which show
traces of paint, and are crowned
with a frieze of intersecting blind
arches.

Mosque of Bahrâm Shah
Ghaznavid dynasty
Ghazni, Afghanistan
Late 11th-early 12th century

Only the brick minaret,
star-shaped in plan, remains
of the original mosque.

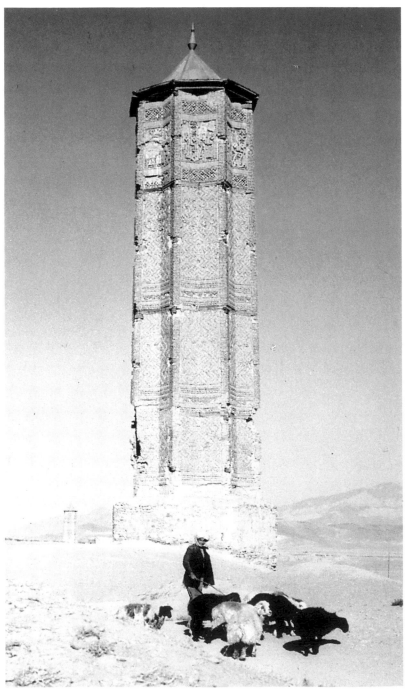

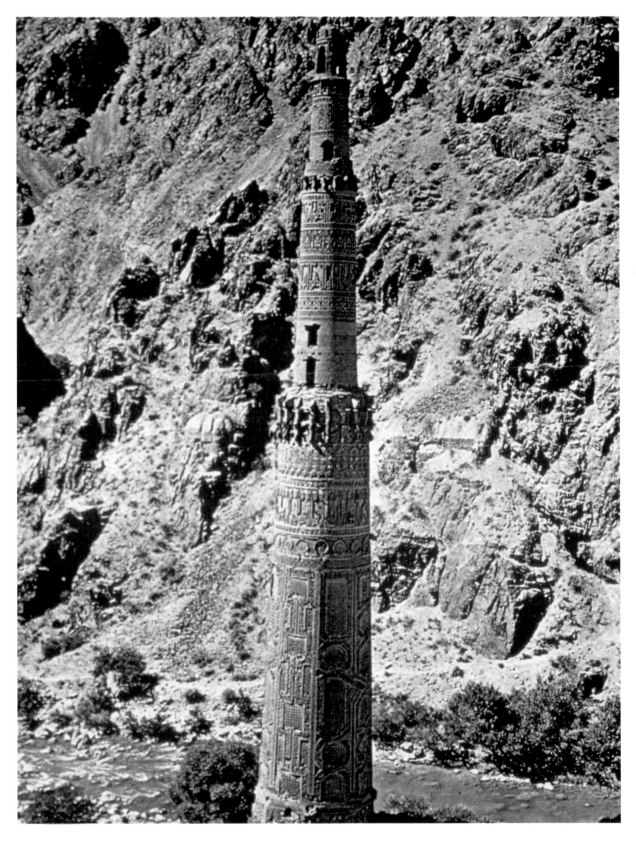

Minaret
Jam, Afghanistan
1162-1202

The minaret, located in an
inaccessible mountain valley, was
attached to a Great Mosque which
has not survived. A brick structure
of four successively tapering
storeys, almost 70 metres high, it
contains on the second storey an
(incomplete) foundation
inscription in a turquoise-coloured
glazed brick. Exceptionally
inventive use was made of
terra-cotta revetment plaques
decorated with Kufic inscriptions
from the Koran in the form of
interlace ornament.

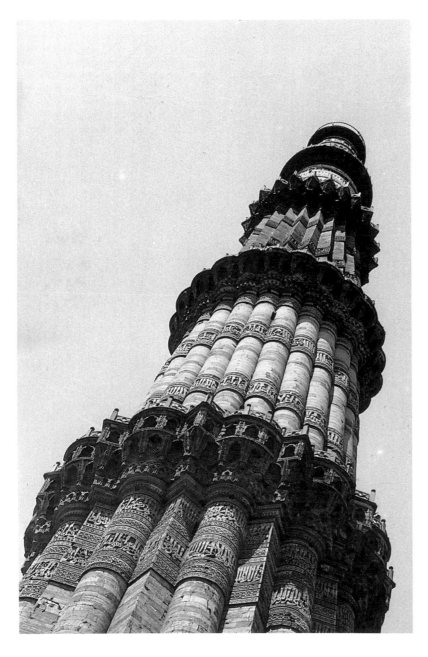

Great Mosque, minaret
Damascus, Syrian Arab Republic
14th century

The minarets stand on the site
of the towers of the pre-existing
Roman temple enclosure. The
present structure, popularly
known as the 'Bride's minaret',
dates to the Mamluk period.

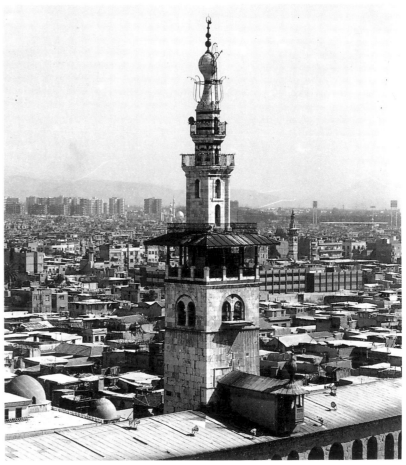

Qutb Minar
New Delhi, India
Begun 1199

The minaret was added to a
mosque built of stone plundered
from Hindu temples by the
victorious Ghurid ruler,
Muhammad Sâm, to mark the
triumph of Islam and the choice of
Delhi as the Ghurids' capital. Like

the mosque, the minaret bears
inscriptions commemorating the
victory. The series of tapering
storeys, with corbelled profiles
and lavish carved ornament with
stalactite corbels, derives directly
from the terra-cotta and brick
decorated structures of 12th-
century Ghaznavid and Ghurid
Afganistan.

Selimiye
Edirne, Turkey
1569-75

The mosque of Selim II, described
by the great Ottoman architect
Sinan as his masterpiece, has four
minarets which serve partly as
buttresses to counterbalance the
outward thrust of the domed
space.

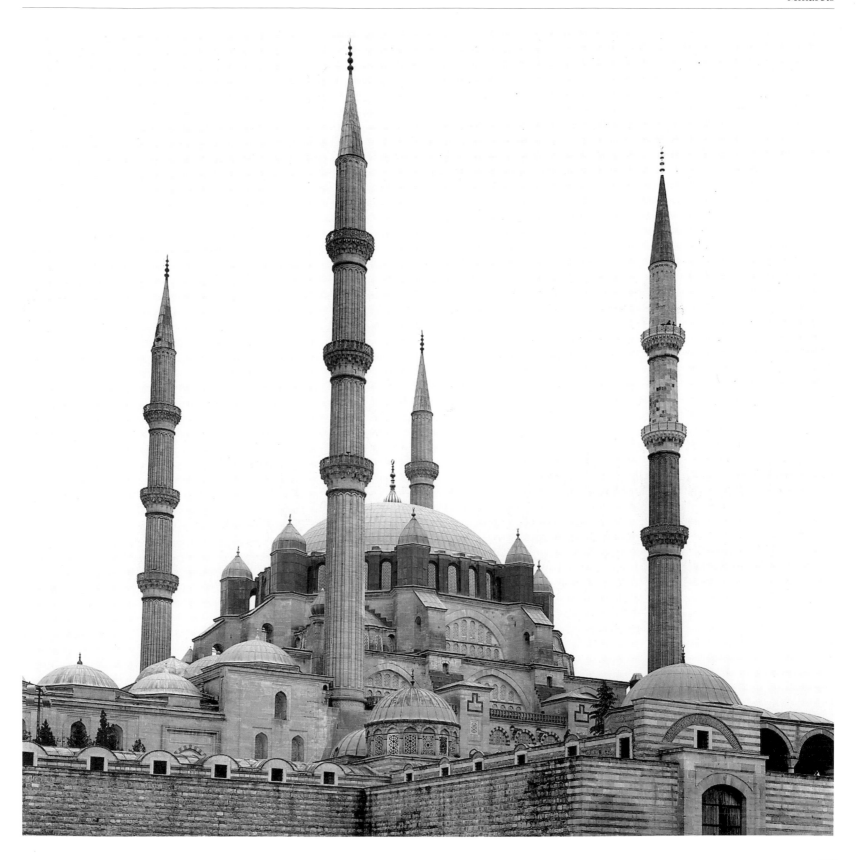

Tomb of Jâhangîr
Lahore, Pakistan 1627

The square tomb centred in a
monumental garden is crowned
by tiered octagonal minarets
decorated with a chevron pattern.
The proliferation of minarets is not
due to any religious cause but
rather to a desire for architectural
symmetry.

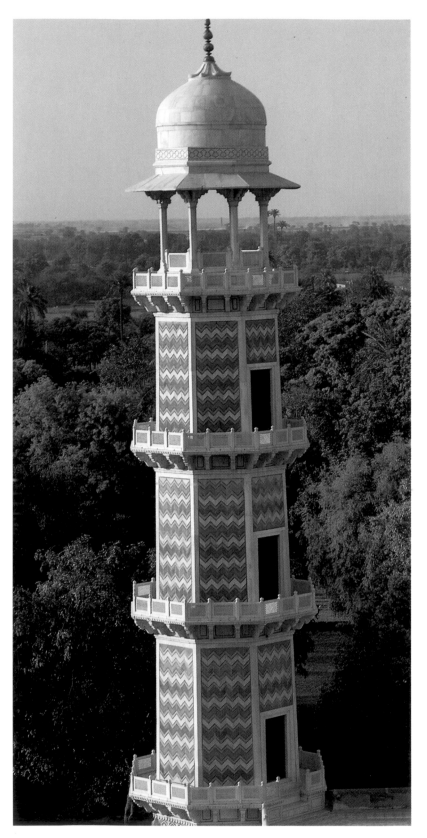

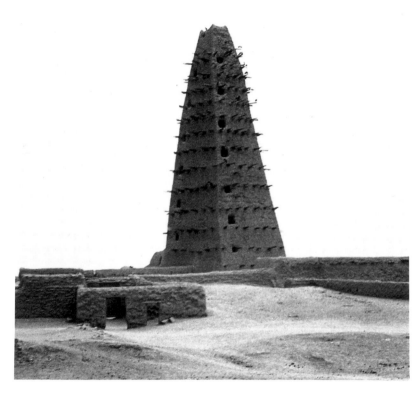

Great Mosque, minaret
Agadez, Niger
Probably 19th century

The tapering minaret of adobe
is reinforced with cross-beams
projecting from the walls and its
great height attests to the skill of
the local builders in the use of
such a relatively weak material as
mud.

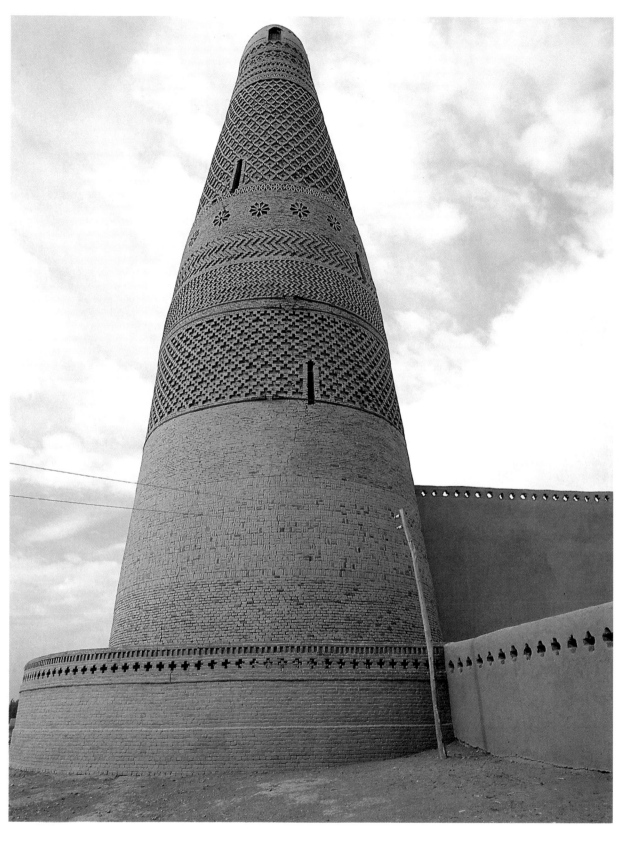

Amin Mosque, minaret
Turfan, West China
19th century

The sharply tapering conical form
and the bands of decorative brick-
work are the product of an
architectural revival which swept
Central Asia from Khiva to
Kashghar in the early 19th
century.

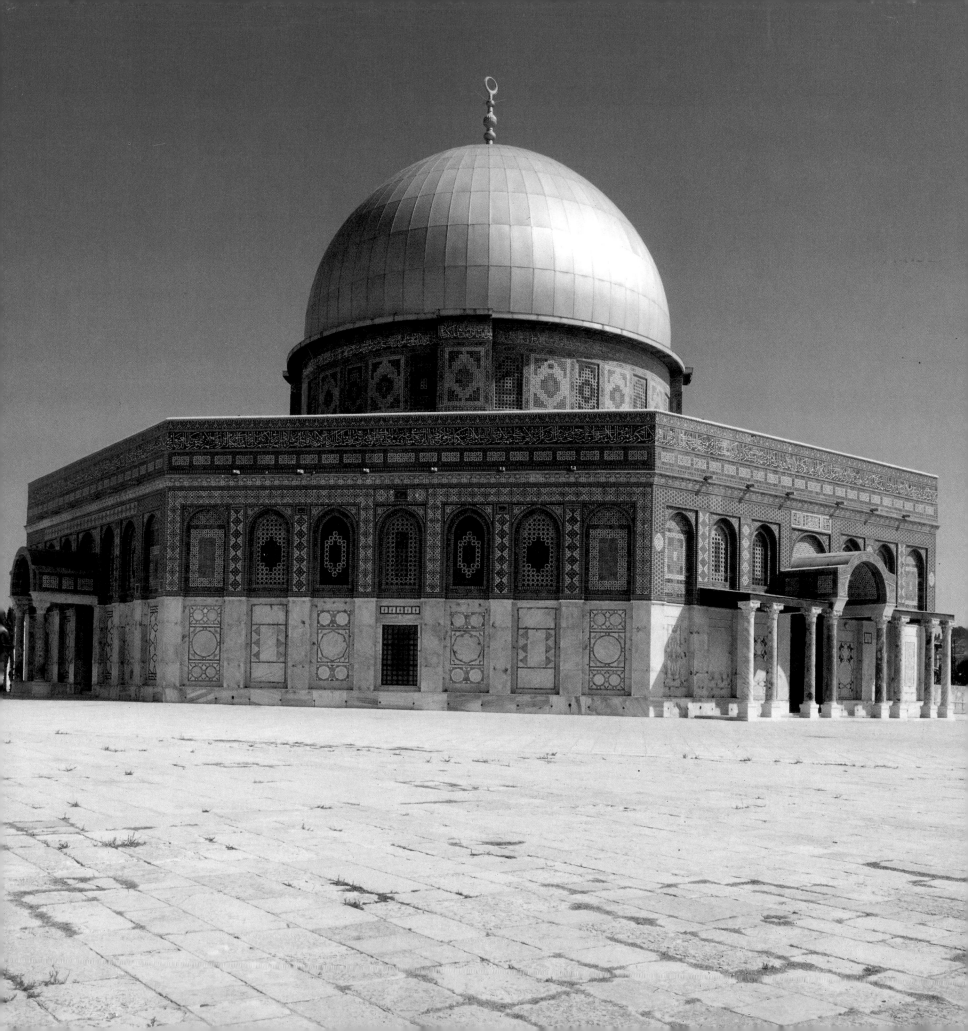

The Dome of the Rock
Jerusalem, al-Haram al-Sharif,
built by the Umayyad Caliph, 'Abd
al-Malik, 691-92

The Dome of the Rock, octagonal
in plan, was built on a site which
already by the late 7th century had
become associated with the
Prophet's Night Journey (mi'râj,
isrâ).
From the exterior, the building,
although much restored,
comprises a stone-arcaded
octagon, a circular drum with
polychrome tile facing, and a gilt
dome. The interior consists of a
double wooden dome, set on a
tall drum, which covers the centre
of the large octagon. This dome is
supported by piers and columns
forming two ambulatories, and is
covered with polychrome and gilt
arabesques of the 14th century or
later. The piers and arcades of the
ambulatories, however, retain
their original mosaics, richly
designed, while above the dado
of split marble panelling, the walls
have lost their revetment of gold
and polychrome mosaic.

in Russia also?

Domed Spaces

Islam, like other great civilizations, has always been sensitive to the impressive effect of domed spaces, both from outside, making the building conspicuous from afar, and from inside, awing the visitor. Early domes were cautiously built, normally spanning a square bay, but later a simpler solution was found and the rectangular base of the dome was heightened rather than its span increased. The earliest large domes were of wood, but the use of baked brick in Abbasid Mesopotamia spread rapidly all over Islam. By the 15th century, stone domes were widespread from Syria and Egypt to the Indian subcontinent, but even the great Ottoman architects of the 16th century failed to match the span of Justinian's church (now a mosque), the Haghia Sophia, in Istanbul. More recently ingenious use has been made of mud-brick with an elaborate timber scaffolding to form domes in the Islamic architecture of Central Africa.

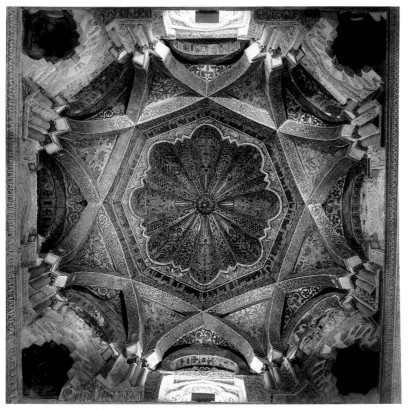

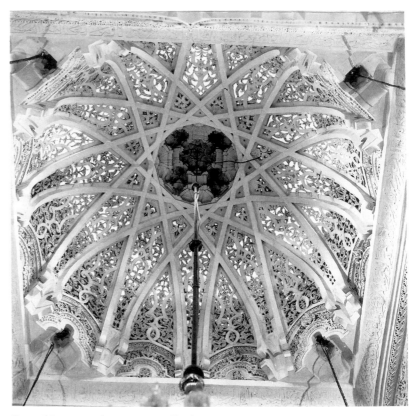

Great Mosque, dome over
mihrab
Cordoba, Spain
c. 965

The ribbed domes are completely
covered with glass mosaic. The
bay is one of three very elaborate
structures which give onto the
ruler's enclosure *(magsûra)*.

Great Mosque, dome over *mihrab*
Tlemcen, Algeria
Completed 1136

The intersecting ribs of the dome
are of brick while the infill is of
openwork stucco arabesques.
The vault recalls the luxurious
tracery of the 10th-century
domes of Cordoba.

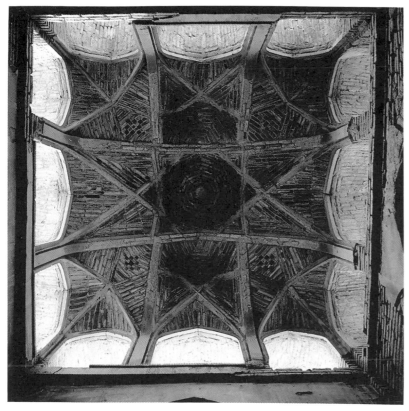

Great Mosque, vault of a bay on
the *qibla* side of the mosque
Isfahan, Islamic Republic of Iran
Late 11th century

The arcades of the *qibla* in the
original 8th to 9th-century
Abbasid mosque were altered
radically under the Seljuks, when a
monumental domed bay, in brick
and open-sided, was built to
house the *mihrab*. On either side
were bays with intersecting
ribbed brick vaults.

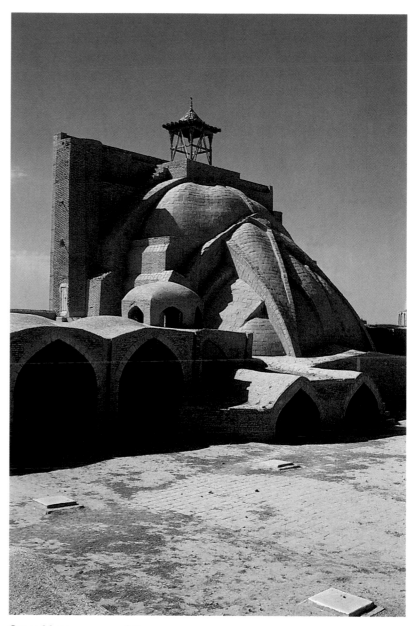

Great Mosque, rear of the
western *iwan*
Isfahan, Islamic Republic of Iran
11th century

The semi-domes of the *iwans*
were buttressed by an elaborate
system of ribs and carved
segments.

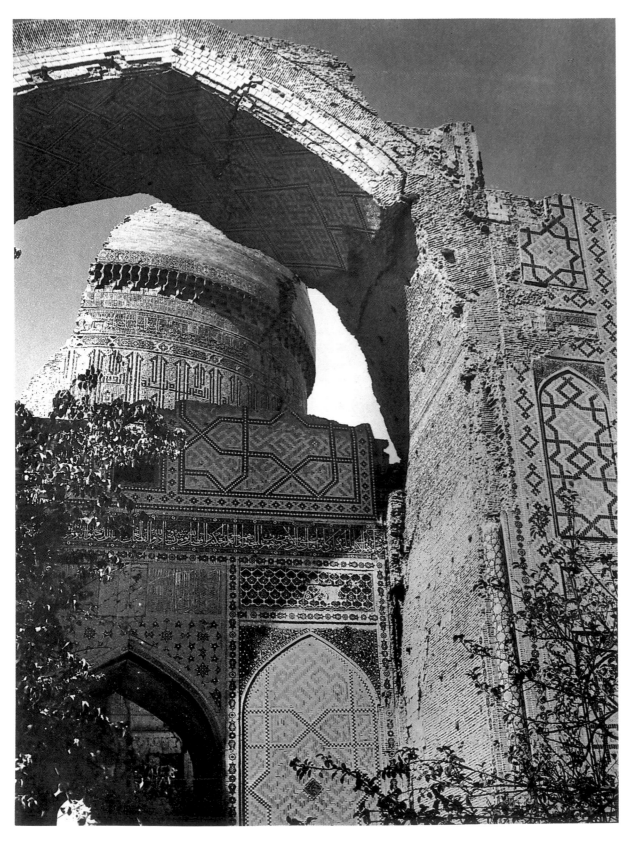

Bîbî Khanum Mosque
Samarkand, USSR
Begun 1399

Only ruins remain of the domed
chamber above the *mihrab* and
of the massive open tiled-veneer
porch that preceded it.

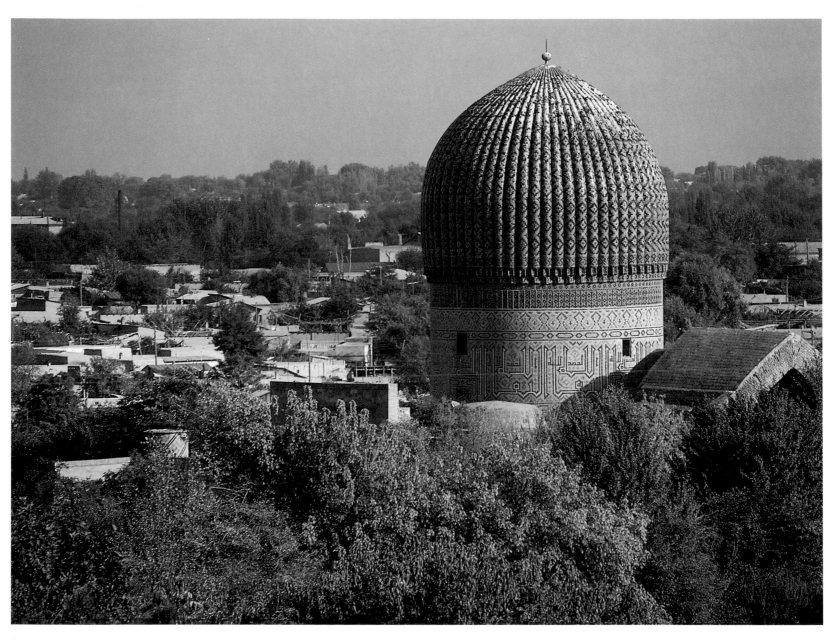

Gûr-i Mîr
Samarkand, USSR
Early 15th century

Timur (Tamerlane) was buried in
the *Khanqah-Madrasa* built by his
favourite son, who predeceased
him. Soon afterwards his
grandson Ulugh Beg turned it into
a dynastic mausoleum and had a
cenotaph of Siberian jade placed
over his own tomb.

35

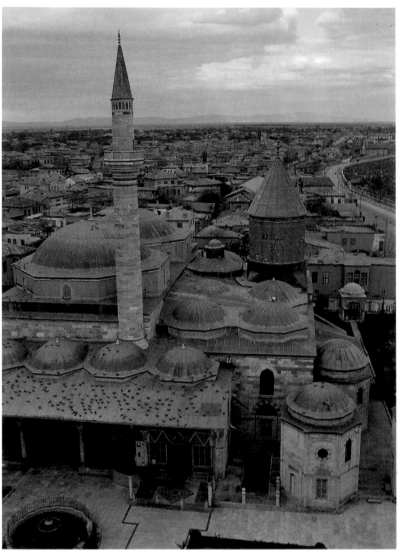

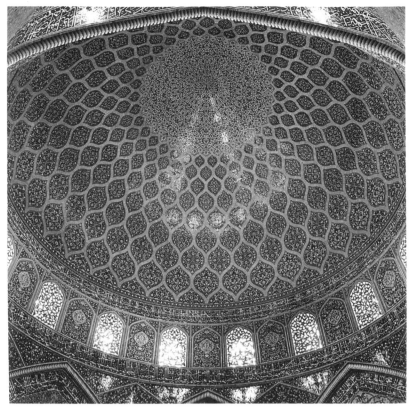

Mosque of Shaykh Lutfallâh
Isfahan, Islamic Republic of Iran
1617

Built in conjunction with the
Maydan-i Shah 'Abbâs, the dome
is remarkable for its polychrome
earthenware tiles, both inside
and out.

Mausoleum of Jalâl al-Dîn Rûmî,
dome
Konya, Turkey
13th century and later

The building, which also
functioned as the main house of
the Mevlevi, or whirling dervishes,
was restored in the early 16th
century. The tomb of Jalâl al-Dîn,
who even in his lifetime was
revered as a saint, has long been a
place of pilgrimage.

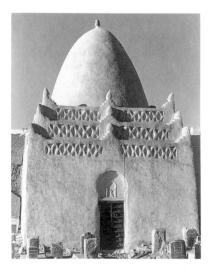

Mausoleum
Taribsa, Yemen

From the early centuries of Islam,
domed constructions were
popular as a means of
aggrandizing mausoleums,
despite considerable orthodox
disapproval. The profile of the
dome and its transitional zone
show local variations, yet such
architectural forms, though
probably recent, clearly reflect
much older traditions.

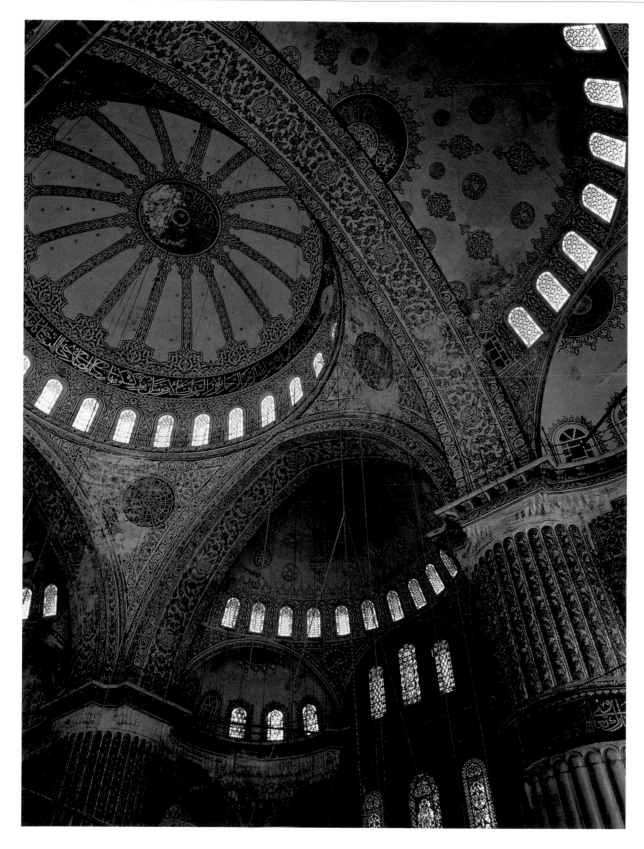

Mosque of Sultan Ahmed
Istanbul, Turkey
Early 17th century

Since Istanbul is subject to
earthquakes, architects have to
build with safety factors in mind.
Perhaps this explains the
disproportion between the four
massive piers supporting the
dome, which is built up of
buttressed tiers of semi-domes,
and the span of the whole.

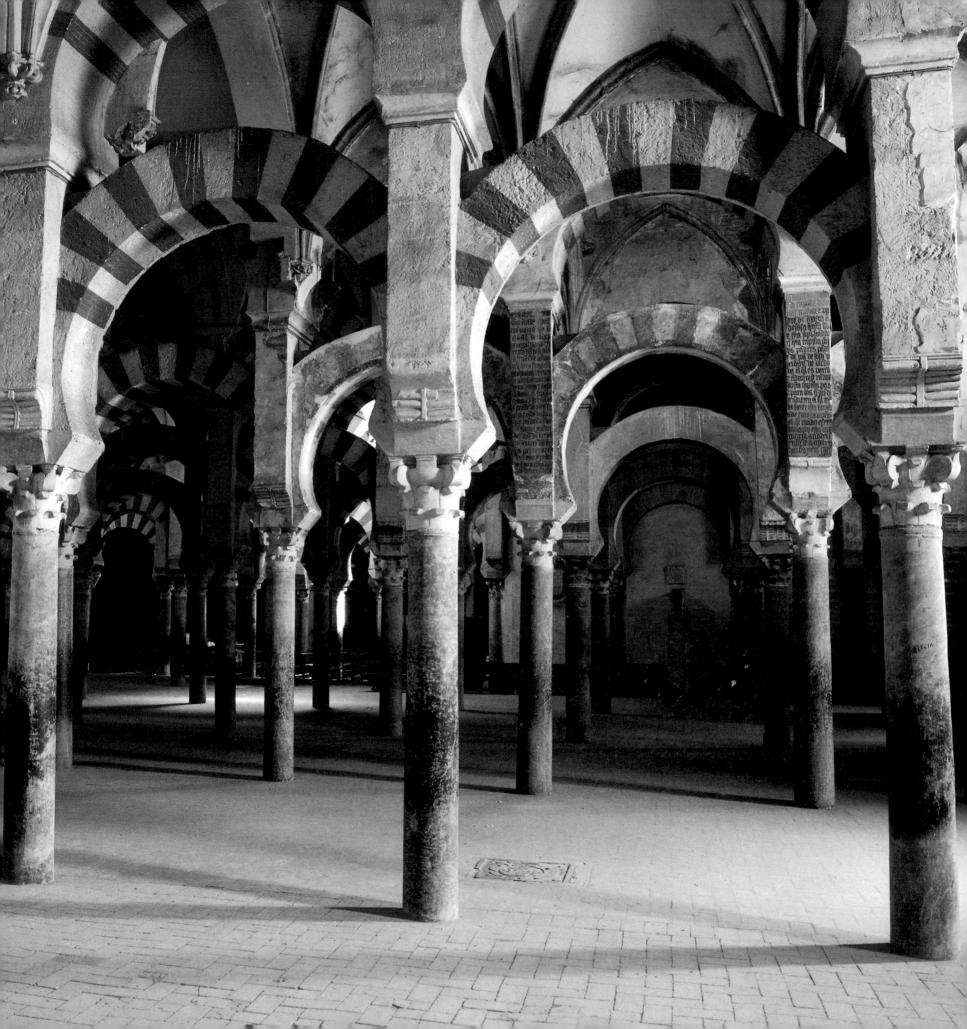

Capitals, Columns and Arches

Great Mosque, capitals,
columns and arches
Cordoba, Spain
Founded 785-87

The first site chosen for the Umayyad mosque at Cordoba was on sloping ground and could not be levelled easily, while the Roman or Visigothic capitals and columns available were of different sizes. Thus regular arcades were ruled out and the solution, possibly inspired by the aqueducts of Roman Spain, was to construct tiers of arches. The bi-coloured *(ablaq)* voussoirs come from Roman Syria and doubtlessly were introduced by the Syrian garrison that the Umayyads maintained at Cordoba.

The pointed arch, with two or more centres, appeared in Islamic architecture by the 8th century and was adopted everywhere as an effective means of increasing the height of arcades. In Western Islamic regions, horseshoe arches, both round and pointed, remained popular. Arches in many Islamic areas are lobed, cusped or broken, with elaborately decorated soffits or borders that lend interest to surface and profile. Arcades, which are indefinitely extensible, become a feature of basilical mosque plans, although often they require artificial reinforcements like wooden tie-beams, which may also be heavily decorated.

Both arcades and domes in massive architecture need brick and stone piers. However, in numerous Islamic buildings, arcades are light screen walls. This and the taste for luxurious decoration explain the importance of columns (often Roman or Byzantine marble ones which are re-used) with decorated bases and capitals. Many of the latter are re-used too, or else are adaptations of Roman Corinthian capitals. But stalactite faceting, both in wood and in stone, is a decorative device that originated in Islamic art.

Chinese Muslim architecture generally adopts traditional architectural forms. In the grandiose mud-brick architecture of many Islamic regions, too, the arches spring not from columns, but from the ground in a single grand sweep.

Screen arches of al-Hakam (961-66): in the axial bay immediately before the dome over the *mihrab*, a raised pavilion known as the 'Capilla de Villaviciosa' was built with a ribbed vault. The upper arcade comprises a type of screen wall with intersecting tiers of horseshoe arches, which was an adaptation of the multi-tiered arcades of the original building.

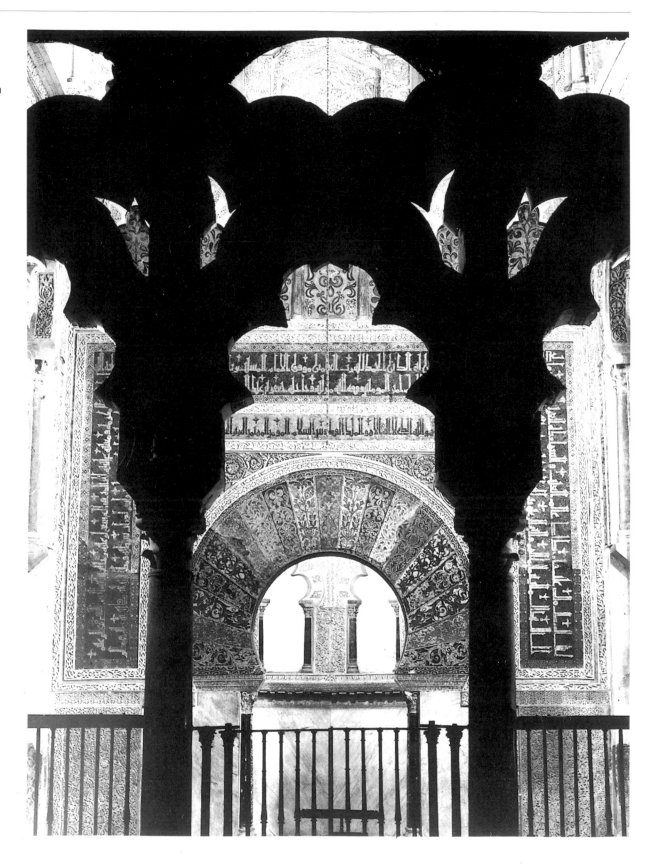

Nô Gunbad
Balkh, Afghanistan
10th century or later

Quincuncial in plan, this mosque was constructed with stout cylindrical piers, compressed rectangular capitals or impost-blocks and arcades with elaborately carved stucco work.

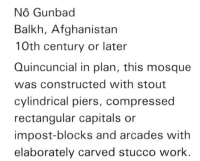

Great Mosque
Wasit, Iraq
Early 8th century

Of the Umayyad mosque nothing remains but this column decorated with motifs inspired by the crowns of the Sasanian kings, whom the Arabs conquered in 641.

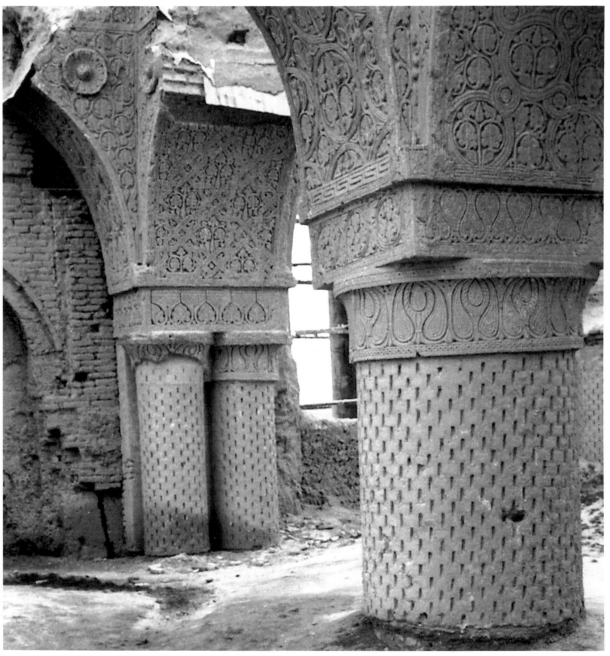

41

Quwwat al-Islam Mosque
New Delhi, India
c. 1197

Erected mostly with elements
taken from Hindu temples, the
mosque was built
to commemorate the Ghurid
conquest of North India. In 1199
the heterogeneous result was
unified by a stone screen wall on
the *qibla* side of the courtyard.

Mosque of Aba Khoja
Kashi, Western China
18th century or later

The architecture of Kashi
combines traditional flat-roofed
mud-brick architecture with
Chinese decorative elements
(notably beams). The
stalactite-carved wooden capital
marks a deliberate attempt to give
the building an Islamic character.

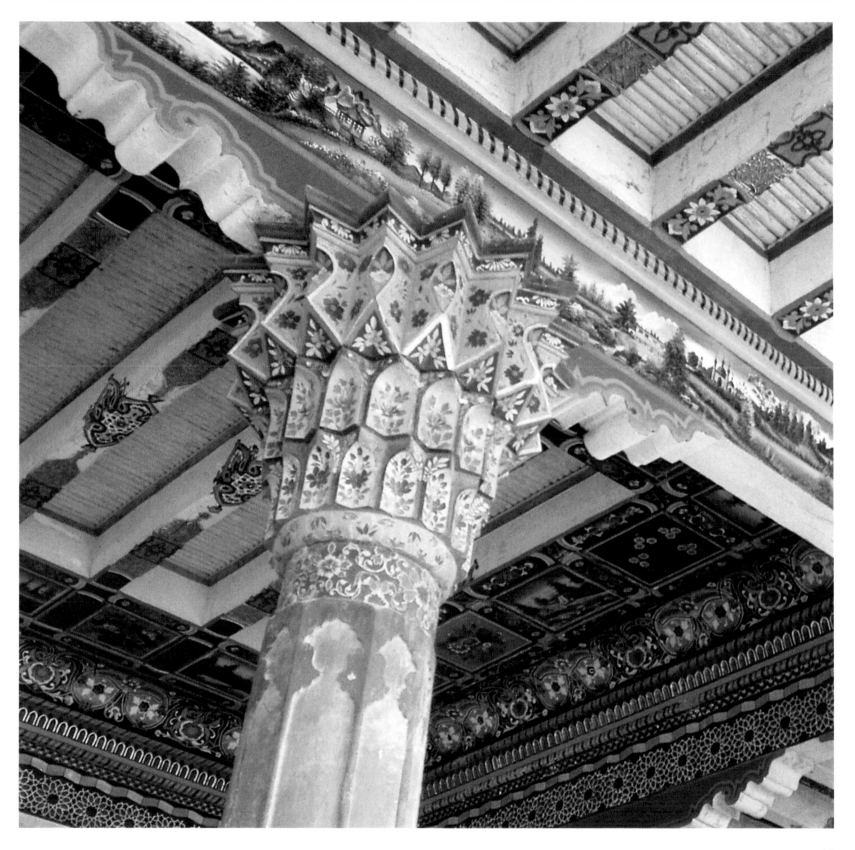

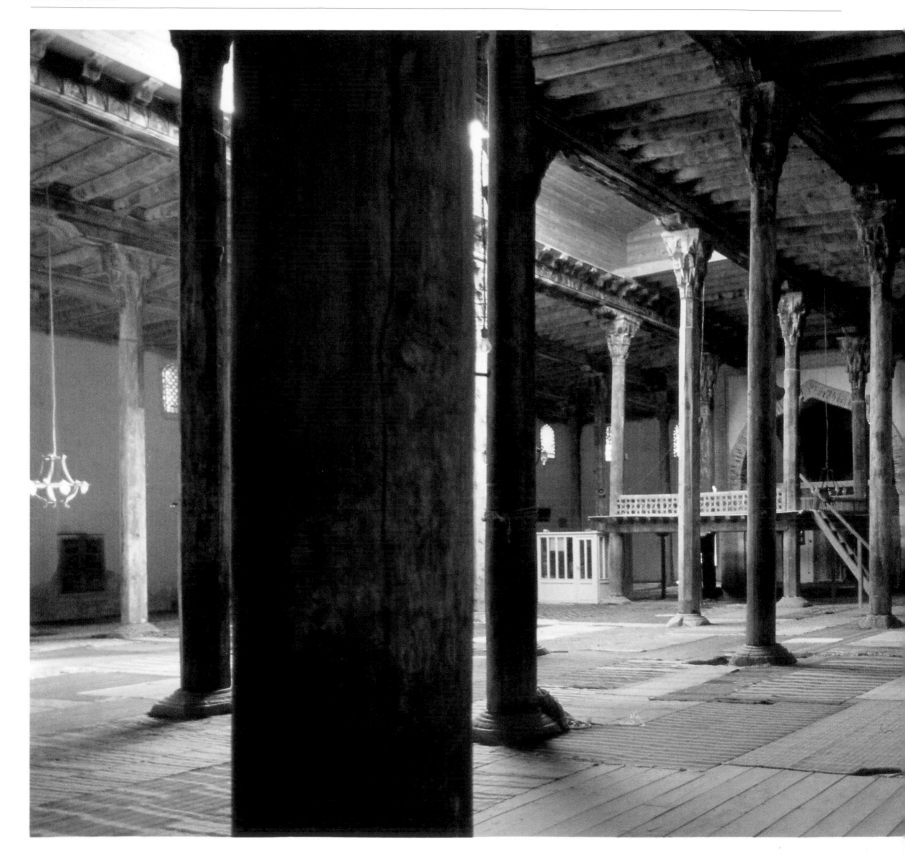

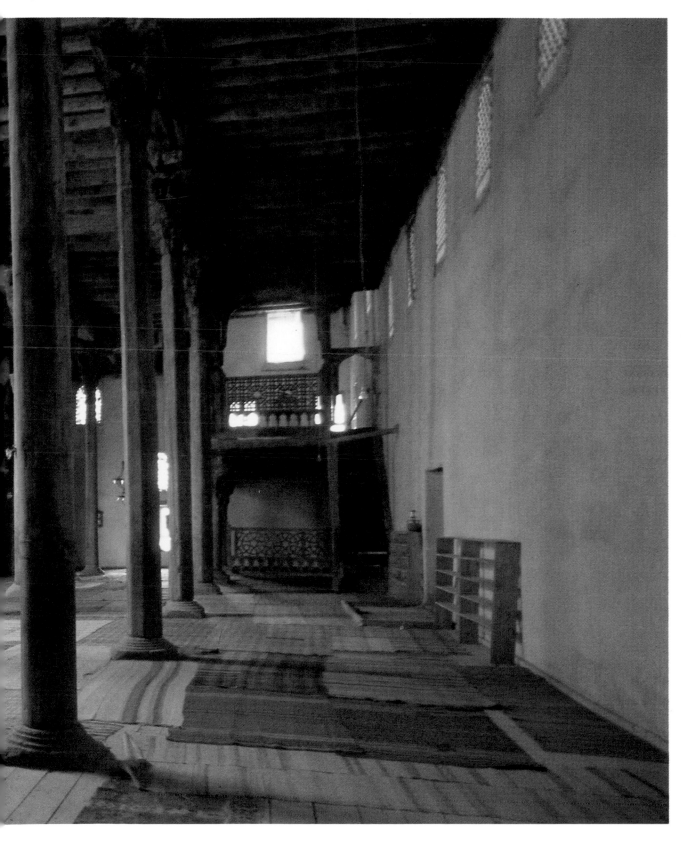

Eşrefoğlu Mosque wooden
columns
Beyşehir, South-Western Turkey
1299

Wood has traditionally been
a luxury material in Islamic
architecture, and although it is
easy to carve and sculpt, few
such capitals survive. However,
13th-century Anatolian great
mosques, which are often basilical
in plan, are built to a scale that is
very suitable for wooden columns
and capitals.

So-called 'Abbasid Palace',
actually a *madrasa*
Baghdad, Iraq
c. 1240-50

The vaulting of this narrow
corridor is composed ingeniously
of faceted capitals or corbels
joined at the top to form broken
arches with stepped profiles.
Above these transitional zones,
small stalactite domes cover
each bay.

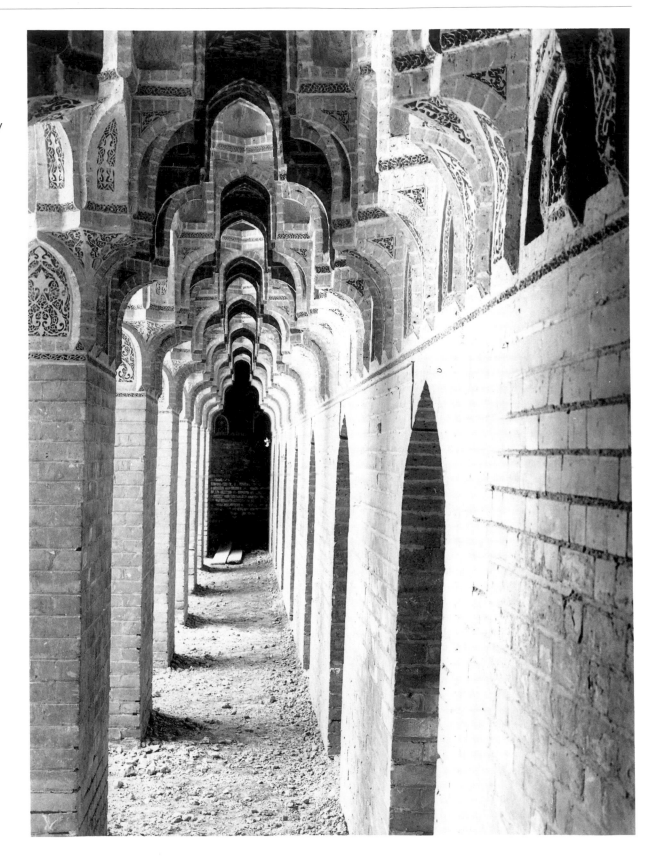

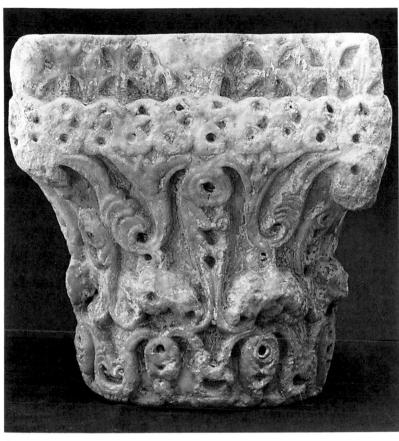

Capital
Raqqa, Syrian Arab Republic
Late 8th century
National Museum, Damascus

Raqqa was essentially an Abbasid foundation of the reign of Hârûn al-Rashîd and its architectural remains therefore date from the 9th century or later. However, capitals found there show the continuing influence of the late Roman tradition of Corinthian columns and acanthus volutes on Abbasid ornament.

Great Mosque, largely rebuilt
Zaria, Nigeria
Early 19th century

The steep, pointed arches with engaged piers are constructed of mud-brick reinforced with palm trunks. Such arches are characteristic of Islamic mud-brick architecture of Western Africa and show the brilliant use of inexpensive materials.

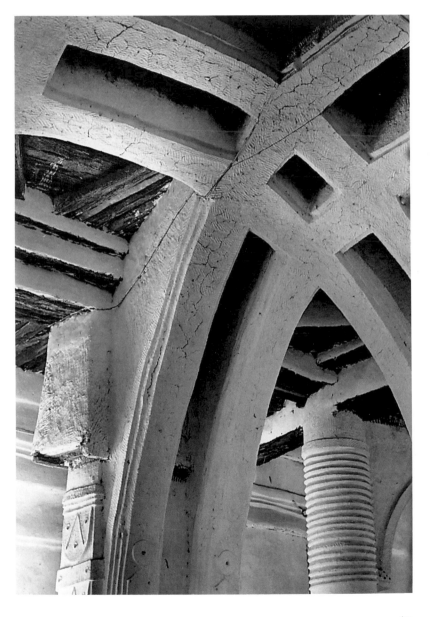

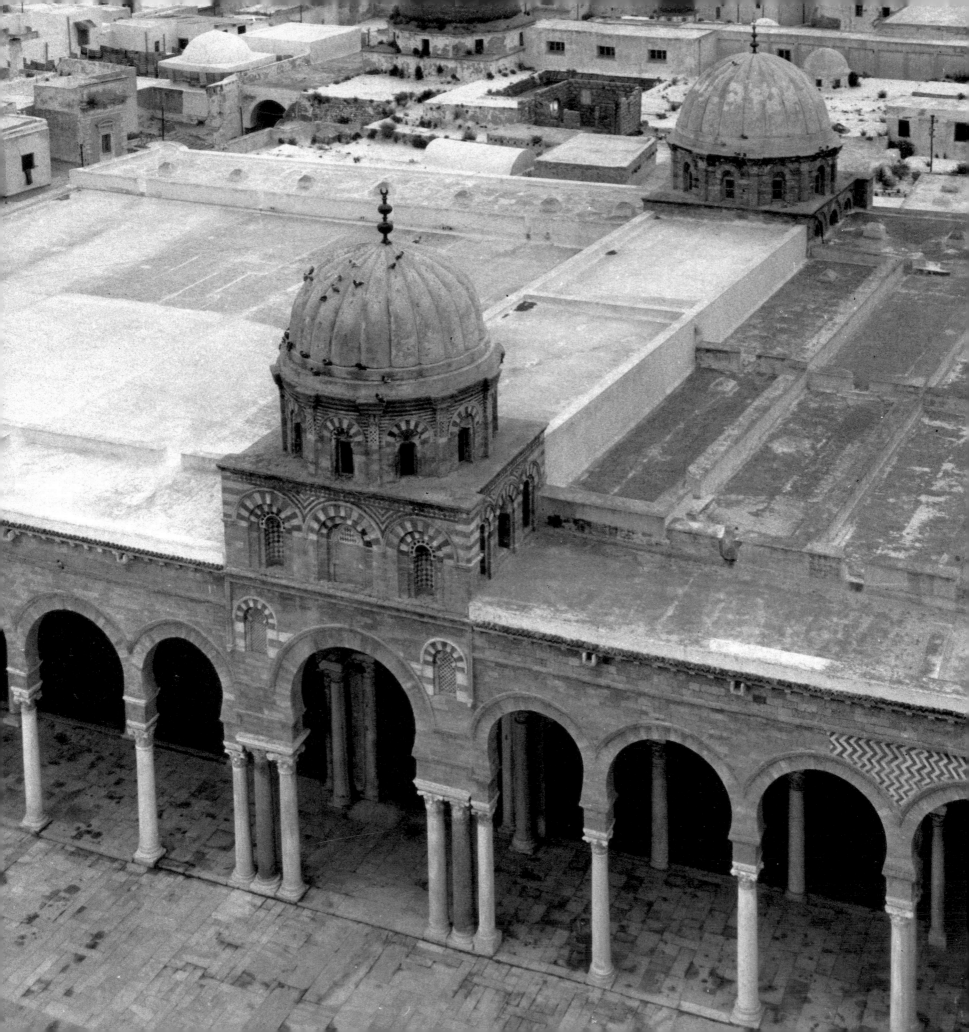

Façades, Entrances, Arcades, Courtyards and *Iwans*

al-Zaytuna Mosque
Tunis, Tunisia
Rebuilt 856-63

The courtyard façade and the domes are late 10th-century additions plainly inspired by the Great Mosque at Qayrawan (after the major refurbishment of 862). The axial bay has an impressive clerestory. In the 15th century under the Hafsids, a monumental raised gallery and shops were added on the western side. This then became the main façade.

Some of the most famous buildings of Islam possess entrances which give no idea of the scale of the building behind them. But by the 10th century, grand entrances both plain and decorated appeared. The idea was probably derived from palace architecture which had to impress the visitor from the outset. The entrances generally are stoutly built, dominate the façade and often form independent blocks. Doorways are recessed in decorative frames with elaborate stalactite canopies, and where the plan allows, are located on the axes of the building. For many façades, the grand entrance may not be enough and so may be flanked by open balconies or minarets, which from the 14th century onwards were built at the corners not only as buttresses but also as architectural accents. Thus the exterior façade often echoes the arcades of the prayer-hall or the *qibla*.

The almost universal inclusion of courtyards in the planning of mosques is probably a reaction to the rarity of open spaces in the centre of Islamic cities. They were used for assemblies, study and trade, in the same way as the forum of Roman cities before them, while the surrounding arcades provided shade. In some regions of Islam, though not all, the courtyard contained the fountain for the obligatory ritual ablutions before prayer in the mosque.

It was customary in early mosques and palaces to mark the axis of the prayer-hall with a grand triple entrance, sometimes surmounted by a decorative dome and containing a raised passage to the *mihrab*. Open porches (*iwans*) were also

adopted not only as entrances but also to mark the axis of the building, and considerations of architectural symmetry encouraged *iwans* on the cross axis, creating a four-*iwan* plan. Such *iwans* generally preceded the domed chambers, and their decorative frames, which towered above the low prayer halls, were elaborately buttressed from behind.

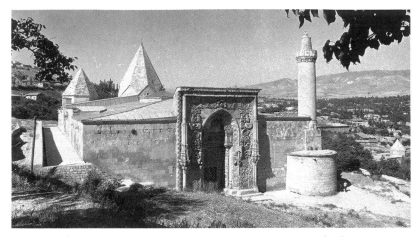

Great Mosque, north porch
Divriği, Turkey
c. 1228

The mosque, attached to a hospital foundation, is roofed entirely with a variety of domes and vaults, the one over the *mihrab* bay being the most elaborate. The mosque has two entrances in markedly different styles: the northern one, set in a larger frame, is decorated with an abundance of architectural mouldings and ornate details which show the brilliance of 13th-century stonework in Anatolia.

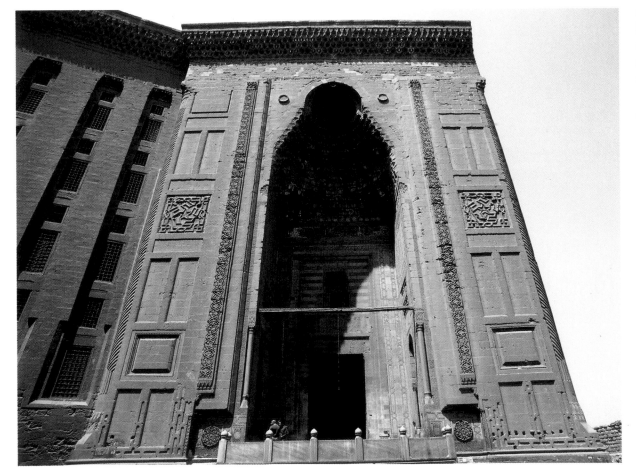

Mosque of Sultan Hasan, entrance
Cairo, Egypt
Begun 1356

The monumental entrance, one of the grandest in Islam, is constructed of an unfinished projecting block with a deep porch, which was originally intended to be surmounted by two minarets.

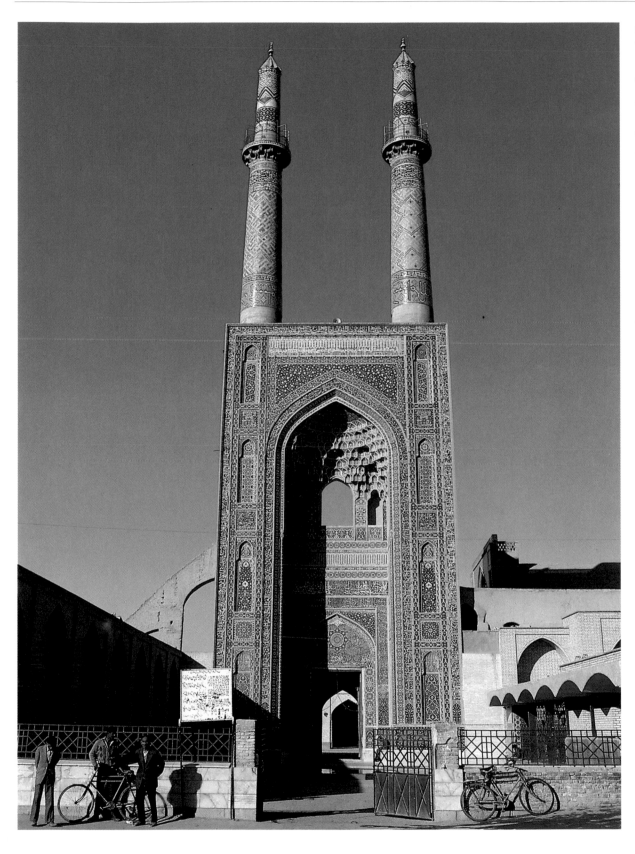

Great Mosque, courtyard
Yazd, Islamic Republic of Iran
14th-15th centuries

The Great Mosque incorporates
elements of very different periods.
In the later 14th century these
were unified by arcades in the
courtyard and by an *iwan* on the
qibla side, facing the domed
mihrab. Rich polychrome tile
mosaic covered the additions.
The main entrance, now to the
east, was built in the 15th century
and is composed of a great
rectangular frame crowned by two
tapering minarets which dominate
the rest of the mosque. Within the
frame, a high ogivc arch is
surrounded by blind niches
covered in mosaic revetments.

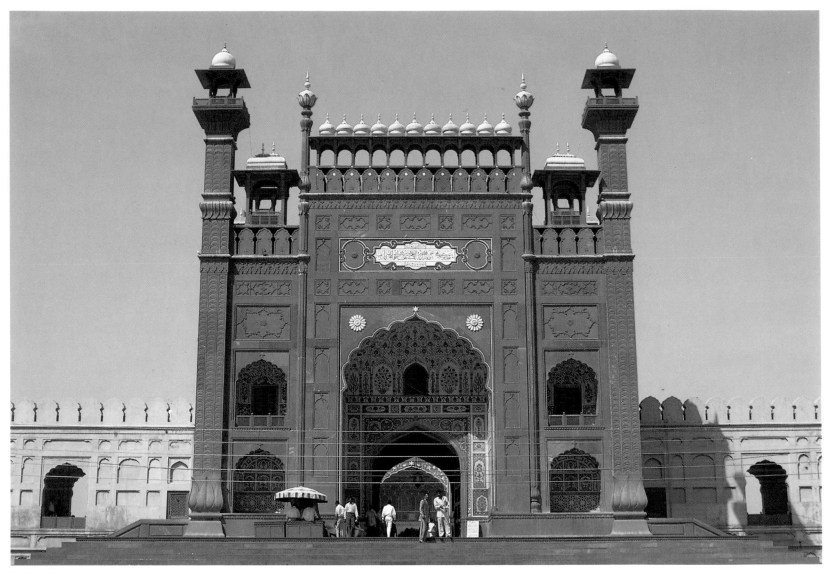

Padshahi Mosque, gateway
Lahore, Pakistan
1673-74

The pink sandstone gateway,
flanked by slender towers and
approached by a grand staircase,
is topped by turrets and a
canopied platform.

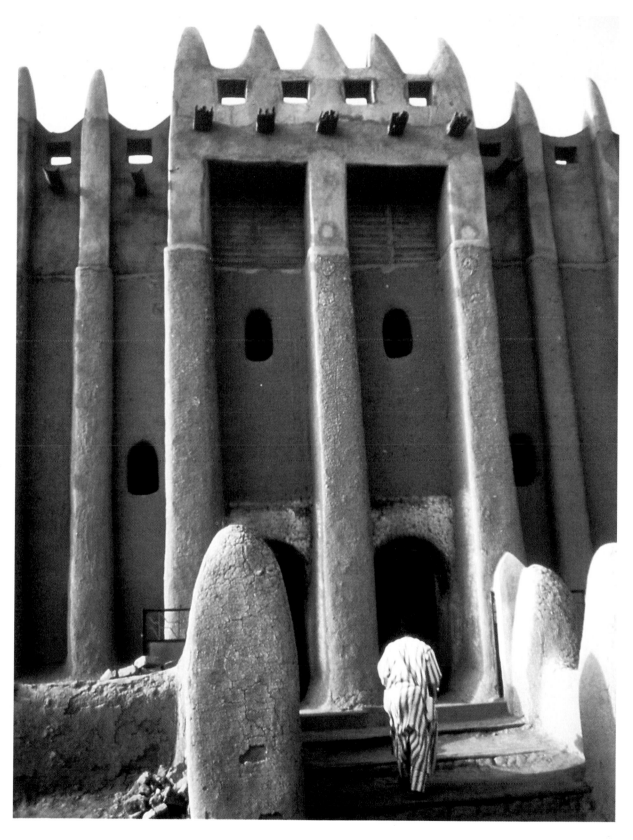

Great Mosque
Mopti, Mali
Rebuilt 1935

Impressive use can be made of mud as a building material, even in areas with a relatively high rainfall. Both tapering buttresses and sharply grooved walls are devices used to carry off heavy rain before it can damage the fabric. This type of mud structure, while reflecting local architectural traditions, is nevertheless somewhat impermanent and demands periodic rebuilding.

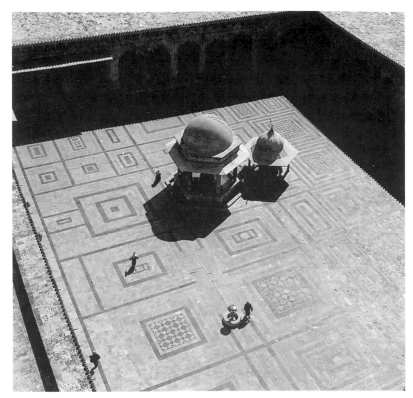

Mosque of Al-Azhar, courtyard
Cairo, Egypt
Founded 969

The courtyard was gradually restored in the early 12th century with fine Roman marble columns and capitals and an upper storey of decorative blind niches.

Great Mosque, courtyard
Aleppo, Syrian Arab Republic

The plan of the mosque is still basically that of an Umayyad foundation (circa 715) but the fabric is Seljuk or later in date and the stone arcades around the courtyard are probably from the 13th century. Typically for early mosques of Syrian type, the courtyard contains small domed buildings, drinking fountains (not for ablutions) and treasuries or libraries, although by the 13th century, these had probably ceased to function.

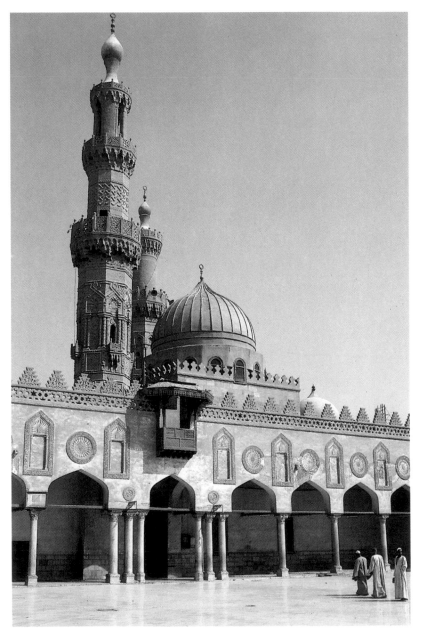

al-Qarâwiyyin Mosque, courtyard
Fez, Morocco
Founded 859, mainly restored in
the Almoravid period,
1135-44

The courtyard is surrounded
by horseshoe arches and
punctuated with projecting side
pavilions. These are linked by a
canal and lead to a central pool
that probably dates from the 17th
century. The mosque is one of the
most important in the Maghrib for
its decoration and furniture.

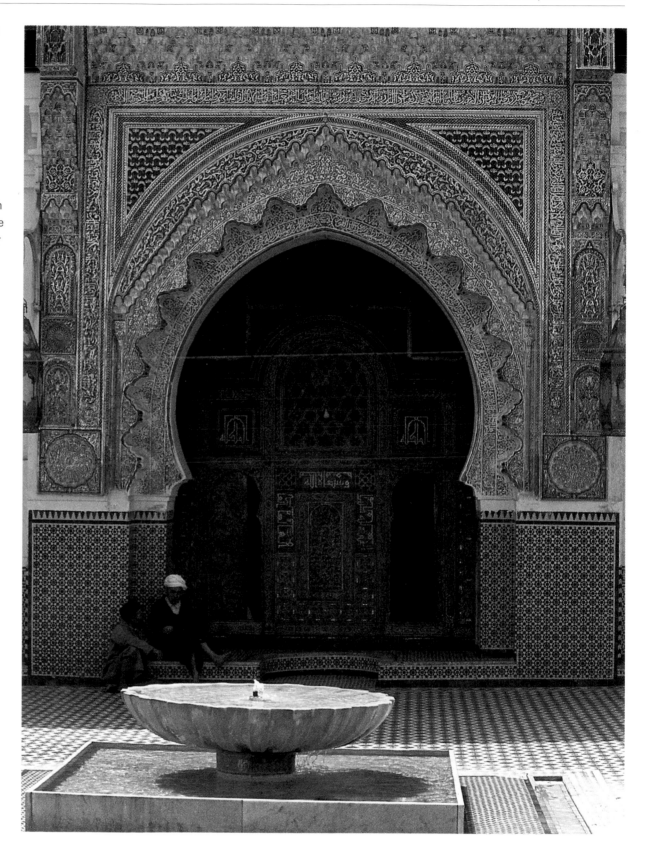

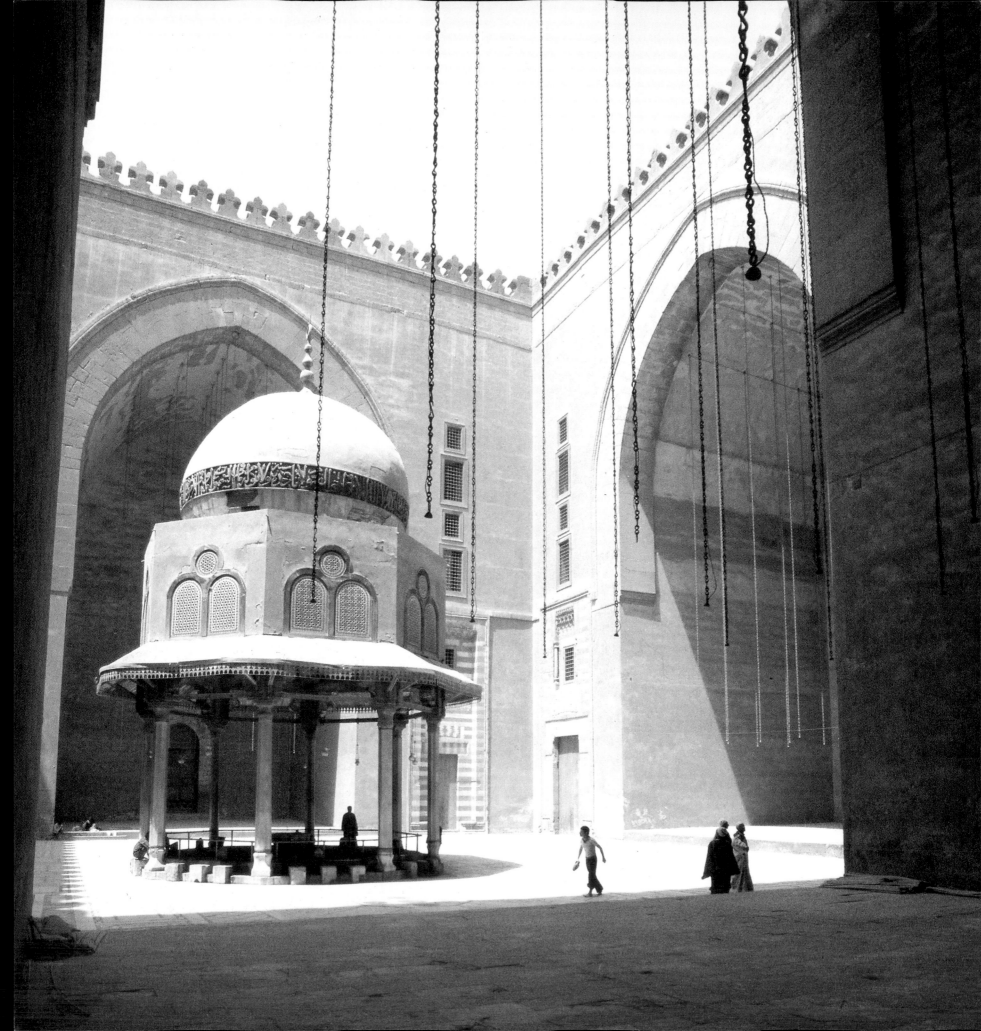

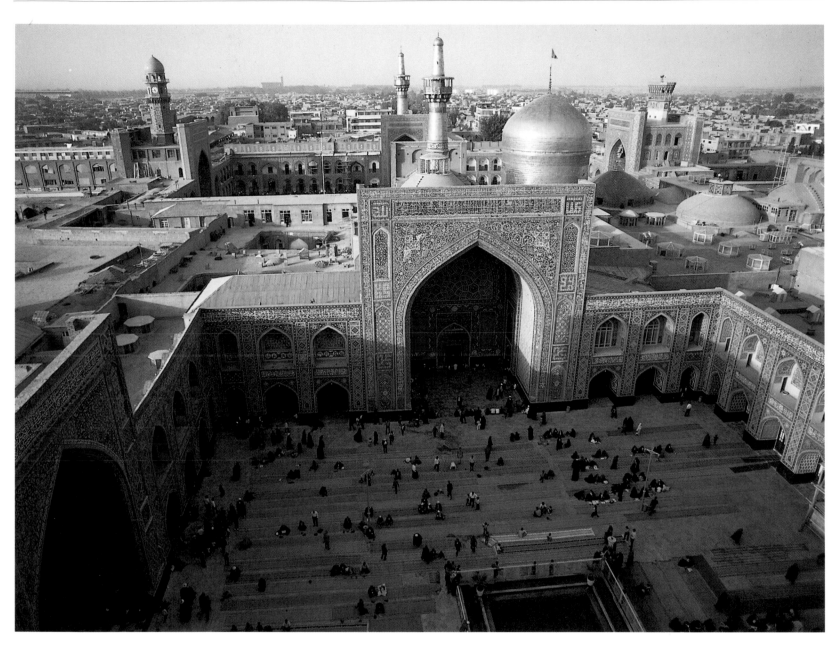

Mosque of Sultan Hasan,
courtyard
Cairo, Egypt
Begun 1356
The interior contains a vestibule
with a bi-coloured stone dome.
The mosque stands on a different
axis, built according to the
four-*iwan* plan with a multi-storey
madrasa in each corner and *iwans*
towering above the courtyard.

Mosque of Gawhar Shâd,
courtyard
Mashhad, Islamic Republic of Iran
c. 1420
This is one of the most
sumptuously decorated buildings
in Iran and Central Asia. The high
iwan in front of the domed *mihrab*
area is decorated with a complex
polychromed tile mosaic in which
cobalt blue is the dominant colour.

Great Mosque, western *iwan*
Isfahan, Islamic Republic of Iran
Restored in the 15th century
or later

The four-*iwan* plan was
superimposed on a plan for an
Abbasid-type basilical mosque
with an arcaded courtyard. The
daring stalactite vault is formed of
a decorative brick shell hung from
the masonry core.

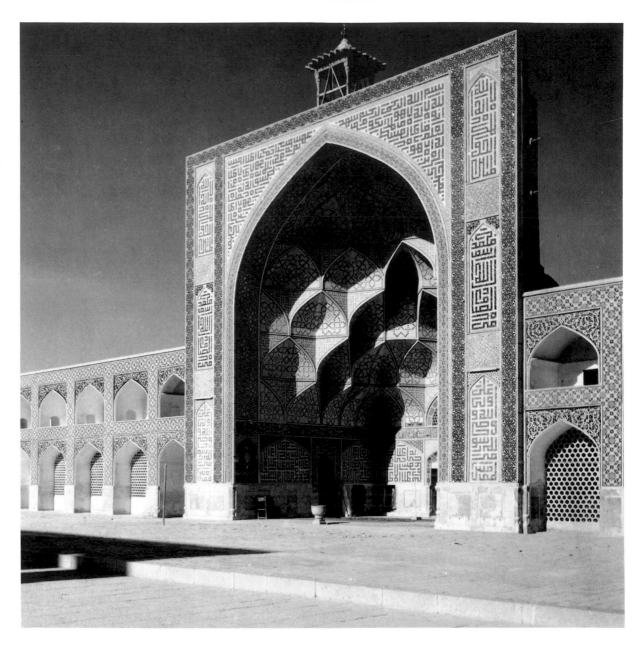

Great Mosque, façade of
prayer-hall with later restorations
Xian, China, Hua Jei Jing
1392-1522

The plan of the mosque consists
of a series of long courtyards
comprising gardens and pavilions,
and, immediately in front of the
gabled prayer-hall, a small open
courtyard flanked by low stone
walls.

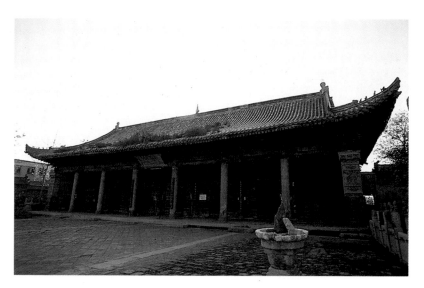

Padshahi Mosque
Lahore, Pakistan
1673-74

The courtyard with minarets at the
corners is so vast that the
prayer-hall is virtually
a separate building. The façade
of the mosque, flanked by faceted
turrets, has a dramatically raised
axial entrance backed by the
silhouettes of three bulbous
domes.

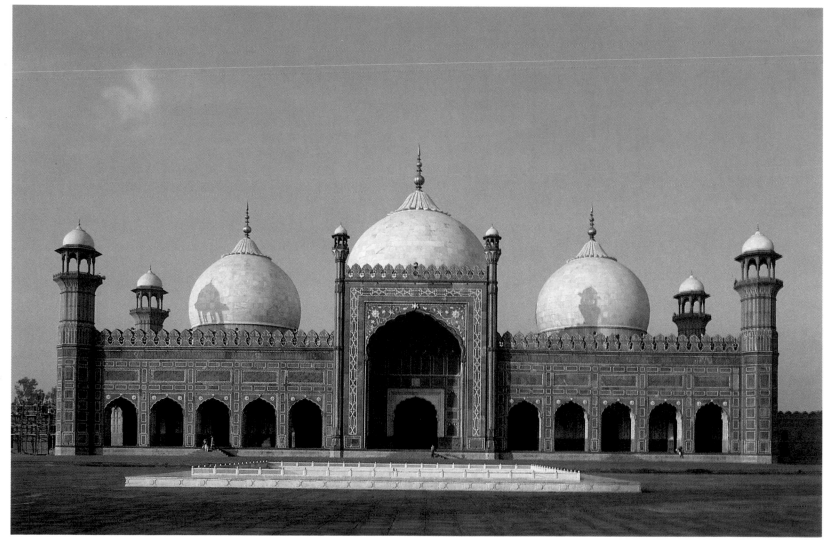

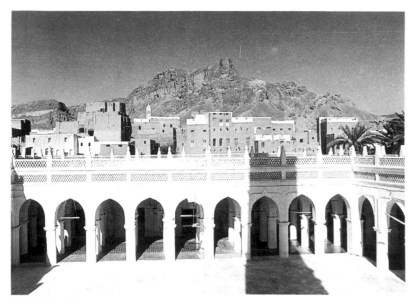

**Al-Mikdar Mosque
Tarim, Yemen**

The courtyard façade is crowned
with decorative bands of
lozenge-work and a balcony with
finials and open-work balustrades.

**Bayt al-Badr, inner courtyard
Kuwait
19th century**

The great merchant families of
Kuwait lived in low flat-roofed
houses arranged around
interconnecting courtyards.
The main reception block was
preceded by a grand arcade.

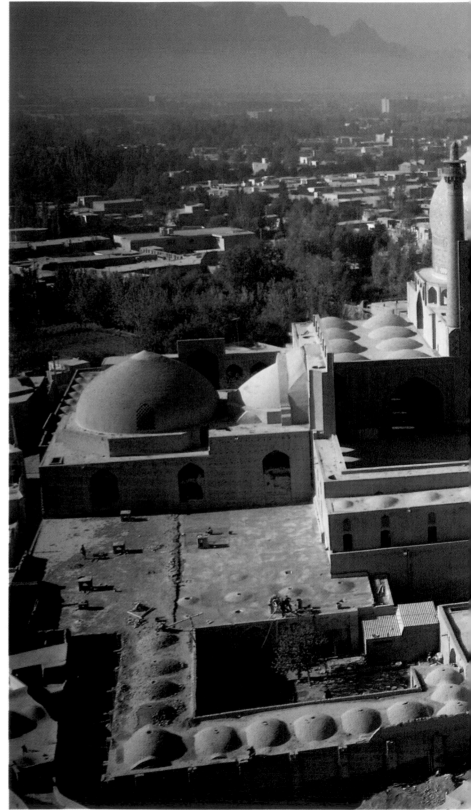

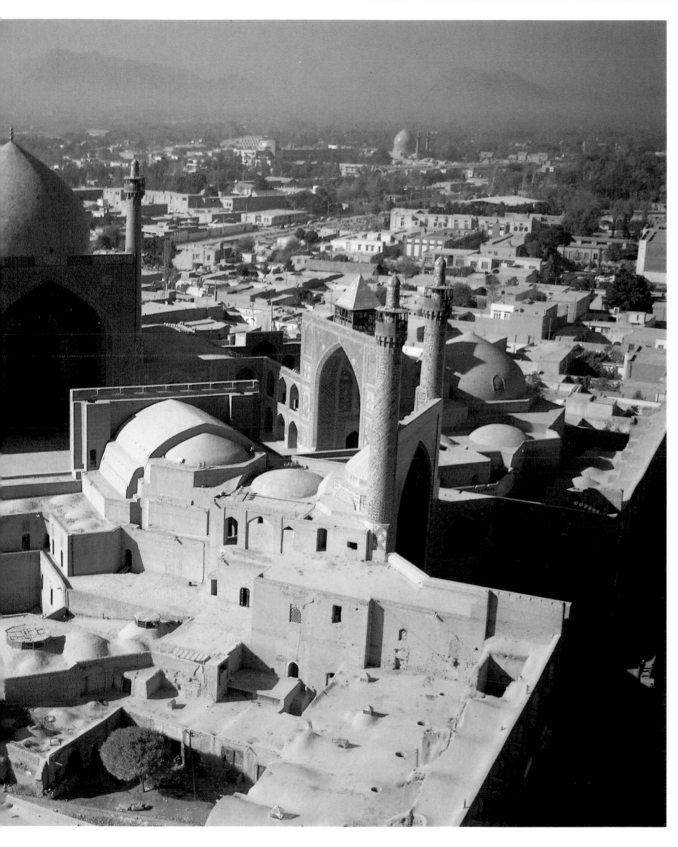

Mosque of the Imam (mosque of Shah 'Abbâs)
Isfahan, Islamic Republic of Iran
17th century

This mosque possessed a courtyard, domed *mihrab* area and three smaller *iwans* with galleries of cells between them. The side *iwans* also fronted domed chambers.

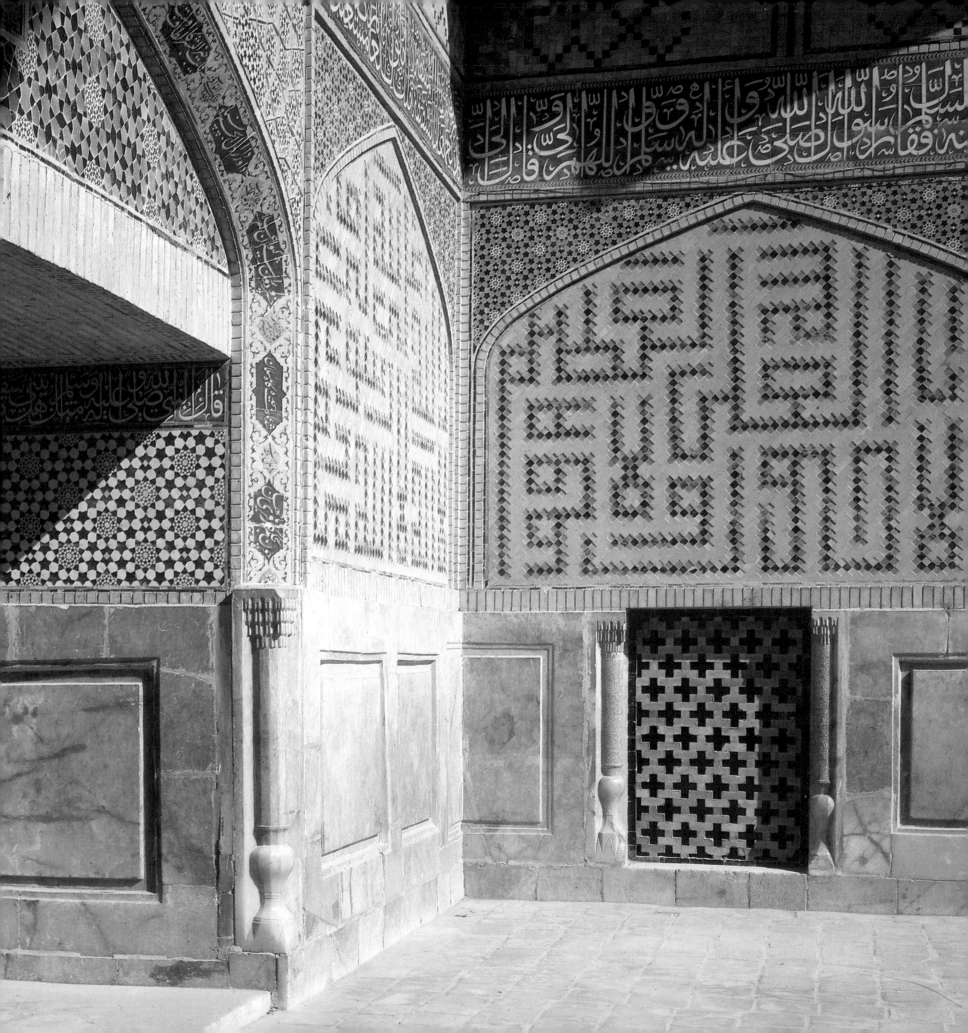

Ceramic and Marble Revetment

Glazed tile mosaic revetment
Great Mosque
Isfahan, Islamic
Republic of Iran

The glazed tile mosaic revetments of the building date from the early 14th century. Thereafter the initial colour scheme of turquoise, cobalt and black was gradually enlarged and the tilework assumed a major role in the decoration.

Initially, surface decoration in Islamic architecture, as in the eastern provinces towards the end of the Roman Empire, was of carved and painted stucco because it was inexpensive. In certain parts of the Islamic world rich in stone, like Syria and Turkey, the primacy of stone-carving was never challenged; but in much of the Islamic world where the only building material available was brick (baked or unbaked), facing materials assumed an overwhelming decorative importance; first in the form of bricks laid in decorative courses, then as terra-cotta unglazed tiles, and finally as glazed tiles. The glazing was initially limited to turquoise inscription bands on *mihrabs*, friezes and framing arches, both inside and outside buildings. The tradition was strongest in Turkey, Iran and Central Asia. Between the 14th and 16th centuries, the range of techniques and colour schemes was vastly extended.

In other areas of Islamic influence, particularly Spain and the Maghrib, tilework was always relegated to second place by decorated and painted plaster, which was generally limited for climatic reasons to interiors. Finally, in Syria, Egypt and Mughal India, tilework gave way to decorative revetments of stone, coloured marbles, alabaster or porphyry, with inlay in contrasting colours.

Cemetery of Shah-i Zinde, mausoleum façade attributed to the craftsman 'Alû Nasafi
Samarkand, USSR
c. 1380

This relief decoration, which includes various types of overglaze and underglaze painted tiles, makes particular use of 'square Kufic', which transcribes verses of the Koran in an angular script without diacritical signs.

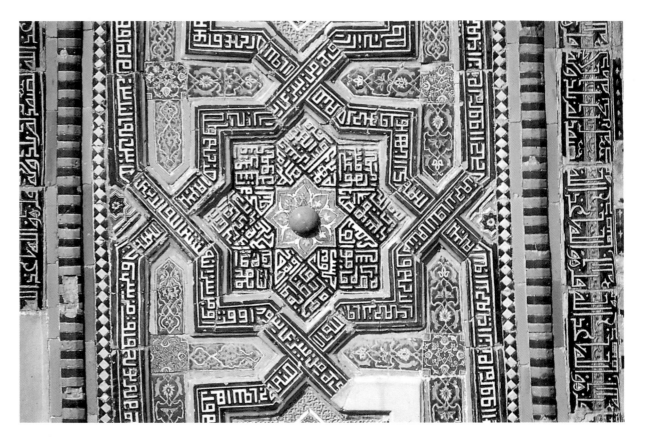

Great Mosque
Malatya, Turkey
c. 1225-70

The interior courtyard, the dome over the *mihrab* and the *iwan* facing it are covered with turquoise, cobalt and black tilework inscriptions, scrollwork and angular cartouches.

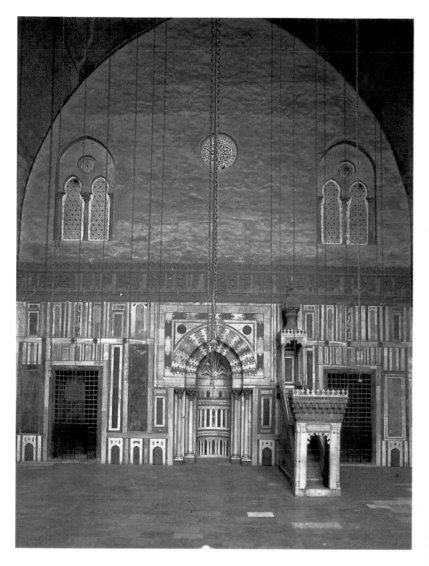

Mosque of Sultan Hasan
Cairo, Egypt
Begun 1356

The *qibla* wall and the *mihrab* niche are partly covered with marble and porphyry panels, round or rectangular in form. The upper part of the *mihrab* is inlaid with elaborately carved coloured stone. The taste for marble in Egypt during the Mamluk period almost entirely replaced the tilework used in Turkey, Mesopotamia and Iran.

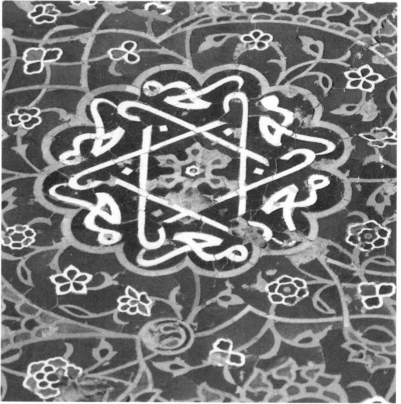

Blue Mosque
Tabriz, Islamic Republic of Iran
Built 1463

This is an inscription medallion in tile mosaic from the main entrance porch. The building is one of the finest examples of the Persian tradition of tile mosaic.

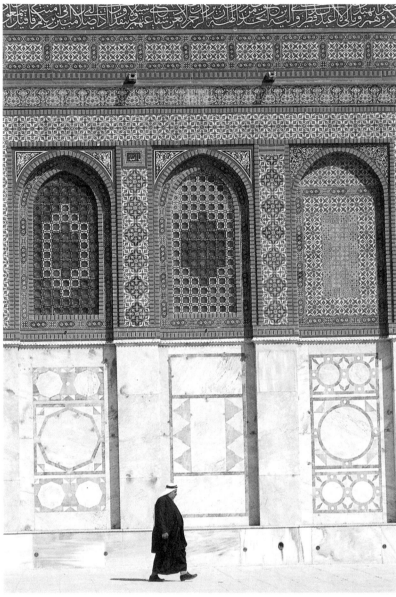

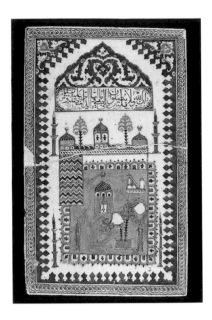

Tile panel
Ottoman Turkey
17th century
Musée du Louvre, Paris

This tile represents the shrine at Medina with the Tomb of the Prophet. The fringed border and niche motif recall a prayer carpet.

Dome of the Rock, exterior marble revetment and tilework
Haram, Jerusalem

The marble revetment, some of which dates from the foundation of the building in 692, was a favourité form of decoration in early Umayyad architecture. The tilework was added under Süleyman the Magnificent around 1540-50 but was later restored, most recently in the 1960s.

Taj Mahal, decoration of inlaid coloured stone in white marble masonry
1632-54
Agra, India

This technique was favoured by architects in the last period of the Mughal Empire.

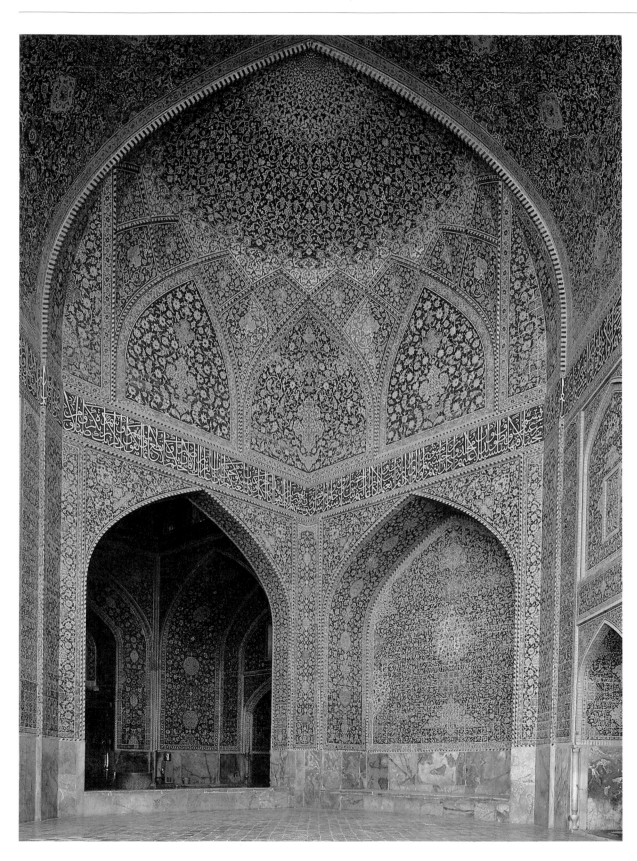

Mosque of the Imam (mosque of Shah 'Abbas)
Isfahan, Islamic Republic of Iran
1612-37

Although the decoration of the mosque was completed only after the death of the shah, the tile revetments (not mosaic but painted under the glaze) indicate a response to the necessities of mass production.

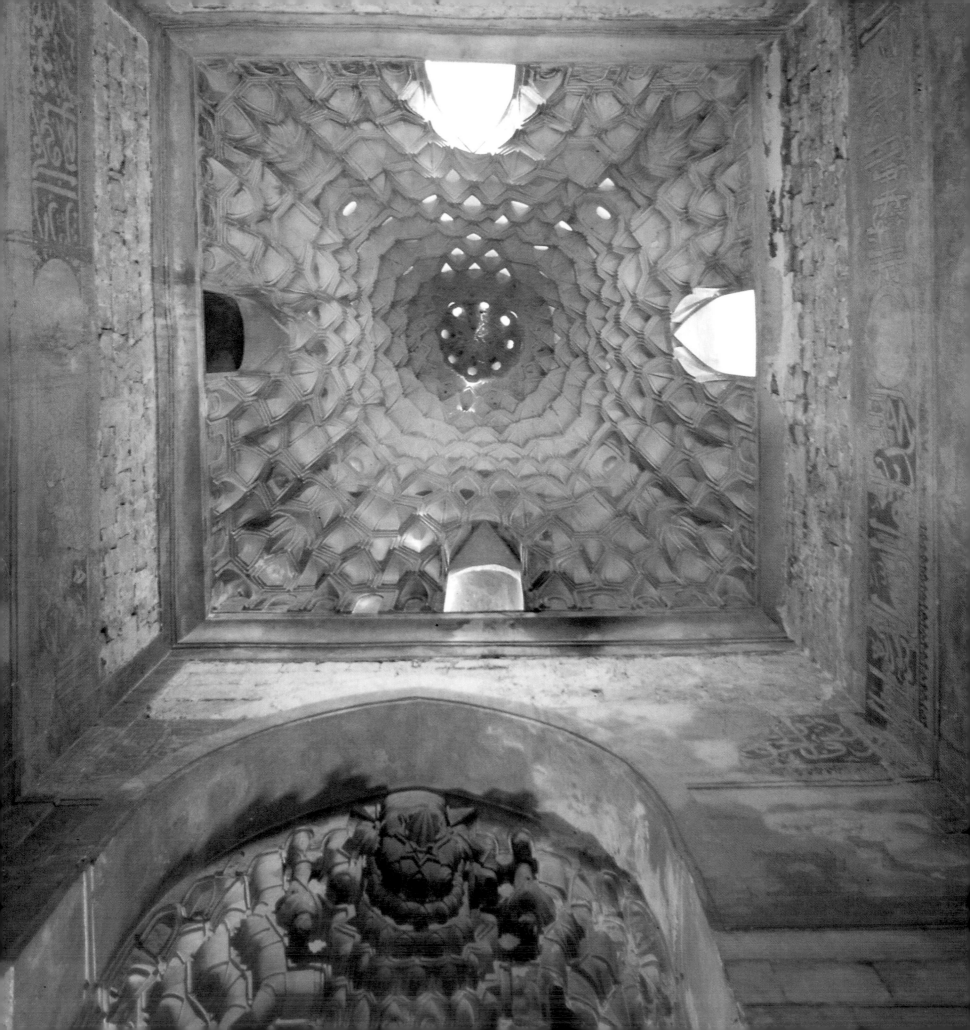

Transitional Zones in Architecture

Transitional elements, often surmounted by tall drums, are necessary to support the dome. Architecturally there are two basic types: pendentives where the stress is exerted outwards, and squinches which bear the stress vertically downwards. Owing to the architectural importance of the dome, these elements attracted decoration on their elegantly curved surfaces. Pendentives could be cut away course by course, suggesting that the top course was supported by a series of stalactite ledges, but squinches lent themselves even better to compartmentalization in tiers, adding variety without detracting from the decorative effect. Ribbed domical vaults in theory require no transitional zone, but already by the 10th century the great ribbed vaults at Cordoba display decorative elements at the corners which are reminiscent of stalactites or *muqarnas.* In later Maghribi architecture, stalactite vaulting is no longer confined to the transitional zones of domes but becomes a decorative canopy, while in 15th-century Central Asia and Iran entire plaster ceilings are constructed of false vaults derived from transitional elements.

Cupola of the entrance
of the Maristan al-Nuri
Damascus, Syrian Arab Republic
1145

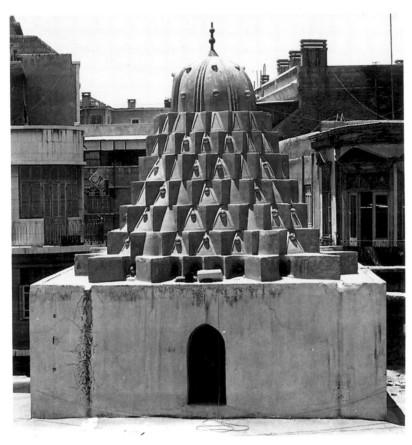

Maristan al-Nuri
Damascus, Syrian Arab Republic
1145

Stalactite vaults were used not merely as transitional zones, but, piled one upon the other, they also formed slender conical or pyramidal domes whose structural nature was apparent on the exterior. This practice is characteristic of brick tomb architecture in 12th to 13th-century Baghdad, and is rarer in Syria and Turkey where it was executed in stone.

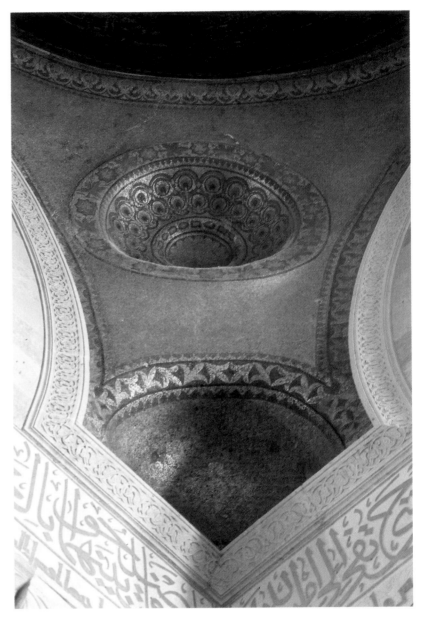

Al-Aqsâ' Mosque, squinch of the dome over the *mihrab*
Haram, Jerusalem

The low squinch and the glass mosaic covering probably date from restorations of the mosque under the Fatimids in the 1020s.

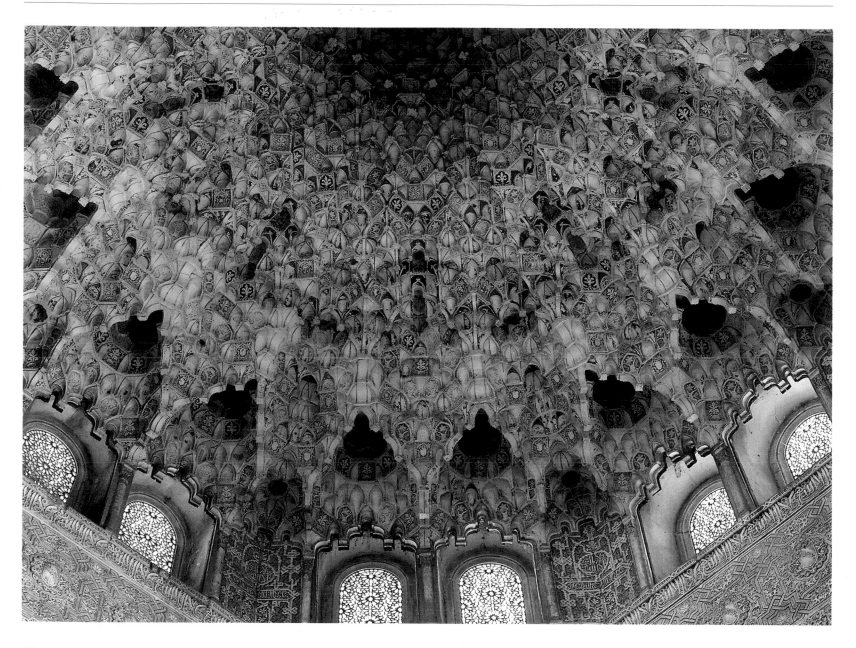

Alhambra, Court of Lions pavilion
Granada, Spain
14th century

Architecturally, *muqarnas* vaulting
was unnecessary here to span the
roofs of the various apartments;
instead it was used
ornamentally to decorate
the capitals, disguise
the cross-beams and
suggest domed vaults.

71

Mosque of the Imam (mosque of
Shah 'Abbâs) entrance porch
Isfahan, Islamic Republic of Iran
1612-37

The vault of the entrance porch
is covered with a plaster shell
of stalactites entirely overlaid
with polychrome tilework.

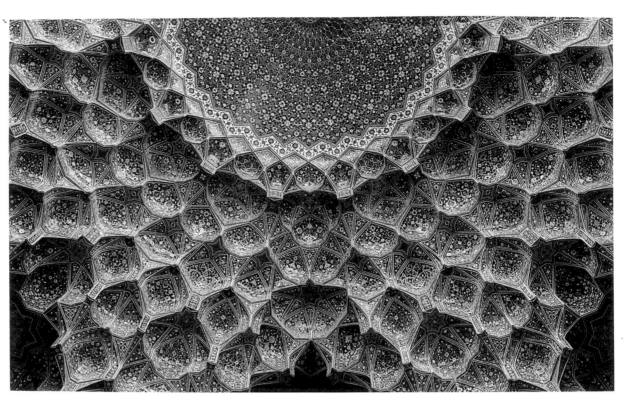

Mosque of Sultan Hasan,
vestibule *muqarnas*
Cairo, Egypt
Begun 1356

The colossal entrance porch
opens on to a domed area with
sumptuous stalactites. This may
well have been where the Sultan
sat in judgement.

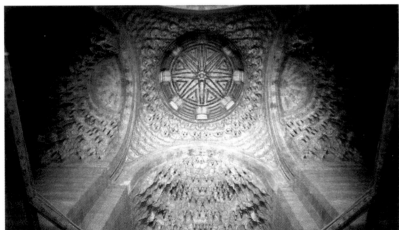

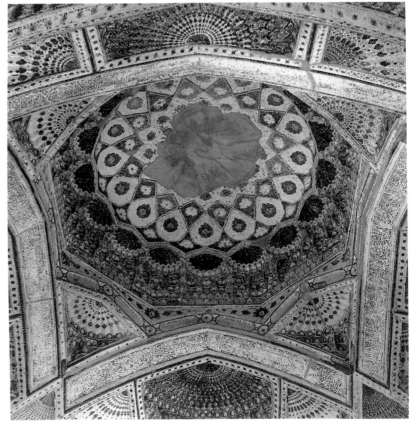

Mausoleum of Gawhar Shad
Herat, Afghanistan
Completed by 1432
The dome covering a *madrasa*
rises from a sixteen-sided base
set on squinches. These are
concealed by a decorative vault
system composed of plaster
stalactites and fan-shaped
pendentives painted elaborately
in blue and red.

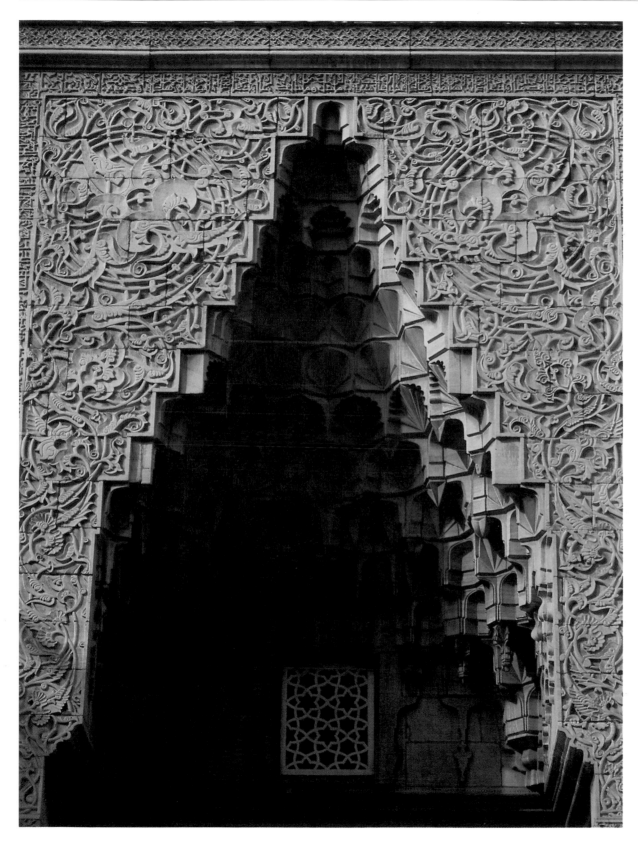

Green Mosque, entrance porch
Bursa, Turkey
c. 1420

The main entrance porch is formed of a canopy of very elaborately worked stalactites. The rich scrollwork of the façade, like the stalactites, evokes the architectural decoration of Seljuk Anatolia.

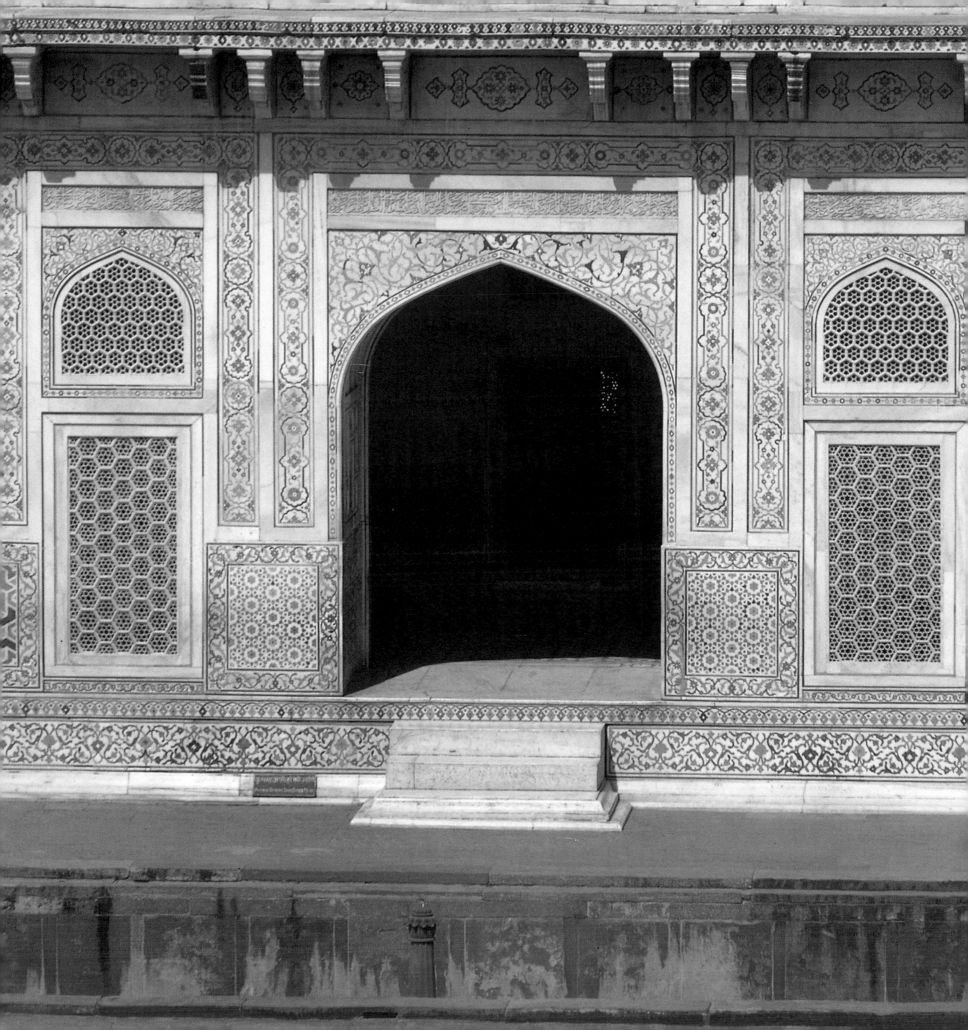

Screens

Although much Islamic architecture was lit from the central courtyard, windows were necessary either for stronger light or as clerestories to emphasize the axial crossing to the *mihrab*. In most Islamic lands, glazed windows were climatically unnecessary and screens generally were of the Byzantine early-Islamic type, at first in marble or limestone but later in moulded stucco, which was cheaper as well as more adaptable. In later Islamic architecture (e.g. in Ottoman Istanbul), light played a much more important part in the architectural aesthetic and windows were often glazed in brilliant colours. Nonetheless, windows rarely play an important part in exterior architectural decoration.

Tomb of I'timad al-Dawla, exterior and interior
Agra, India
1628

The square building with four prominent corner towers contains a central area divided off by marble screens decorated with geometrically repeating designs. Such screenwork is used most imaginatively in Mughal architecture to increase the feeling of space within enclosures and, by breaking up the light, to make even the most solid architecture seem light and insubstantial.

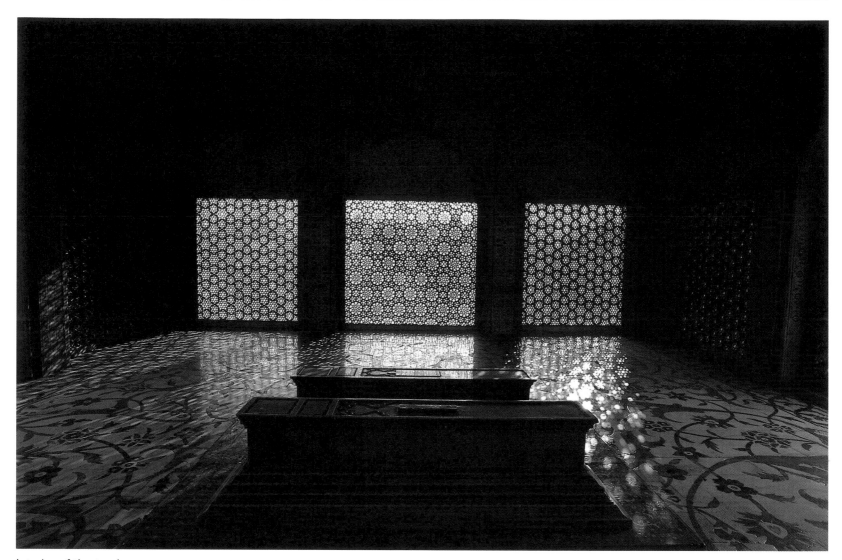

Interior of the tomb
of I'timad al-Dawla
1628
Agra, India

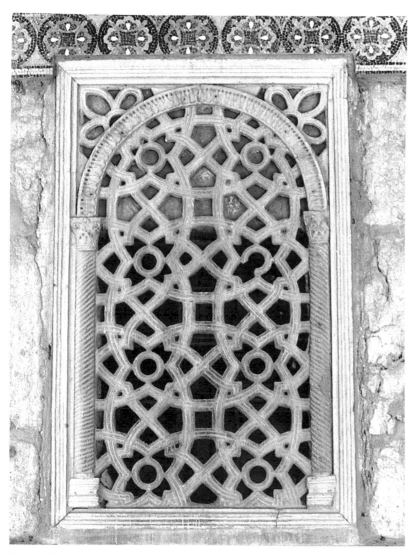

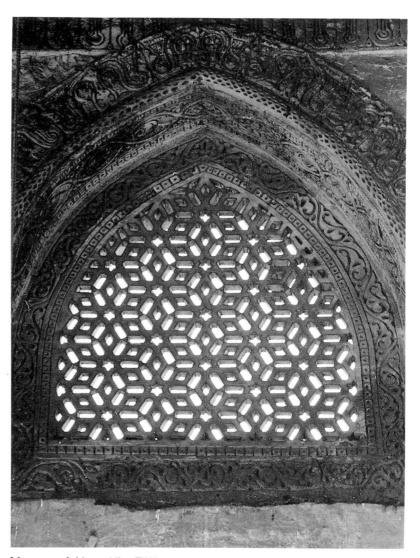

Great Mosque, marble window
Damascus, Syrian Arab Republic
8th century

The interlace design derives
directly from Byzantine marble
work.

Mosque of Ahmad ibn Tûlûn,
stucco windows
Cairo, Egypt
876 or later

Here few if any of the numerous
motifs, mainly angular interlace
work, are original, but the
windows follow the early Islamic
tradition in being unglazed.

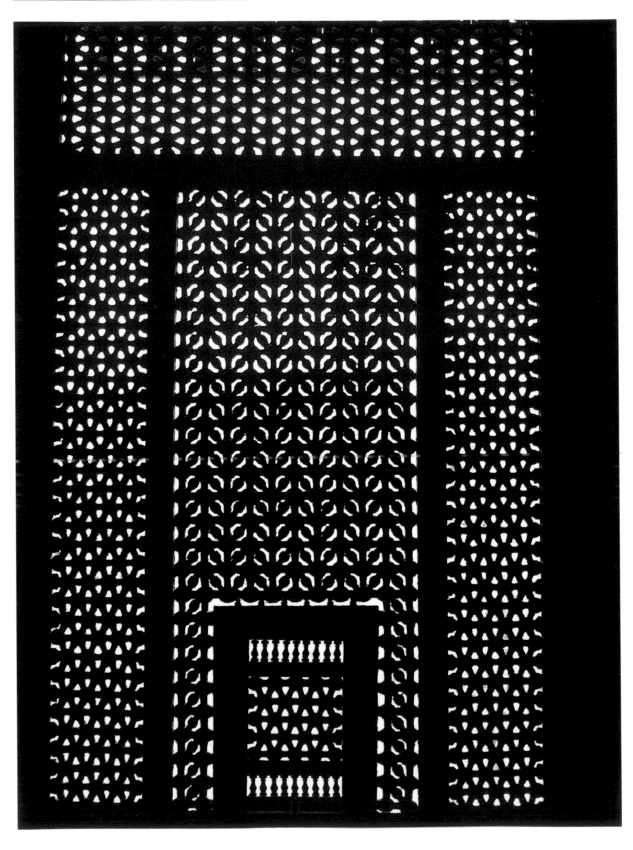

Palace of Beshtak, *Mashrabiyya*
Cairo, Egypt
c. 1340

Wooden screens, often found on corbelled balconies overlooking the street, are a feature of the domestic architecture of Mamluk Cairo and of much of the modern Middle East. In Cairo the screens allowed the north wind to cool the building (generally creating terrible draughts) and gave a measure of privacy, allowing those inside to look out unobserved.

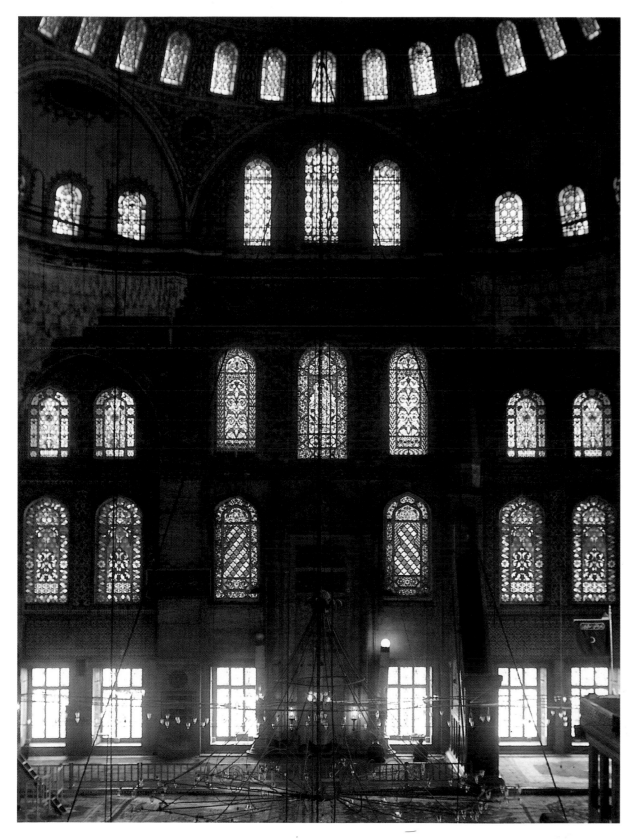

Mosque of Sultan Ahmed, stucco
windows inset with stained glass
Istanbul, Turkey
Early 17th century

These brilliant windows add a
further element of colour to the
lavish interior of the mosque with
its tiled and painted decoration.

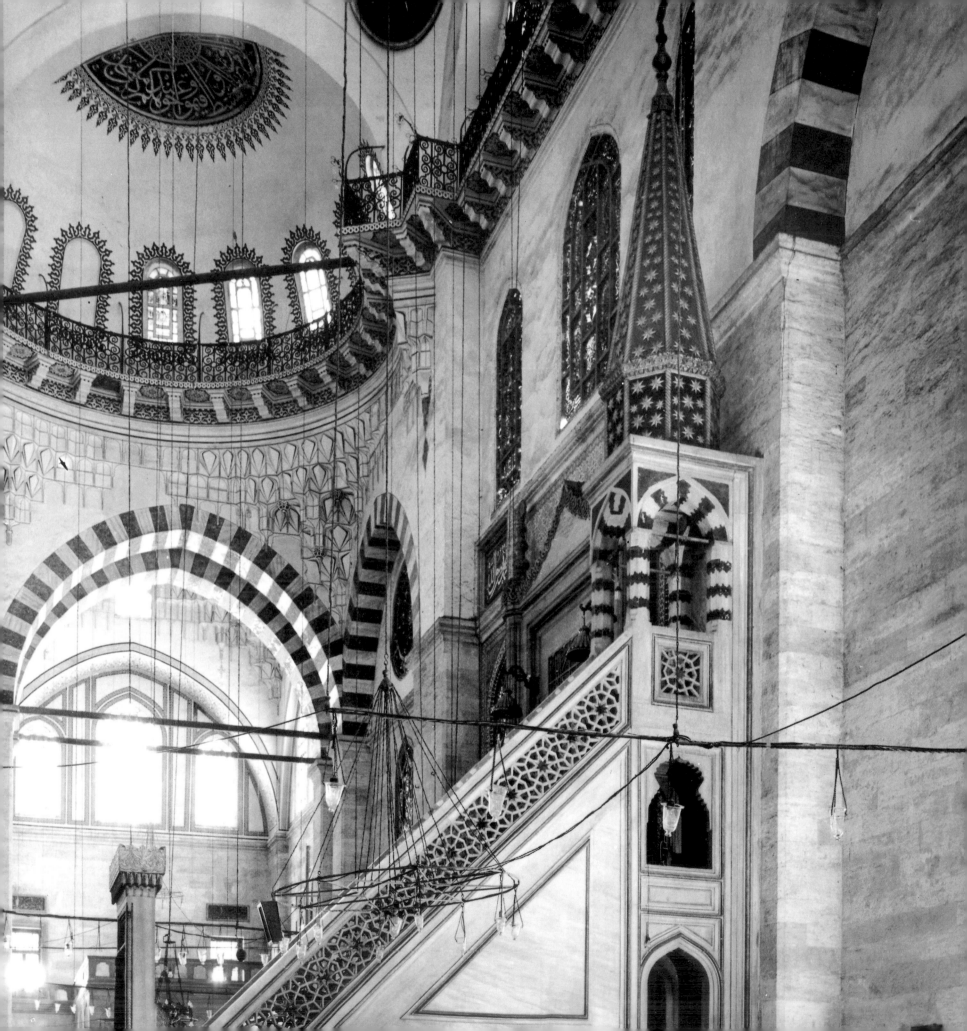

Minbars

Minbar
Süleymaniye Mosque
Istanbul, Turkey
Completed 1557

Süleyman the Magnificent's greatest foundation built by the famous architect Sinan was intended not just as a mosque but as an educational institution for the higher clergy and the administrative officials of the Ottoman Empire. Only the mosque, however, houses a *minbar*. The slender proportions and great height of the marble *minbar* with carved and gilt openwork and a tall faceted conical canopy have clearly been determined by the height of the edifice.

The principal ceremony held in a mosque is the Friday prayer, which includes the *khutba*, a sermon every adult Muslim male is required to attend. The *khutba* is delivered by the leader of the community or his lawful representative and was, in early Islam at least, as much political as moral in content. This sermon is delivered from a throne or pulpit, the *minbar*, located to the right of the *mihrab*, which came to be highly decorated. In the early days of Islam, the Friday prayer, and hence *minbars*, were restricted to a few towns or localities, although the privilege was accorded in later centuries to a larger number of mosques.

In form, *minbars* are composed of a steep staircase and a decorative entrance placed on a triangular base. They are often surmounted by decorative canopies and in the early centuries of Islam, during the Friday prayer, the leader, or *imam*, was flanked by the banners of the Caliphate. From an early date, the *minbar* was highly decorated with carved wooden panelling, carved marble or limestone, or, more rarely, a tile revetment. The height, number of steps, inclination of the staircase and even presence or absence of the canopy seem to have been dictated by local tradition.

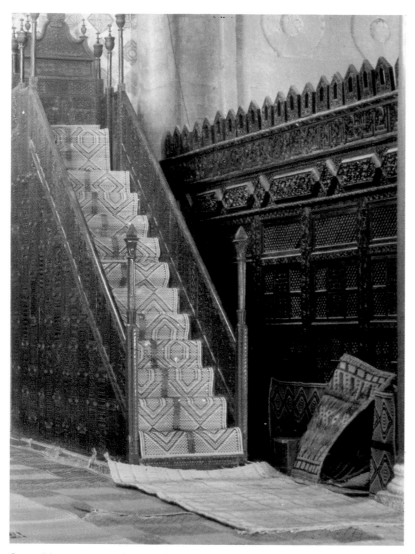

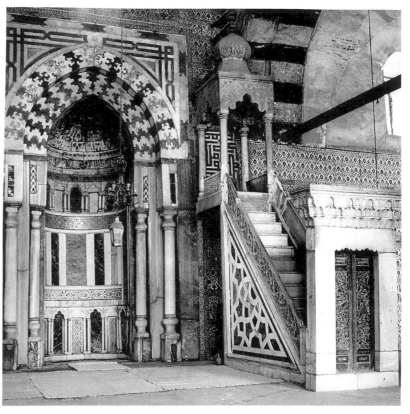

Mosque of Aqsunqur
Cairo, Egypt
1346

The *minbar* is remarkable for its
use of white marble with coloured
marble and porphyry inlay.

Great Mosque, wooden *minbar*
Qayrawan, Tunisia
Mid-9th century

One of the most splendid pieces
of early Islamic carved panelling,
the decoration of this *minbar*
comprises stylized palm-trees,
vine-scrolls and palmettes and
explicitly shows the influence of
contemporary Mesopotamian art
under the Abbasid Caliphs.

Al-Aqsâ Mosque, *minbar*
Haram, Jerusalem

The *minbar*, recently destroyed,
was of panelled and sculpted
wood. It was made by a famous
family of Syrian woodworkers at
the end of the 12th century.

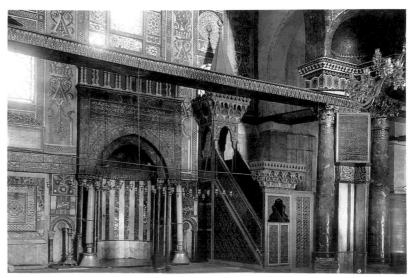

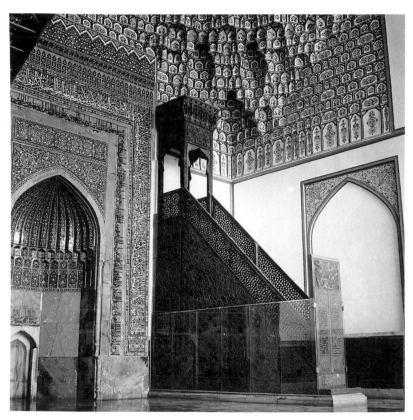

Mosque of Gawhar Shâd, interior
showing *minbar*
Mashhad, Islamic Republic of Iran

The *minbar* of thin openwork
panelling is a rare masterpiece of
15th-century Persian woodwork.

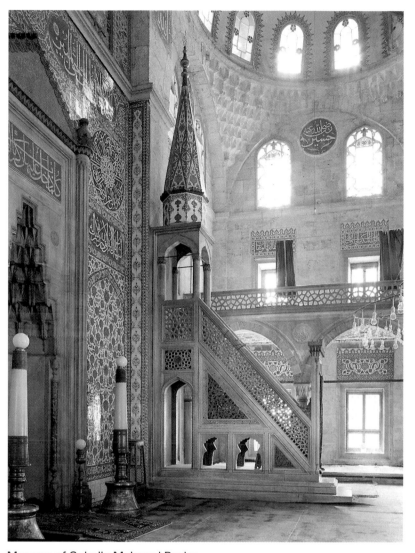

Mosque of Sokollu Mehmed Pasha
Istanbul, Turkey
1572

The marble *minbar* has been
incorporated into the magnificent
Iznik tilework which covers the
whole of the wall of the *qibla* in
the prayer chamber. The *minbar*
is crowned by a faceted conical
canopy faced with tiles.

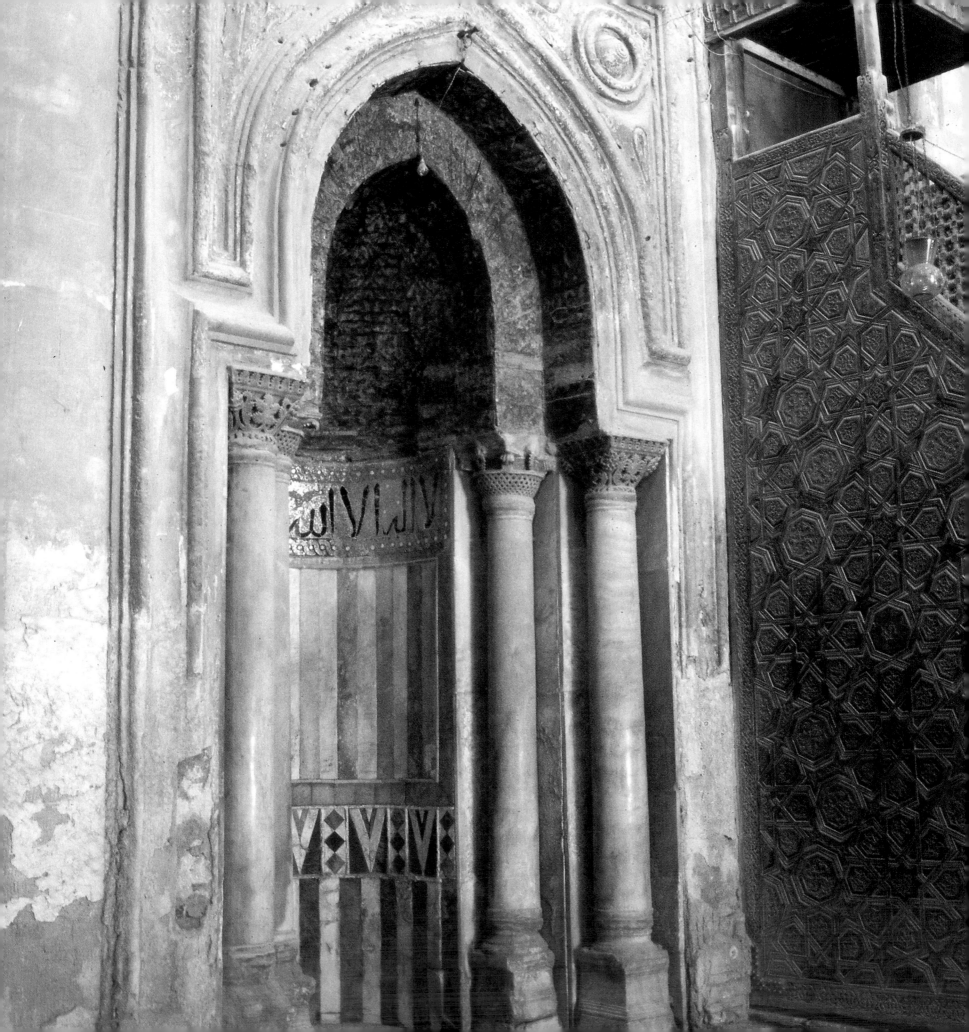

Mihrabs

The *mihrab*, a niche which architecturally emphasizes the *qibla*, is oriented in the direction of Mecca towards which Muslims turn to say the daily prayers. The Caliph or his representative, as the official leader of prayers (*imam*), stood at or in the *mihrab* and this ceremonial custom encouraged the idea of the *mihrab* as a focus for architectural decoration. The *mihrab*, often enclosed in a domed bay, is decorated with fine mosaic, tile or plaster-work. Needless to say, the *mihrab* is not a sanctuary; there are no particularly holy parts in a mosque.

Mihrab
Ahwad ibn Tûlûn Mosque
Cairo, Egypt
876

The plain stucco *mihrab* was set so deeply inside the arcades of the *qibla* that prayers must have been inaudible to most of the congregation. Later *mihrabs* were added nearer the courtyard. The present niche was restored in the late 13th century when glass mosaic, marble and painted decoration were added to embellish it.

Great Mosque, *mihrab*
Qayrawan, Tunisia
Decoration from restoration
of 862

The openwork marble veneer
of the *mihrab* with its panelled
scallop-niches is probably the
work of local craftsmen; but some
or all of the lustre-painted tiles
which surround it are imports
from the Abbasid Court
at Baghdad or Samarra.

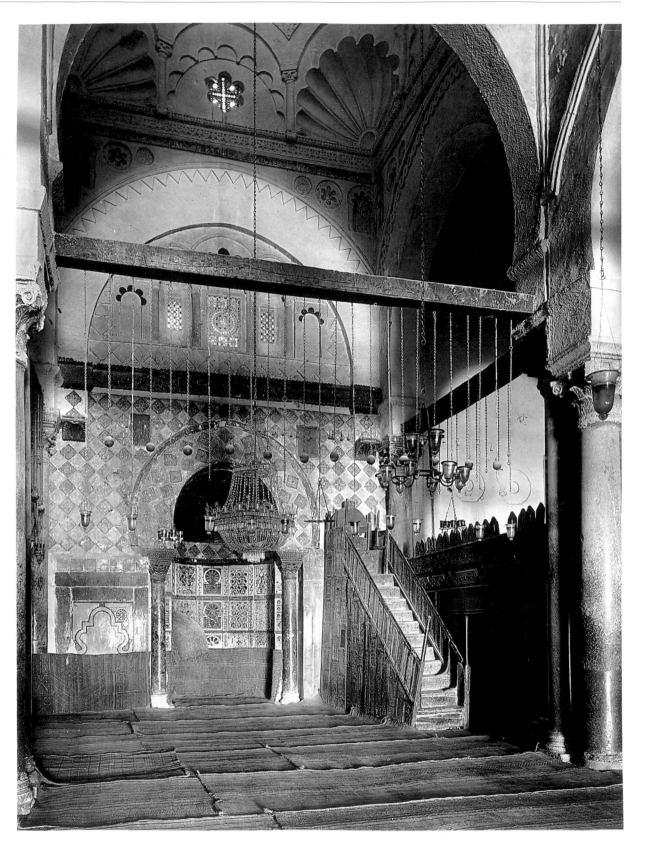

Great Mosque,
mihrab and *qibla*
wall
Cordoba, Spain

The early 8th-century building was fully restored in the 960s by the Umayyad ruler al-Hakam II, who added *mihrabs* in the splendidly domed bays of the *qibla* wall. The latter was connected by a corridor to his palace, thereby enabling him to attend the Friday prayer without having to walk through the crowded mosque.

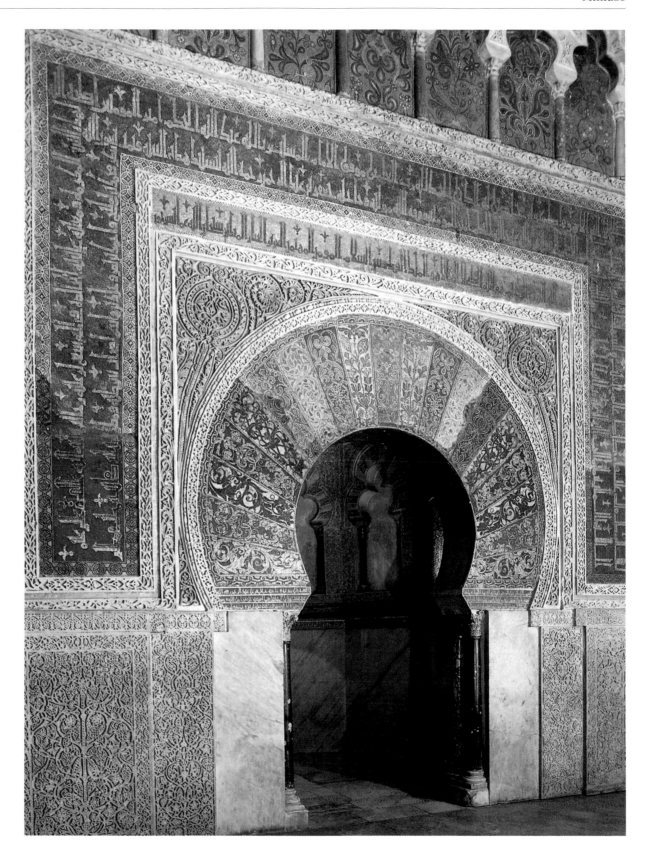

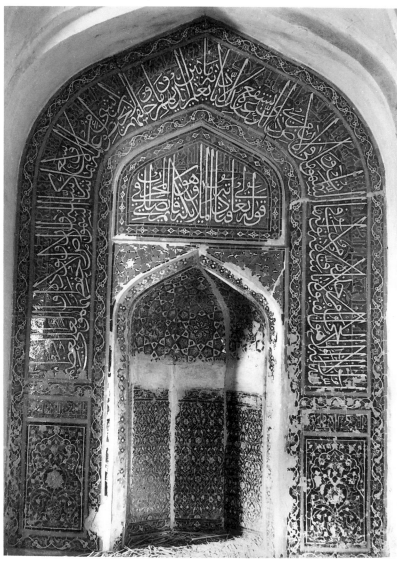

Masjid-i Hauz-i Karbuz
Herat, Afghanistan
1441

The *mihrab*, in the covered
'winter' mosque, is faced with fine
tile mosaic of the best quality
commissioned by the Timurid
rulers.

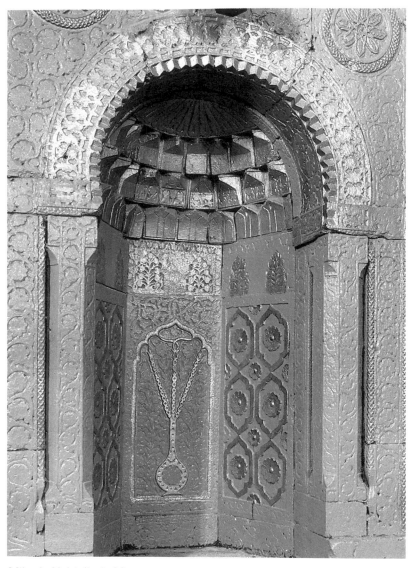

Mihrab, Nabi Jirgis Mosque,
Mausoleum
Mosul, Iraq
14th century and later

Great Mosque, *mihrab* of Öljeytü
Isfahan, Islamic Republic of Iran
1310

The restoration work carried out
on the Great Mosque at Isfahan
under the Mongols included a
covered or 'winter' mosque with
an elaborately carved stucco
mihrab bearing Shiite formulae
and a low carved walnut *minbar*.

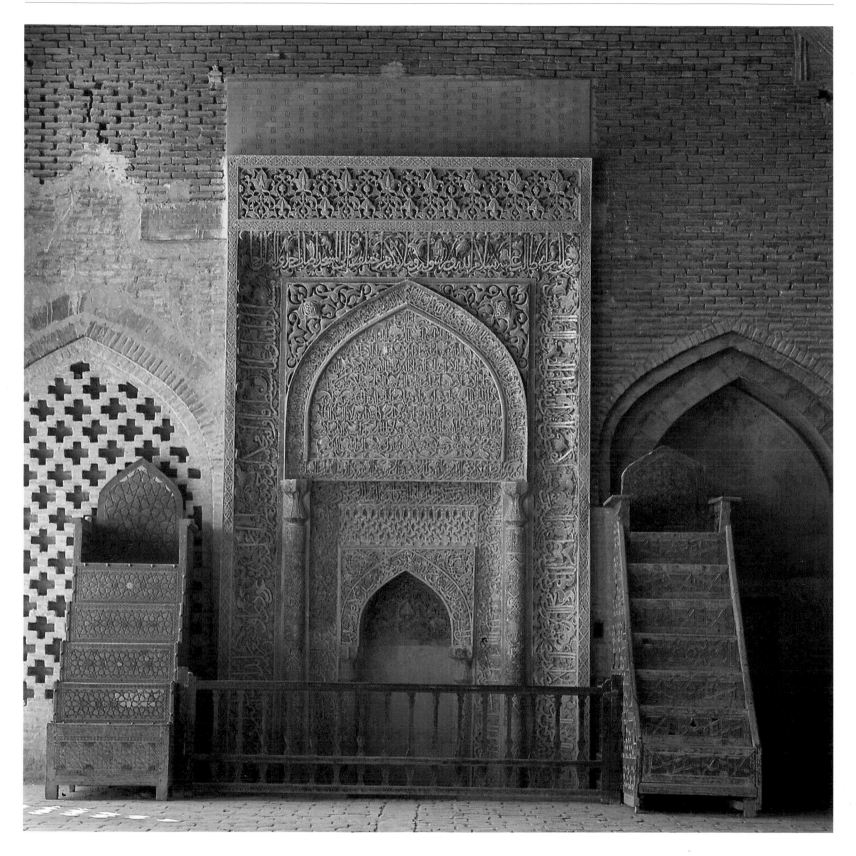

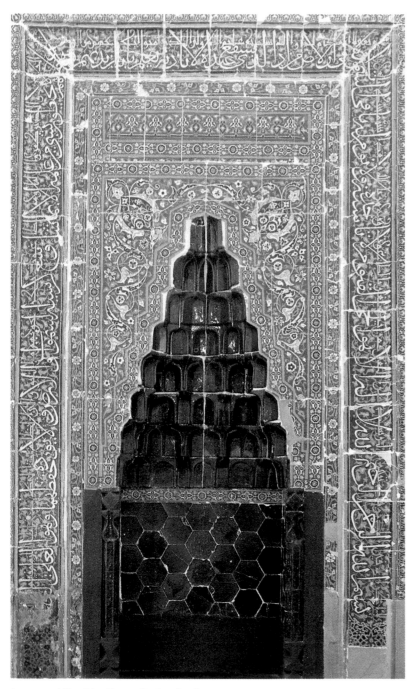

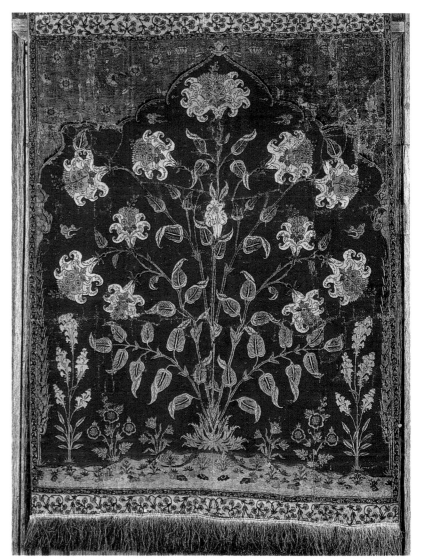

Imaret of Ibrahim Beg, tiled *mihrab*
Karaman, Turkey
1433

Now in the Çinili Kosk, Istanbul.
The polychrome tiles owe much
to work at Bursa (Green Mosque,
1421) and to examples in Eastern
Iran (Mashhad).

Woven wall-hanging in the form
of a *mihrab*, Mughal, India
c. 1640
Thyssen-Bornemiszá
Collection, Lugano

In palaces where there were no
mosques or *masjids*, hand-woven
or embroidered textiles were
frequently used as substitutes for
the *mihrab* to indicate the
direction for prayers.

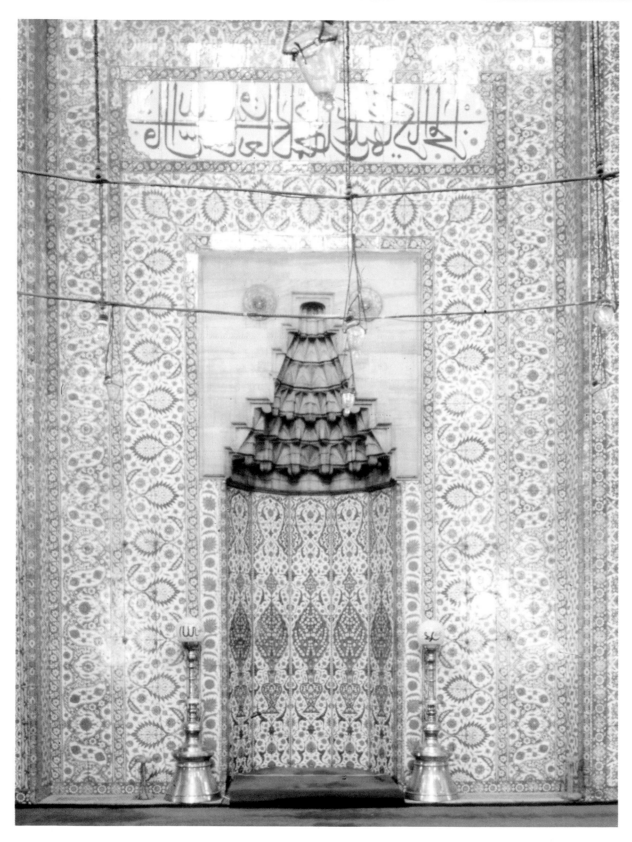

Mosque of Rüstem Pasha, tiled
mihrab
Istanbul, Turkey
c. 1560

The niche is faceted, each facet
depicting a vase with a bouquet
of prunus blossom set
in a lobed panel.

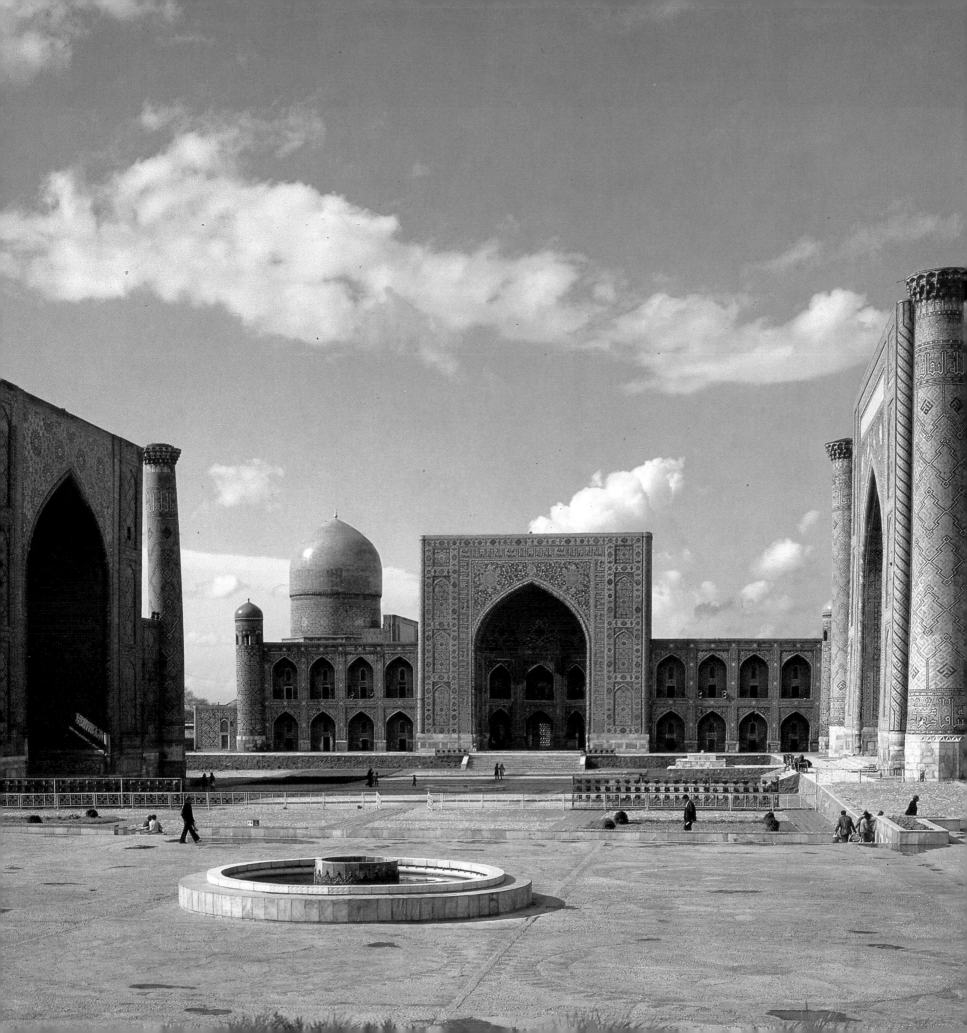

Madrasas

Madrasas were (and still are) the typical Muslim institutions of higher learning, for the teaching of exegeses of the Koran, Muslim tradition and law and a range of subsidiary subjects. From these emerged, after many years of study, the officials appointed to the main legal and administrative positions of the state. The foundation of the *madrasa* is credited sometimes to the Seljuk vizier Nizâm al-Mulk of Baghdad in the late 11th century, but his influence seems to have been limited to bringing *madrasa* education under state control, with lasting effect.

Registan Square, Samarkand, USSR

Of the original buildings, only the *madrasa* of Ulugh Beg shown on the left survives. The square was later reorganized and, in the 17th century, the Shir Dar *madrasa* was built opposite to complement it. The buildings of the Registan are oriented east-west and the *madrasa* therefore does not face the *qibla*. The *madrasa* was dominated by the two-storeyed entrance porch.

**Mustansiriyya Madrasa
Baghdad, Iraq
Founded 1233**

Laid out on the banks of the
Tigris, this *madrasa*, a
masterpiece of architecture and
decoration, was designed to
house the four orthodox legal
schools (*madhâhib*) in Islam.

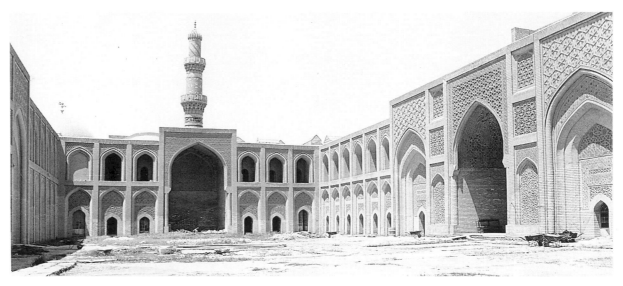

**Madrasat al-Firdaws
Aleppo, Syrian Islamic Republic
1234-37**

The sober arcades of the
courtyard are crowned by marble
or limestone capitals. The marble
paving is recent, but gives an idea
of the skill of the stone-masons of
Aleppo.

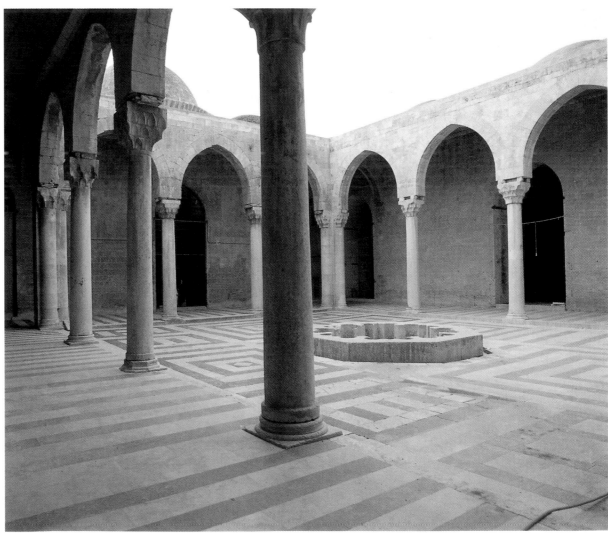

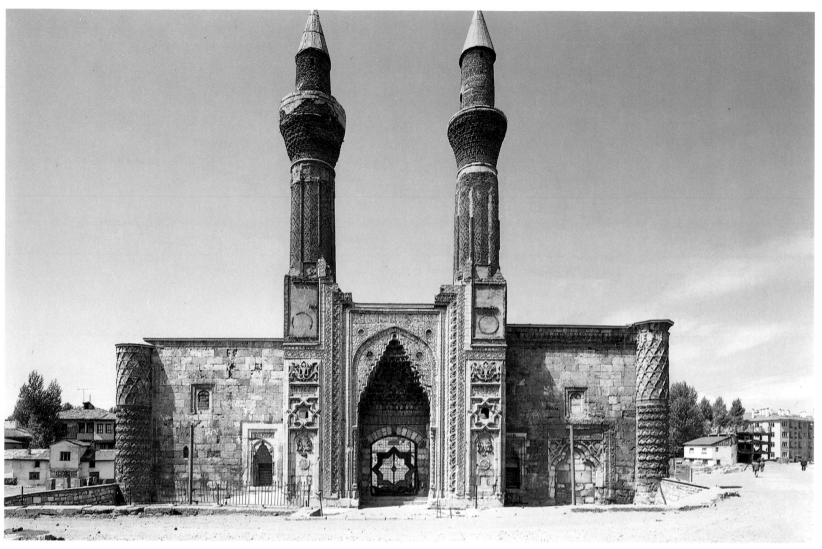

Gök Medrese
Sivas, Turkey
Founded 1271-72

The grandiose façade, with an
entrance porch faced with marble
and topped by twin minarets,
is disproportionally large in
comparison to the *madrasa*
building, which had
room for 20 staff and students
at most.

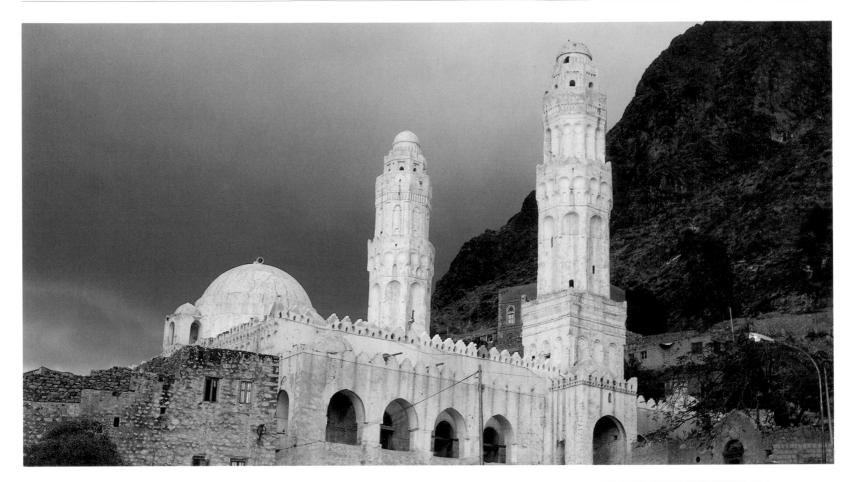

Ashrafiyya Mosque and *Madrasa*
Ta'izz, Yemen
13th and 14th centuries

Originally the *madrasa* was
attached to the mosque and had
two grand minarets on the south
side. In the late 14th century,
classrooms were added to
either side of the south porch.

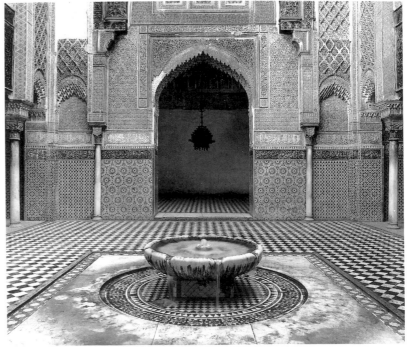

Madrasa of al-'Altârîn
Fez, Morocco
Completed in 1325

The plan is typical of many
madrasas which are not axially
oriented to Mecca. The carved
wood and sculpted plaster
decoration of the courtyard is
as rich as the tilework.

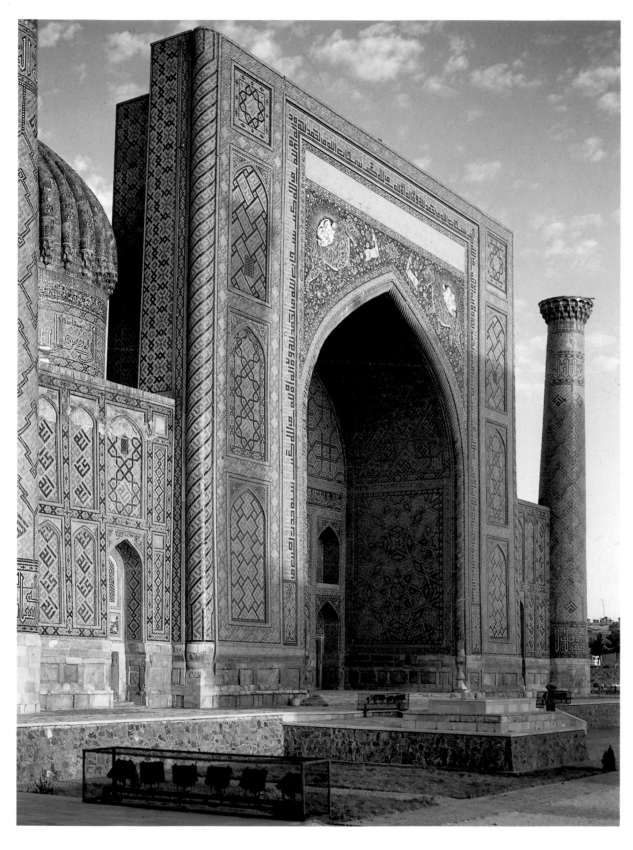

Madrasa Shir Dar, Registan
Samarkand, USSR
17th century

This *madrasa* was built to
complement the *madrasa* of Ulugh
Beg (1417-20) on the opposite
side of the square. It was an
important institution where both
mathematics and astronomy were
taught in the 15th century.

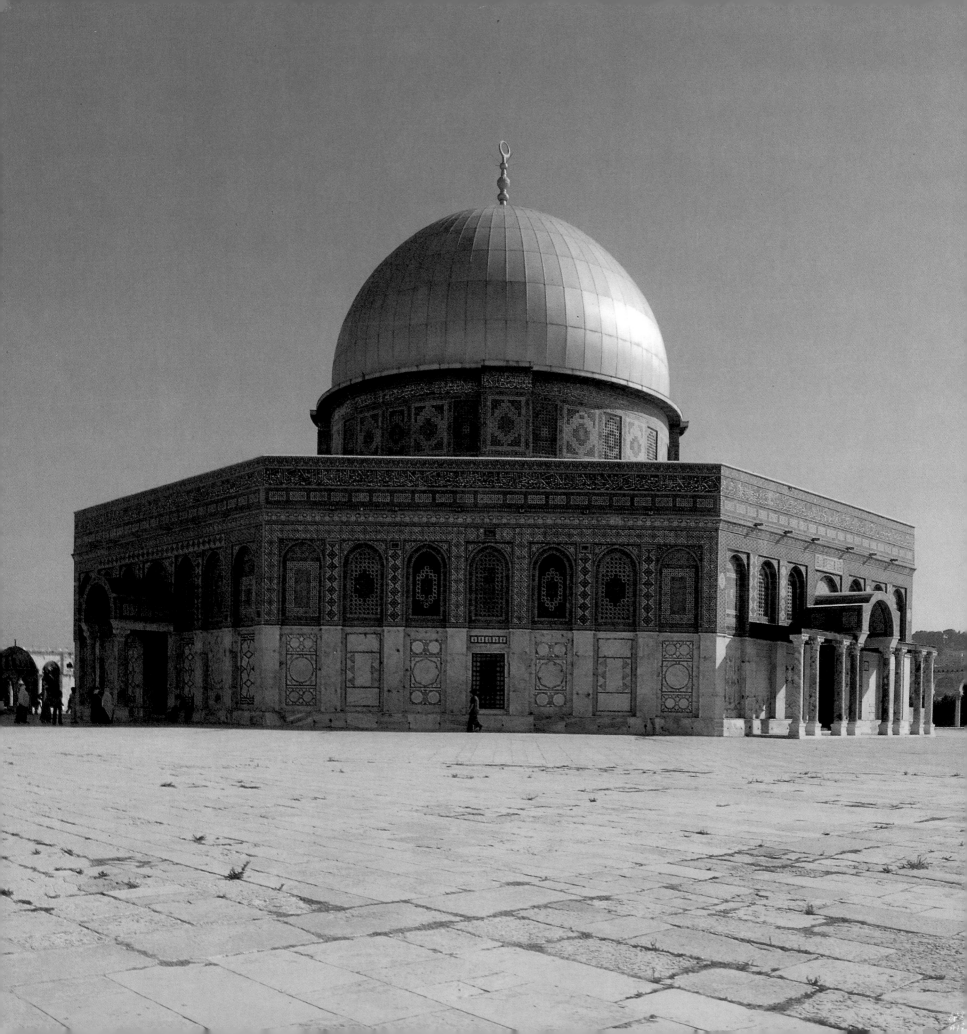

Chapter 3

Masterpieces of Islamic Art

The First Golden Age: The Umayyads and Early Abbasids

Dome of the Rock
Jerusalem
691

Built by the Umayyad Caliph 'Abd al-Malik. The shrine at the centre of what is known as the Haram al-Sharîf was built over the sacred rock from which the Prophet was believed to have made his ascension to heaven (the Mi'râjt or Night Journey).

In the early 7th century Muhammad in Mecca received the revelation of his call to be the Prophet of God. The conquests of his successors, the Umayyad Caliphs, in the following century brought into being an Arab Muslim Empire which included Syria, Palestine, Egypt, Libya, Iraq and Iran.

In the year 661, the seat of the Caliphate moved from Arabia to the ancient city of Damascus in Syria, which had been a Roman and then a Byzantine capital. It remained the capital of the Umayyad dynasty until 750 and, initially at least, the Arabic character of this state was quite marked: Arabic became the language of administration which coined new legal and intellectual terms. The Umayyads expanded rapidly, conquering North-West Africa (670), Spain and Sind (711), and even (by the 730s) Southern France.

The Damascus Caliphate thus became a world power.

In 750 an opposing movement led by the Abbasids overthrew the last Umayyad Caliph. They transferred their capital to Mesopotamia and founded Baghdad on the Tigris; Spain remained independent. Over the next two hundred years, their control over a vast area from Gibraltar to the eastern confines of Central Asia gradually slackened. Semi-independent dynasties arose in North Africa; in the late 10th century, Iran fell to the Shiite Buyids; in 969 the Fatimids took control of much of Syria after gaining power in Egypt, where they founded Cairo.

With political change came shifts of geographical emphasis. Umayyad art and architecture, which had evolved in the wake

99

of the Mediterranean classical tradition, gave way to the Mesopotamian and Iranian traditions fostered by the early Abbasids.

Although today virtually nothing remains of Abbasid Baghdad, the ruins of Samarra (founded by the Caliphs as a refuge from their Turkish troops) show the vast scale of Abbasid architecture: the colossal mosque of al-Mutawakkil (died 861) and the Great Palace of al Mu'tasim (836), the Jawsaq al-Khâqânî. In the latter, fine wall paintings, stucco, pottery and glassware excavated in the present century show the refinement and technical mastery of Abbasid art. Under Ahmad ibn Tûlûn, the Abbasid governor of Egypt and Syria who established his own dynasty, the Tûlûnids (868-905), the splendours of Abbasid metropolitan art and architecture were taken to Egypt.

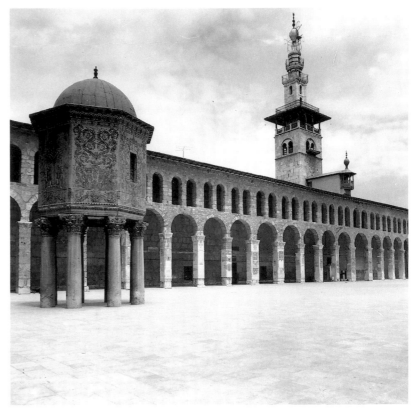

Great Mosque
Damascus, Syrian Arab Republic
714-15

Built by the Caliph al-Walîd
ibn 'Abd al-Malik. Interior view
showing the Bayt al-Mal (treasury)
and the arcades surrounding the
courtyard.

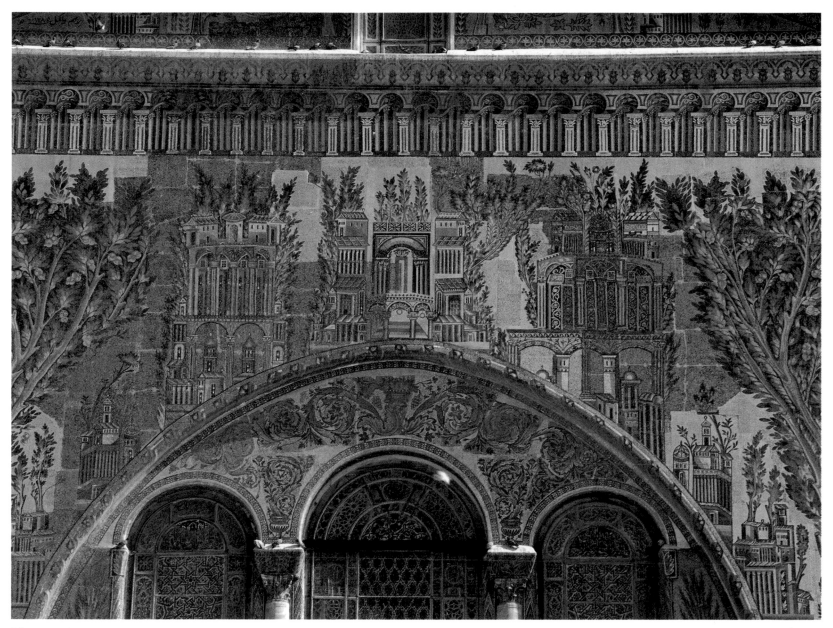

The mosaic may represent
the Barada River
and the gardens of paradise.

Qasr al-Hayr al Gharbîr,
entrance porch
North-east of Damascus,
Syrian Arab Republic
Built by the Umayyad Caliph
Hishâm in 727.

Wooden panel with stylized
foliate motifs
Mesopotamia
9th century
British Museum, London

The carving is typical of the
developed style of Samarra
decoration.

Exterior decoration in carved
stucco on the main entrance
to the palace

Restored
National Museum, Damascus

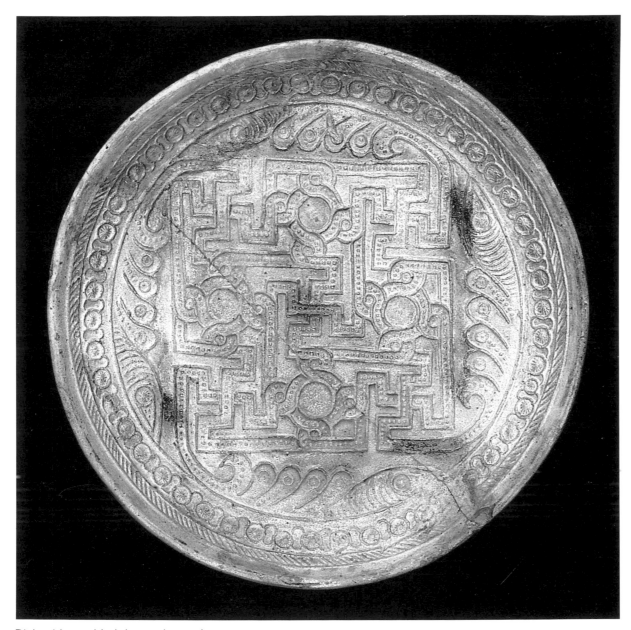

Dish with moulded decoration and
covered with a yellow lustre with
touches of green
Diameter 215 cm
Syria
9th century
Staatliche Museen für
Preussischer Kulturbesitz,
Museum für Islamische Kunst,
Berlin/Dahlem

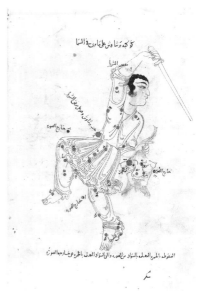

Constellation Perseus as it
appears in the sky. 'Kitâb
Suwar al-Kawâkib al-Thâbita'.
Treatise on the Fixed Stars
by the astronomer Abd al-Rahman
al-Sûfî
Bodleian Library, Oxford

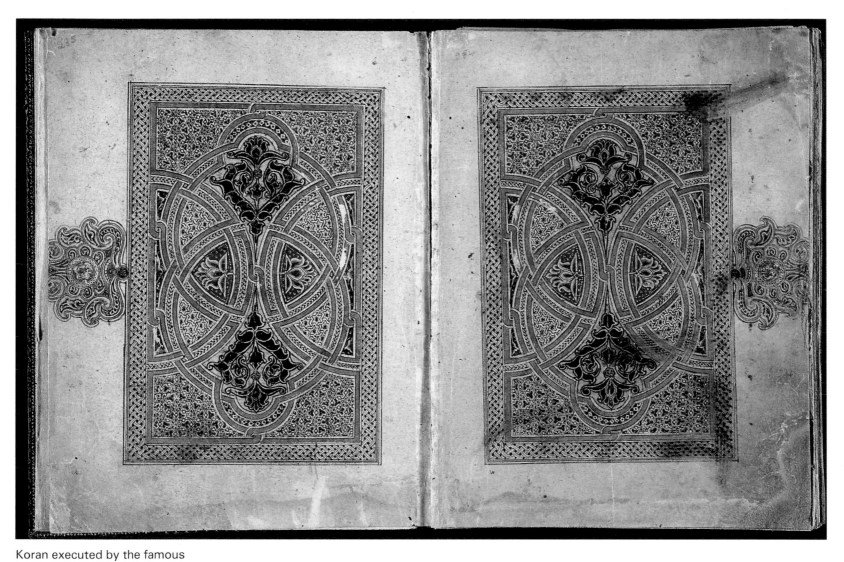

Koran executed by the famous
Iraqi calligrapher Ibn al-Bawwâb
Dated 1001
Chester Beatty Library, Dublin

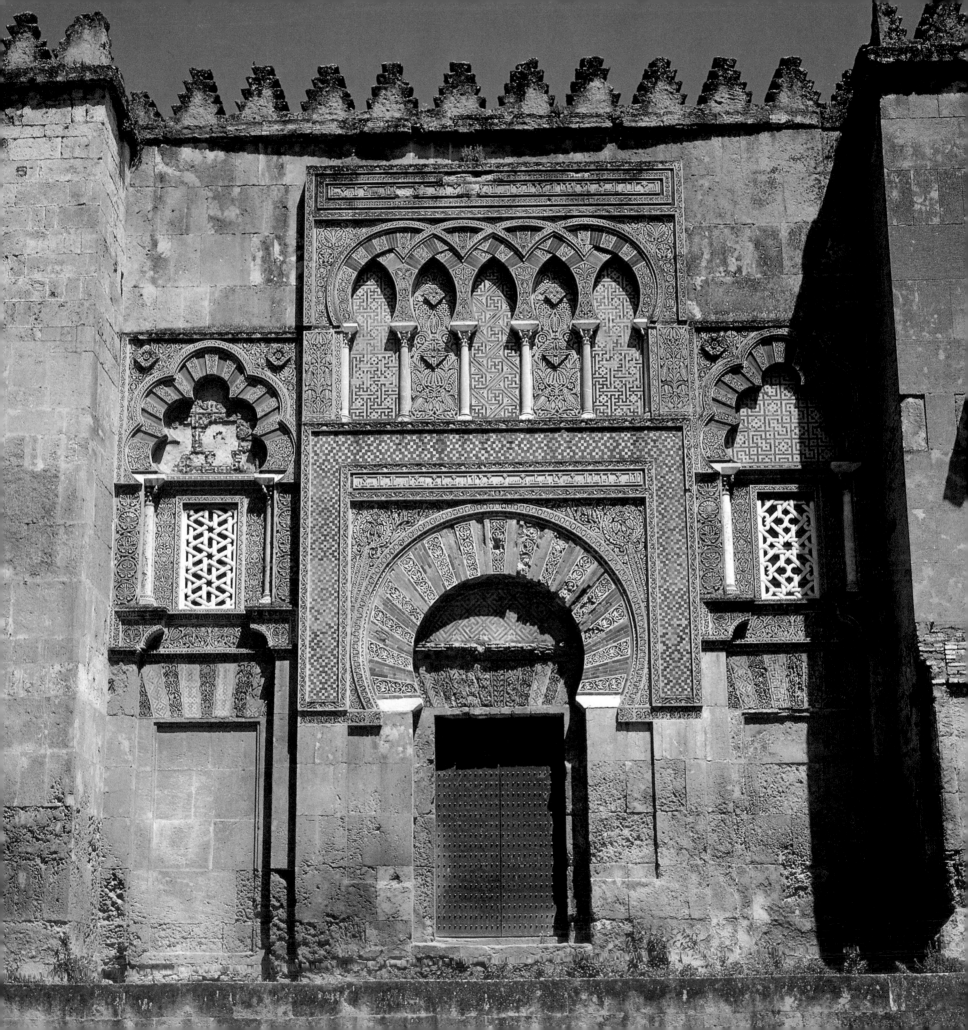

Spain, Morocco and Algeria

The Umayyads, who had conquered Spain in 711, survived the Abbasid revolution and under 'Abd al-Rahmân (756-788) founded an independent Umayyad state with its capital at Cordoba. The Great Mosque of Cordoba was built during his reign.

'Abd al-Rahmân III took the title of Caliph in 929 and founded the palace-city of Madînat al-Zahrâ (936-945) with its Great Mosque (941). During the reign of Ibn Ja'far al-Muqtadir (1046-81) the Aljafería Palace was constructed in Zaragoza.

An independent dynasty, the Aghlabids, ruled in the 9th century in Tunisia, where the capital at Qayrawan was founded by Uqba 'Nafi in 670. The Idrisids of Morocco in 789 founded Fez, a capital as grand as Qayrawan and Cordoba. In the 10th century, the Fatimids founded the town of Mahdiyya in Tunisia, whence they launched their invasion of Egypt in 969. In Algeria, local dynasties like the Zirids based at Ashir and the Hammadids based at the fortress of Qal'at of the Bani Hammad, although politically ephemeral, were patrons of the Islamic arts. Later, the Almoravids established themselves in Marrakesh in 1062 and proceeded to gain control of the western Maghrib and much of Spain. Less than a century later, however, after a seventeen-year campaign, the Almoravid capital Marrakesh fell to the Almohad prince 'Abd al-Mu'min in 1147, and this marked the zenith of the Almohads' power.

Great Mosque, façade
Cordoba, Spain

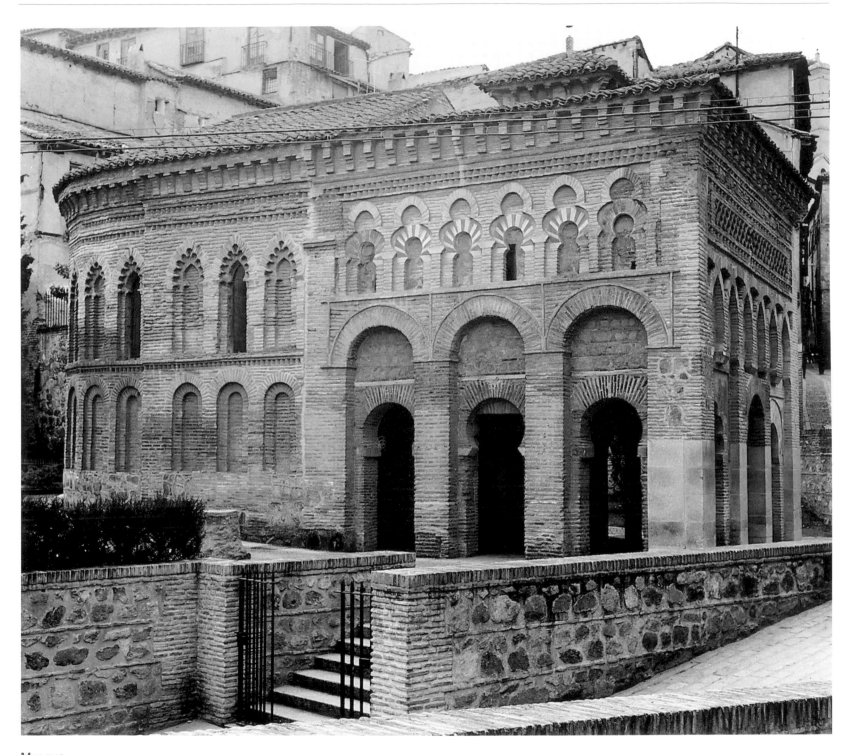

Mosque
Toledo, Spain 999

Today the church of El Cristo de la
Luz, built by Mûsâ ibn 'Alî. Exterior
view from the North-west.

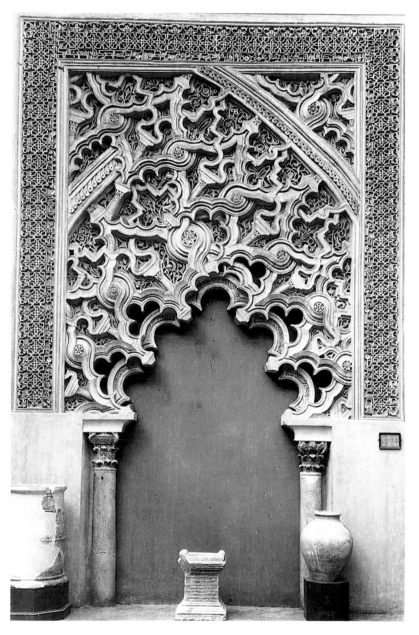

Carved stucco arch from the
Aljafería
Zaragoza, Spain
1049-1081

The palace was built by the ruler
Ahmad al-Muqtadir.
Museo Argueologico National,
Madrid

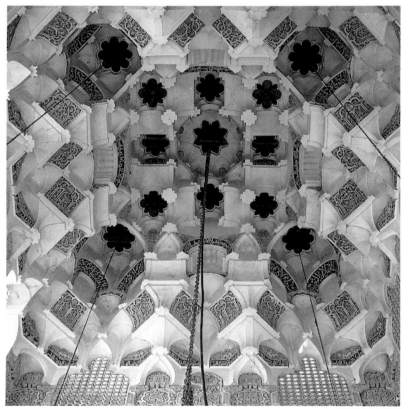

Mosque of al-Qarâwiyyin
Fez, Morocco
11th century
Stalactite dome before the
mihrab.

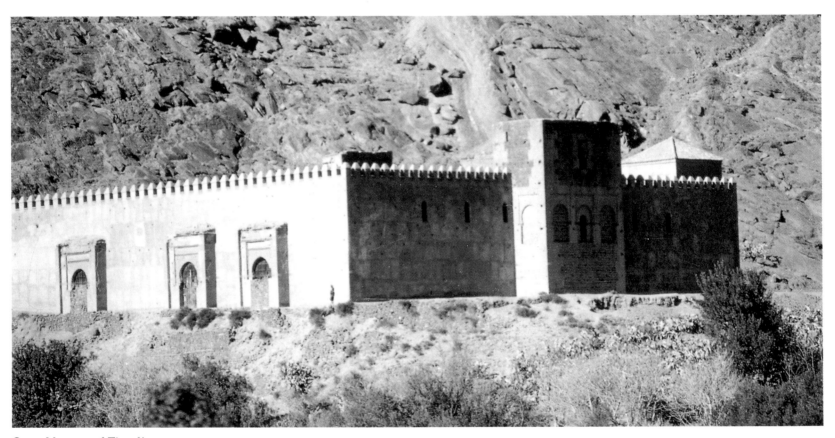

Great Mosque of Tinmâl
Morocco
1153-54

An Almohad building restored
by the ruler 'Abd al-Mu'min.

Court of the Lions, Alhambra
Palace
Granada, Spain
1354-91

Built by the Nasrid ruler
Muhammad V.

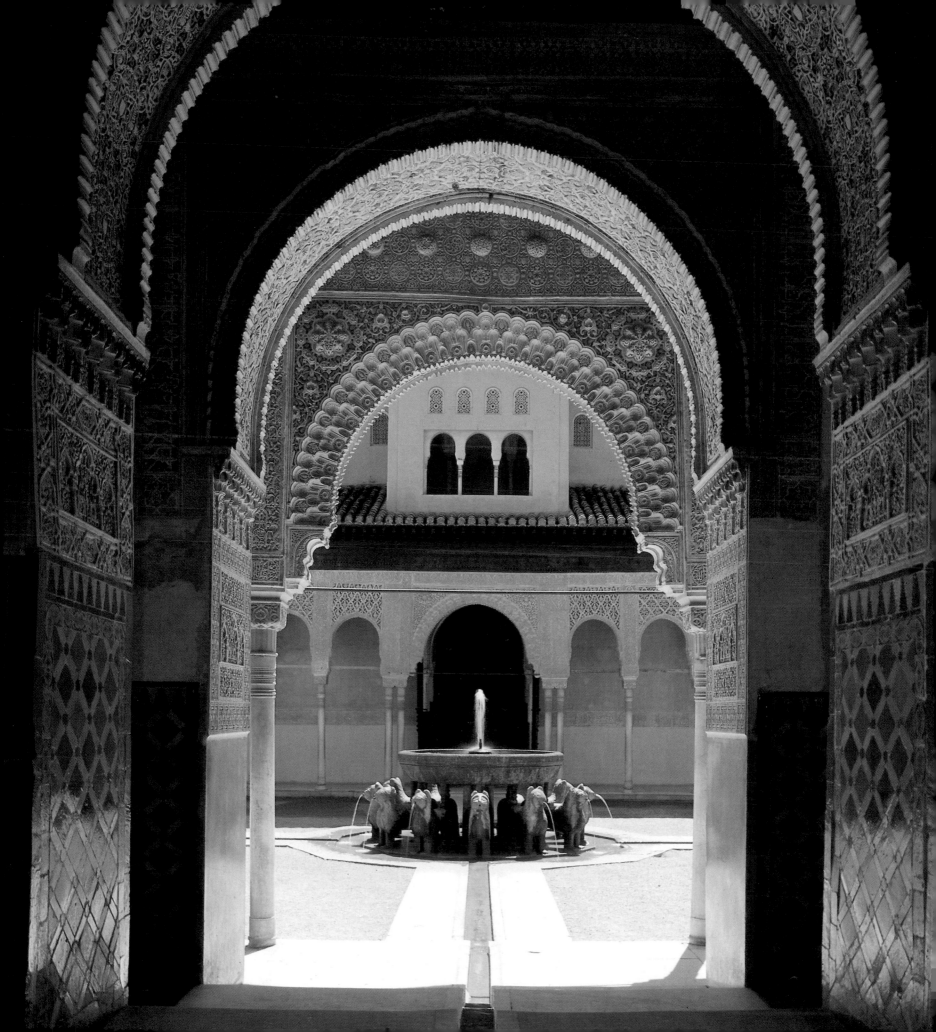

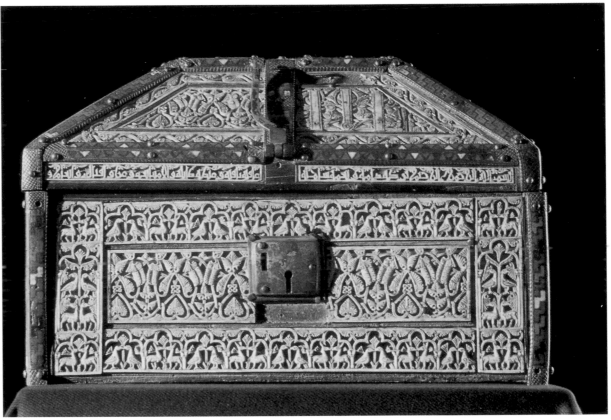

Ivory box
Cordoba, Spain
968
Musée du Louvre, Paris

Inscribed with the name of a son
of the Caliph 'Abd al-Rahmân III.

Wooden casket with ivory panels
and ivory with
cloisonné enamel
Cuenca, Spain
Dated 1049-50
Museo Argueologico Nacional,
Madrid

Made by 'Abd al-Rahmân
ibn Zayyan for the chamberlain
Husâm al Dawla Ismâ'îl, son of
al-Ma'Mûn, king of Toledo and
governor of Cuenca in New
Castile.

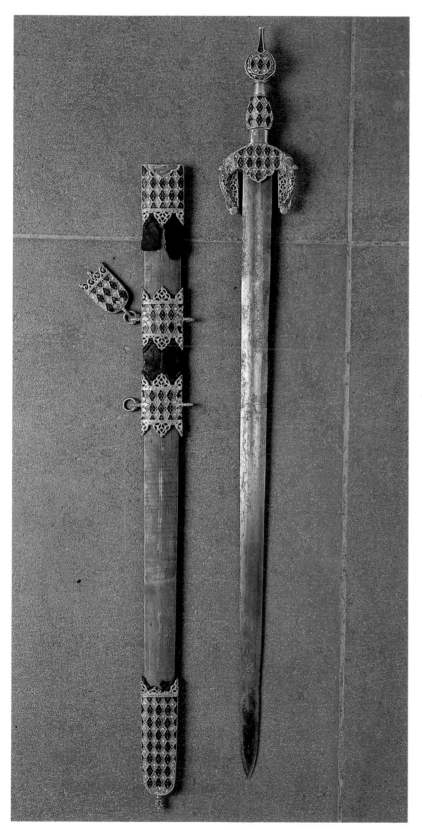

'Sword of Boabdil'
Granada, Spain
Late 15th century
Staatliche Kunstammlungen
Kassel

Steel sheath decorated with gilt
and bronze mounts and with
gold filigree and enamelwork.

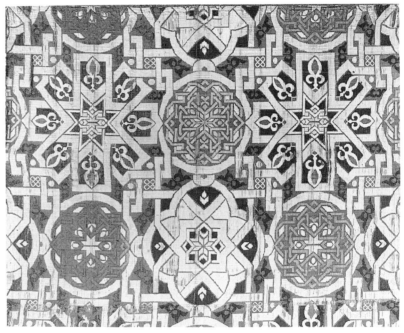

Silk cloth with medallions and
eight-pointed stars of angular
interlaces

Southern Spain or North Africa
Nasrid period, 14th century
Victoria and Albert Museum,
London

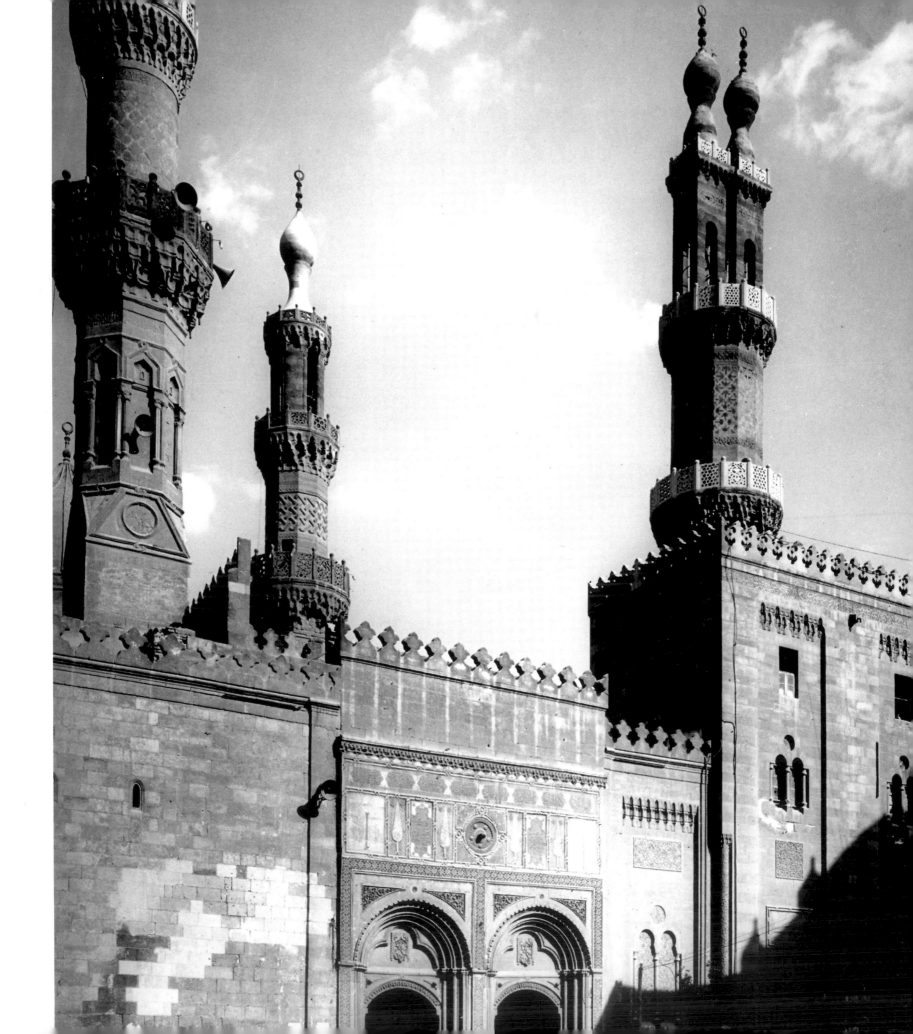

The Western
and Central Lands
of the Islamic World
during the High
Middle Ages

The Great Mosque and the
University of Theology of
Al-Azhar
Cairo, Egypt
Founded in 972

Initially the institution was created
to spread Fatimid propaganda, but
with the fall of the Fatimids it was
devoted to the teaching of
orthodox Islam. Today it is the
most famous Muslim educational
institution. The view shows the
façade and the minarets that were
added by the later Mamluk
Sultans.

Between 969 and 1169, the heterodox and fiercely proselytizing Fatimid dynasty which arose in Tunisia reigned supreme in Egypt and for a time in parts of Syria and Palestine. Their first capital was at Mahdiyya in Tunisia, but they also occupied Qayrawan, restoring *inter alia* the painted ceilings of the Great Mosque. In the mid-11th century, Tunisia was devastated by nomadic raids, and architecture was temporarily brought to a halt.

In Egypt, the Fatimids founded a new capital, Cairo, originally with mud-brick walls, where they had their palace and their Great Mosque, al-Azhar. Among the many buildings they erected was the vast mosque of al-Hakîm, which in the late 11th century was brought within massive stone walls. In the south of Egypt the frontier trading city of Aswan prospered, and its medieval cemetery is one of the most important surviving from mediaeval Islam. No Fatimid Korans or illuminated manuscripts have been identified, although their palace library was famous. They also patronized the minor arts–wood and ivory carving, glass and lustre-painted pottery.

With the rule of Saladin and the collapse of the Fatimids in 1169, unity was restored to Islam, although the Maghrib henceforth developed independently within the traditions established by earlier dynasties in Morocco and southern Spain. At the same time, Yemen and Hijaz became prominent again because of trade and patronage: Syrian stonemasons travelled throughout the Islamic world and pottery, woodwork, illumination and the arts of the book assumed an

international style. Enamelled glass made in Syria and Egypt was especially popular, and was exported via the Rasulid dynasty in Yemen even as far as China.

The Mongol invasion, which put an end to the Abbasid caliphate in Baghdad in 1258, turned Syria and Egypt, then under the domination of the Mamluks, back towards the Mediterranean. By 1300, Baybars and his successors, Qalâwûn and al-Nâsir Muhammad, had united the two countries and had put an end to the Christian crusader states in Syria and Palestine. They were great builders, restoring and developing the Hejaz and influencing grand architecture in Yemen. For the endowments of their mosques and other pious foundations, they commissioned magnificent large-scale illuminated Korans, although their personal taste ran to war manuals and illustrated books of automata. In the period up to the Ottoman conquest in 1516-17, Cairo and Damascus assumed the glory which Baghdad had enjoyed earlier as the capital of the Caliphate.

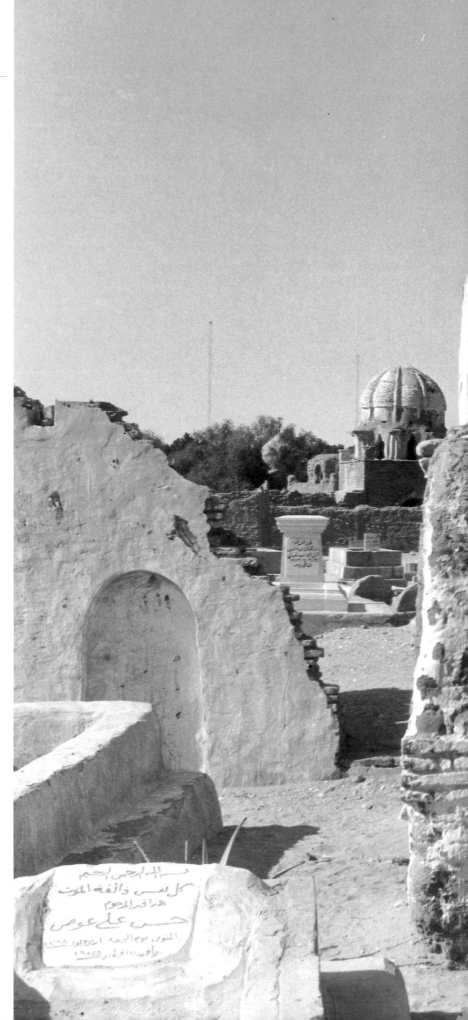

Mediaeval cemetery
Aswan, Egypt
11th-14th centuries
Brick-domed mausoleums are typical of Fatimid architecture in 11th to 12th-century Cairo. Some have elegantly ribbed domes and carved plaster *mihrabs*. Originally the exterior was plastered and had fluted transitional zones.

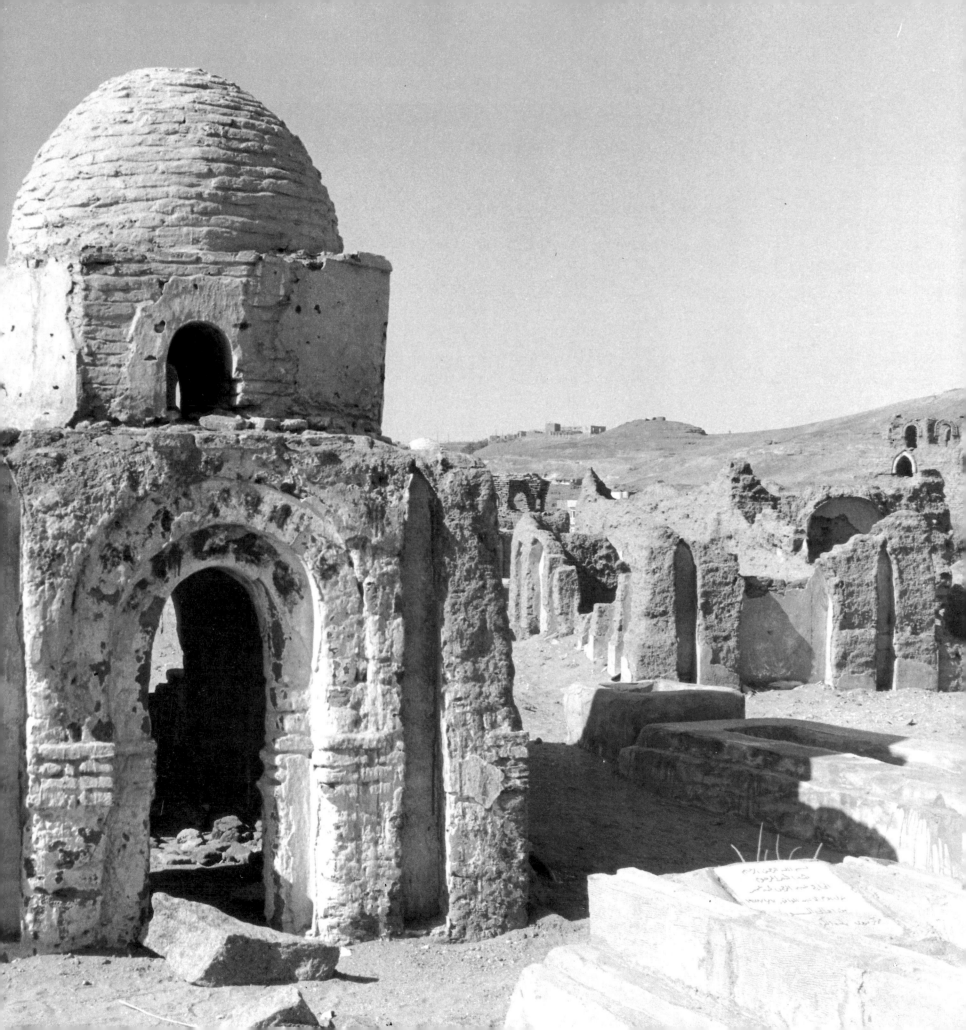

Lustre dish
Fatimid period, Egypt
11th century
Benaki Museum, Athens

The surface is decorated with two
Kufic votive inscription bands.

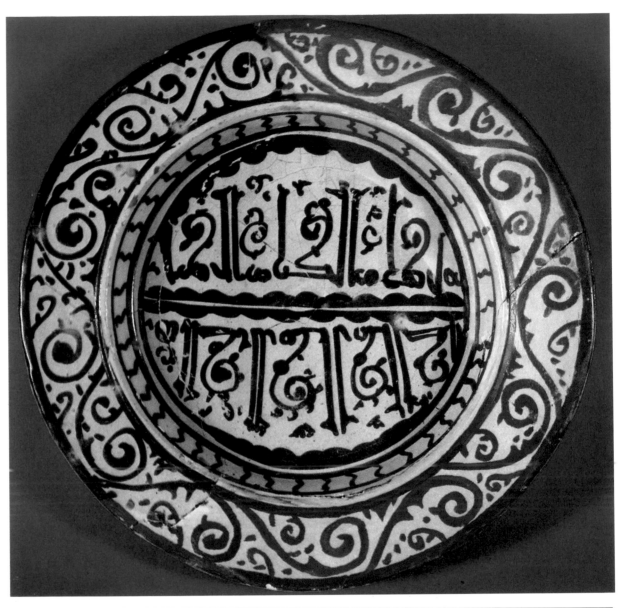

Boat-shaped rock-crystal lamp
Fatimid period, Egypt
c. 1000
Hermitage Museum, Leningrad

The continuous acanthus scroll
pattern recalls the late 7th-century
Umayyad mosaics at the Dome of
the Rock in Jerusalem.

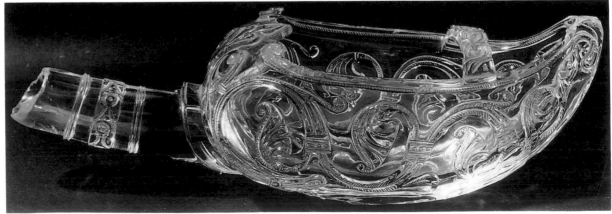

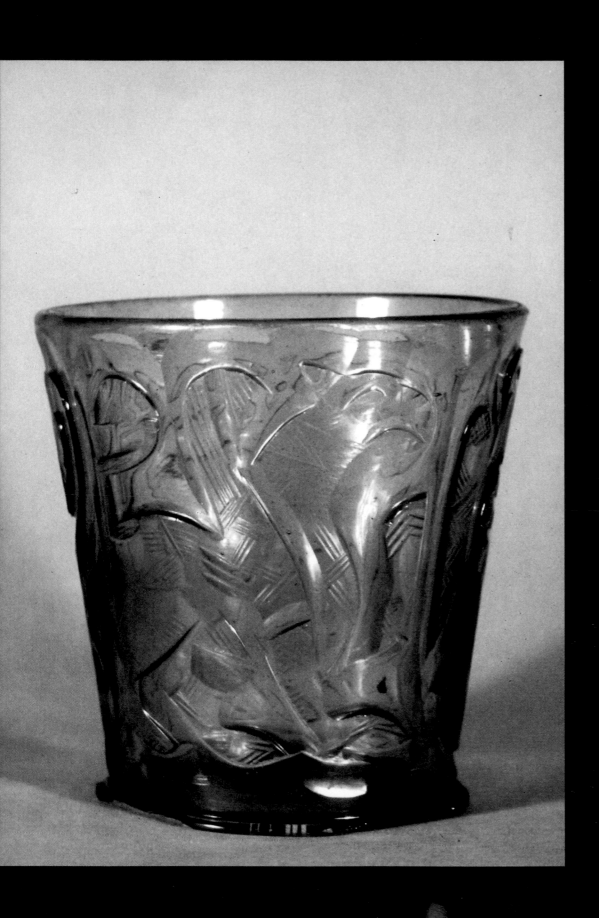

'Hedwig glass'
probably from Syrian Arab
Republic
Late Fatimid period,
c. 1150
British Museum, London

The glass, carved in relief, is incised with a lion, griffin and a spread eagle.

Book of Antidotes (Kitâb
al-Diryâq)
Probably from Mosul
1199
Bibliothèque Nationale, Paris

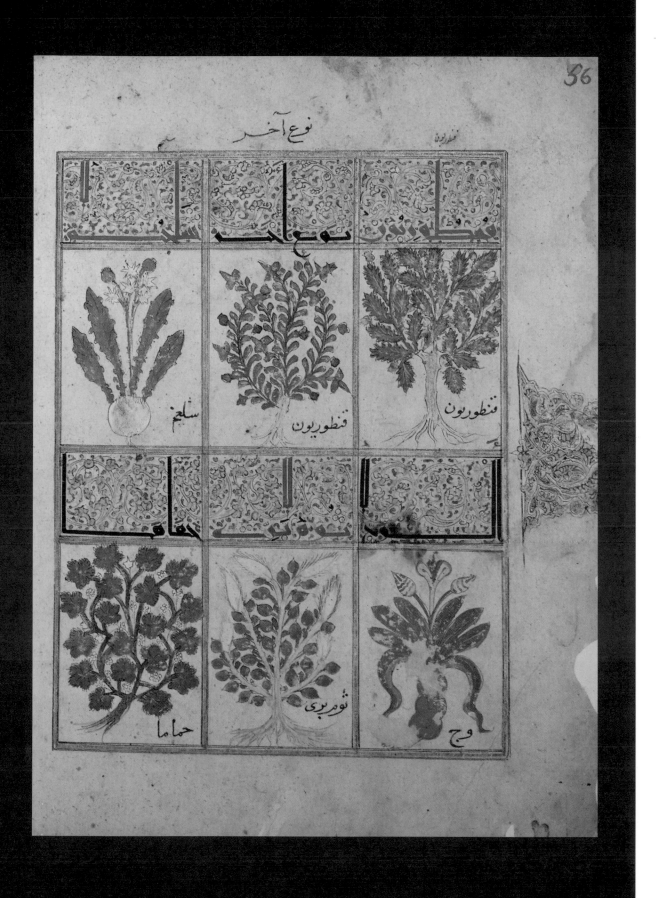

Illuminated frontispiece
Koran, Iraq
1289
Bibliothèque Nationale, Paris

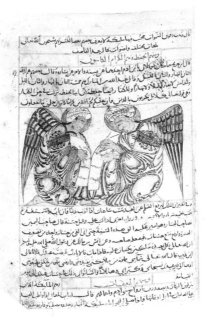

The Wonders of Creation
('Ajâ 'ib al-Makhlüqât)
Iraq
1280
Bayerische Staatsbibliothek,
Munich

Angels hold the Great Book of
the good and bad deeds of men.

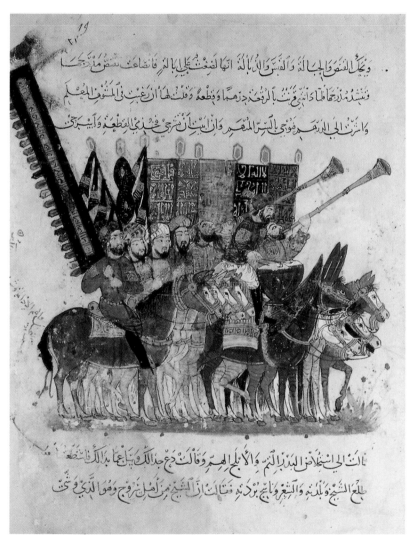

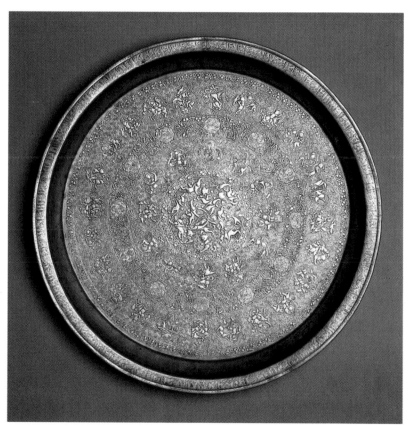

Maqâmât of al-Harîrî
Baghdad, Iraq
1237

Bibliothèque Nationale, Paris
Celebration of the end of
Ramadan.

Tray of beaten brass inlaid with
silver
Mosul
c. 1233-59
Staatliches Museum für
Volkerkunde, Munich

Made for the household of Badr
al-Dîn Lu'lu, ruler of Mosul.
The decoration includes figures of
the seven planets and medallions
of hunting scenes, dancers,
wrestlers, animal
combats and mythological
creatures. The tray is part of
the loot taken by the Elector of
Bavaria, Max Emmanuel, at the
recapture of Buda in 1686.

Great Mosque
San'a, Yemen

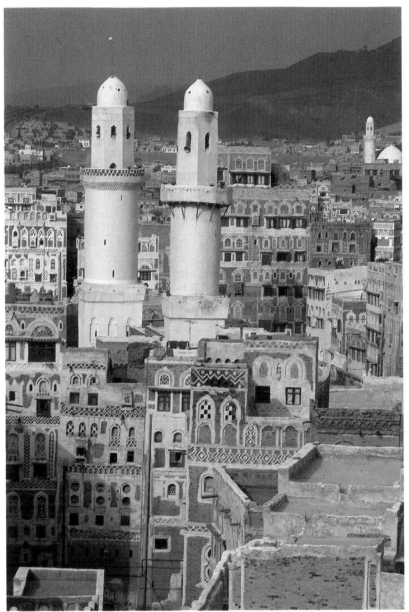

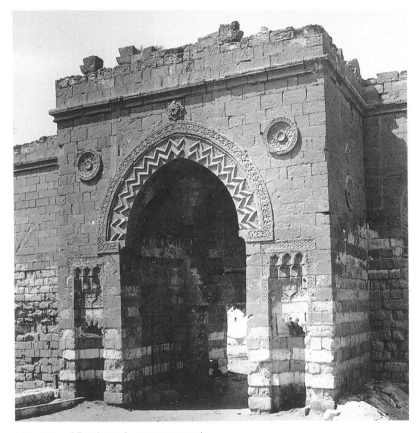

Mosque of Baybars I, monumental
entrance
Cairo, Egypt
1264

The mosque, now in ruins, was
decorated originally with marble
acquired as booty by the armies
of Baybars in their campaigns
against the Crusaders in Palestine
and Syria.

Funerary foundation of Khayrbak
Cairo, Egypt
Early 16th century

The founder's domed mausoleum occupies a conspicuous place, as was characteristic of pious foundations of Mamluk Egypt.

Ashrafiyya madrasa-mosque
Ta'izz, Yemen
14th-15th centuries

The painting in the dome, in gilt and polychrome, was strongly influenced by contemporary Mamluk decorative painting.

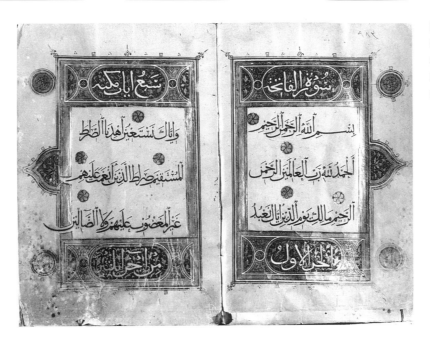

Koran, Suras I and II with
illumination in gold and blue
Syrian Arab Republic
Late 13th century
National Museum, Damascus

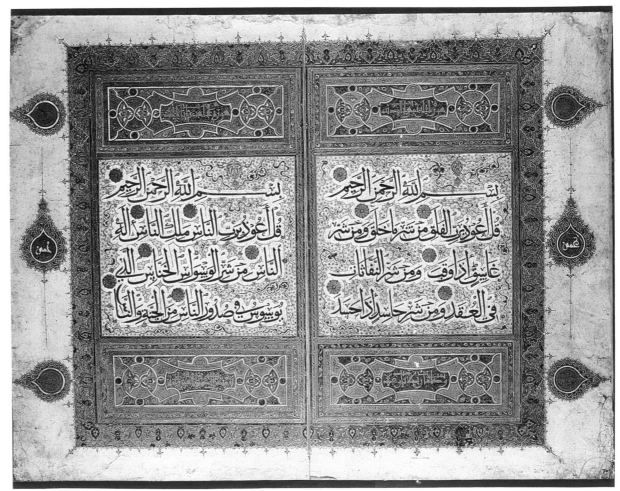

Two pages of the Koran, Suras
CXIII-CXIV
c. 1400
Probably came from Mamluk
Cairo. Its style is indebted
to Tabriz illumination of the
early 14th century.
Chester Beatty Library, Dublin

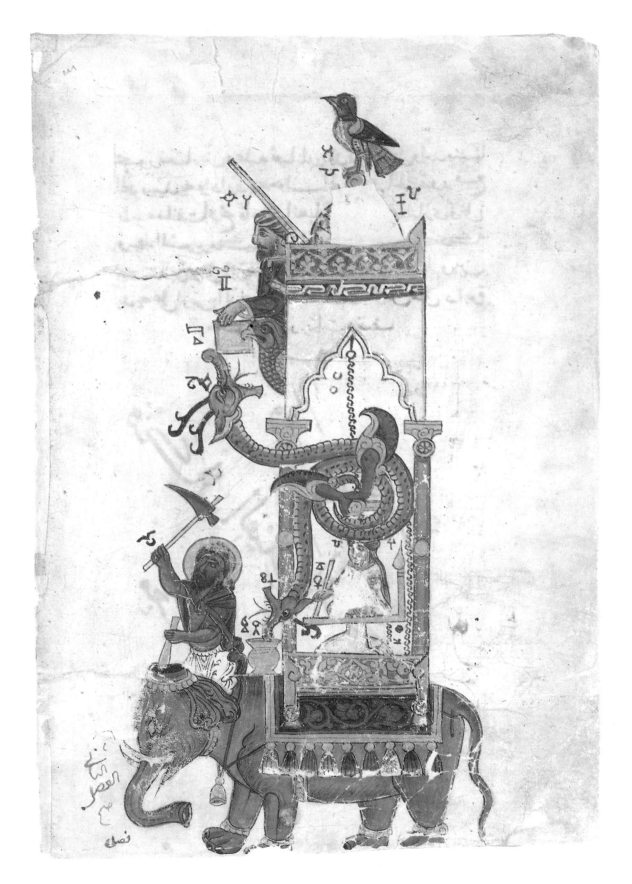

Treatise on Automata or Book
of Knowledge of Mechanical
Devices of al-Jazarî (Kitâb fî
Ma rifat al-Hiyal al-Handasiyya)
Elephant Clock
Syrian Arab Republic
1315
Metropolitan Museum of Art,
New York

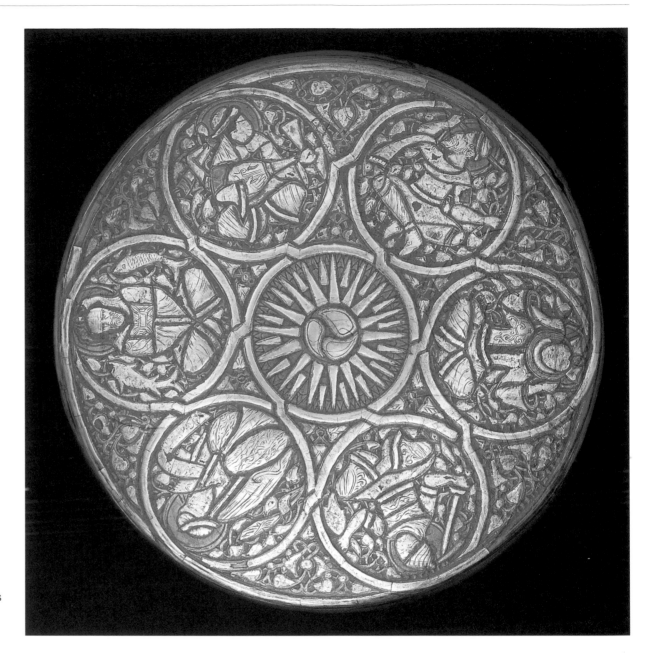

Bowl of beaten brass inlaid with
silver
Syria or Egypt
Early 14th century
Musée du Louvre, Paris

Figures of the seven planets
decorate the base, while
medallions of drinkers, musicians
and animal combats adorn the
sides.

Enamelled and gilt glass mosque
lamp
Syrian Arab Republic or Egypt
Musée du Louvre, Paris
14th century

This lamp bears the name of the
Mamluk Sultan al-Nâsir
Muhammad
(died 1341).

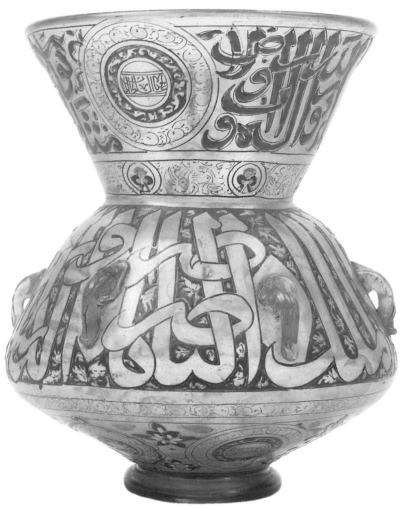

Carpet
Damascus or more probably Cairo
c. 1500
Osterreichisches Museum für
Angewandte Kunst, Vienna

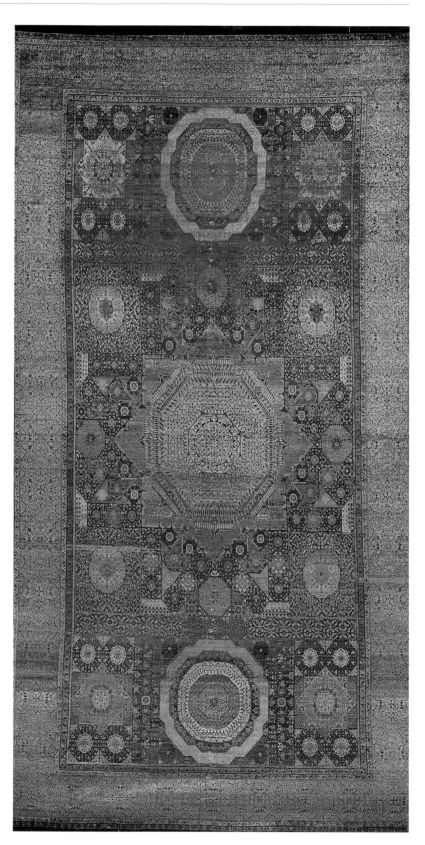

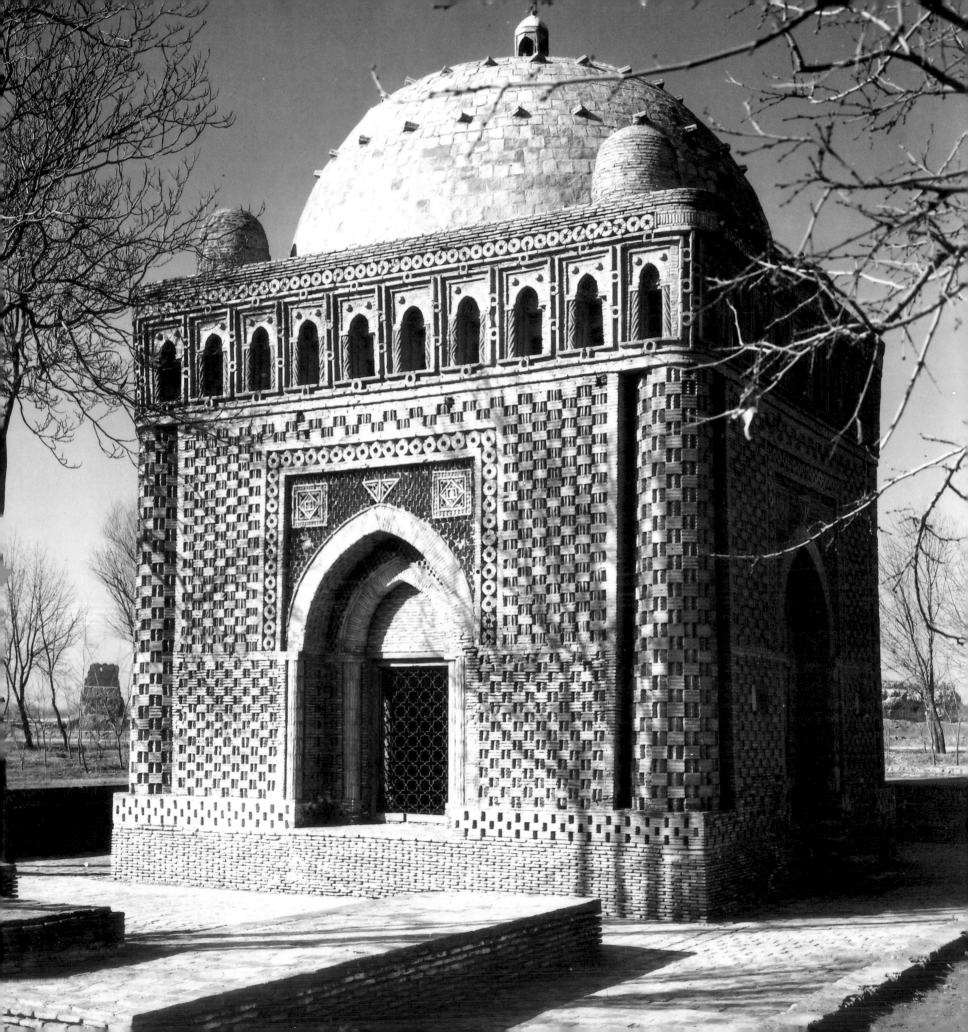

Anatolia, the Iranian World, and Central Asia in the Later Middle Ages

The disintegration of the Abbasid Caliphate was most serious in Iran and Central Asia where, by the late 9th century, the Samanid dynasty, with capitals at Nishapur and Bukhara, reintroduced Persian as an official language. Western Iran was controlled by the Buwayhids, a Shiite dynasty, who also looked to their Iranian past. Subsequently, Central Asia was ruled by Turkish dynasties of pagan nomads, like the Karakhanids, the Ghaznavids, the Seljuks and the Khwarazmshahs, all of whom converted to Islam and took over their predecessors' capitals, Merv, Nishapur, Ghazna and Isfahan. The 11th century saw an expansion into Northern India, first by means of military campaigns which may have had no lasting effect. But towards the end of the 12th century, under the Ghurids from Afghanistan, Delhi became the first of many Muslim imperial capitals in North India. The Seljuks, although their power soon disintegrated, left behind in 13th century Anatolia a style of architecture which is one of the glories of Islamic civilization.

The architecture of these dynasties obviously reflected the influence of the Baghdad Caliphate, the religious authority of which they generally recognized. Northern India (*c.* 1200) and Seljuk Anatolia preserve the best architectural examples where, for the most part, buildings were constructed in lavishly carved stone. Towns had their Great Mosques, *madrasas* and other religious foundations (palaces have survived less well), and all were linked by chains of often luxuriously appointed caravanserais. This period also saw the

Mausoleum of Ismâ'îl the Samanid
Bukhara, USSR
c. 907

This domed square displays one of the earliest and most spectacular uses of brick in Iranian architectural decoration, and brick patterns appear inside and outside the building.

131

introduction of colour in architecture, first as turquoise inscription bands then as tile mosaic, in turquoise, cobalt and black.

The coming of the Mongols in 1218-58 threw this part of the Islamic world into disarray. Much was destroyed, including the Abbasid Caliphate (1258), but more serious was the lack of stability engendered by the constant campaigns of the Mongols, which, in Central Asia, lasted into the 14th century. By the later 13th century, the Mongols in Mesopotamia and Iran (the Il-Khans) had settled urban areas and in 1296 under Ghâzân Khan they became Muslim. He brought builders, tileworkers and woodworkers to Tabriz from all over his domains and patronized a revival of the arts of the book which had survived in Baghdad under its Muslim governors. Hence, partly in deliberate competition with the Mamluks in Egypt and Syria, the Mongols created Tabriz as an artistic capital, renowned for its magnificently illuminated Korans and illustrated books. But all over Iran, from Mashhad to Isfahan, fine Islamic architecture arose, and the desire to revive the grand Seljuk tradition was manifest.

Karatay Medrese, interior
Konya, Turkey
1251-52

The decoration of the central dome and walls consists of geometric designs in turquoise, cobalt and black tile mosaic.

Great Mosque and hospital, west porch
Divriği, Turkey
1228 or later

The extremely varied carving, inside and out, makes this complex unique in Anatolian architectural decoration.

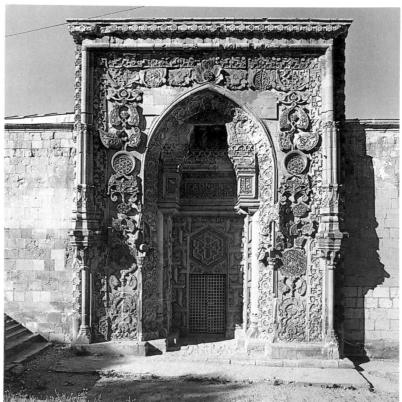

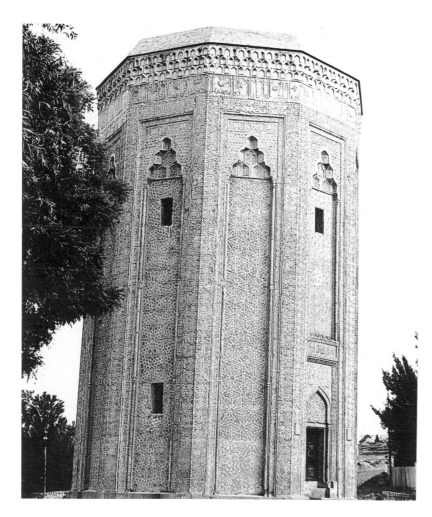

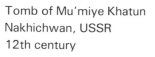

Tomb of Mu'miye Khatun
Nakhichwan, USSR
12th century

The panels are abundantly covered with arabesques and Kufic inscriptions.

Great Mosque of Ashtarjan
Isfahan oasis, Islamic Republic of Iran
1315

The tall entrance is surmounted by two minarets and faced with glazed terra-cotta and tile mosaic in a style characteristic of Iranian monumental architecture of the early 14th century.

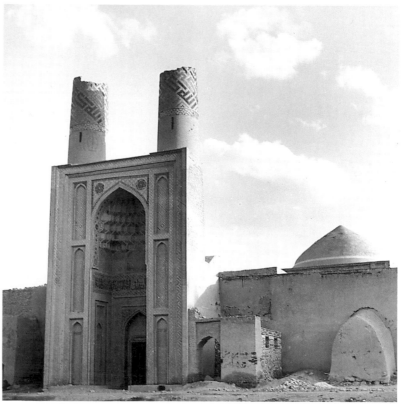

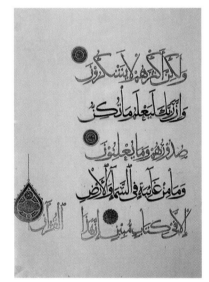

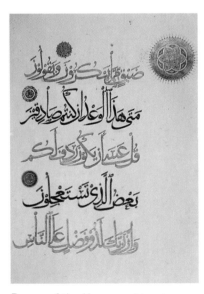

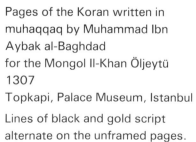

Pages of the Koran written in
muhaqqaq by Muhammad Ibn
Aybak al-Baghdad
for the Mongol Il-Khan Öljeytü
1307
Topkapi, Palace Museum, Istanbul

Lines of black and gold script
alternate on the unframed pages.

Koran pages, Sura IV, 147-169,
Eastern Kufic
12th century
Chester Beatty Library, Dublin

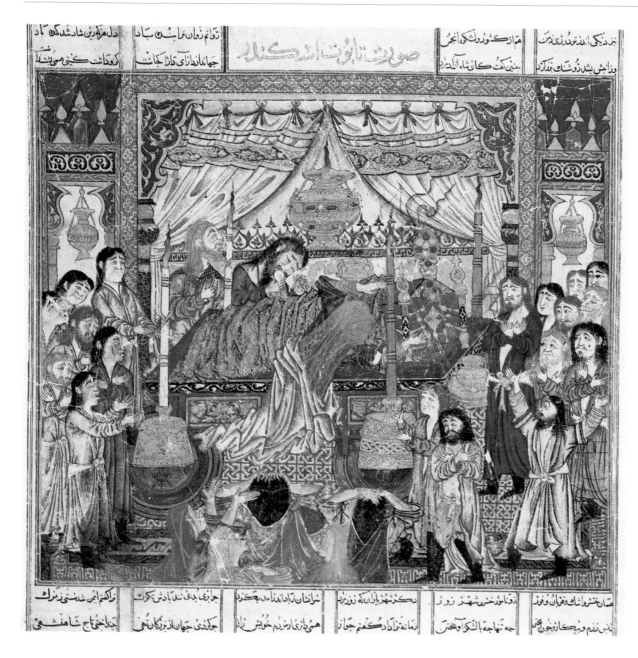

Bier of Alexander the Great
Shâhnâme (Book of Kings),
known as the Demotte Shâhnâme
Tabriz, Islamic Republic of Iran
c. 1340
Freer Gallery of Art
Washington, D.C.

A splendid example of tragic
expression in Muslim painting.

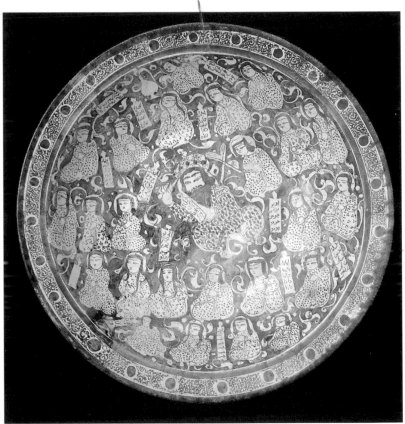

Slip-painted glazed dish
Nishapur, Islamic Republic of Iran
10th century
Musée du Louvre, Paris

The Kufic inscription on the border
transcribes the following
saying: 'The beginning of
Knowledge is bitter to taste, but
the end is sweeter than honey.
Peace be (to the owner)'.

Dish painted in lustre over a white
glaze (probably Kashan)
Islamic Republic of Iran
c. 1200
David Collection, Copenhagen

A teacher is surrounded by his
pupils.

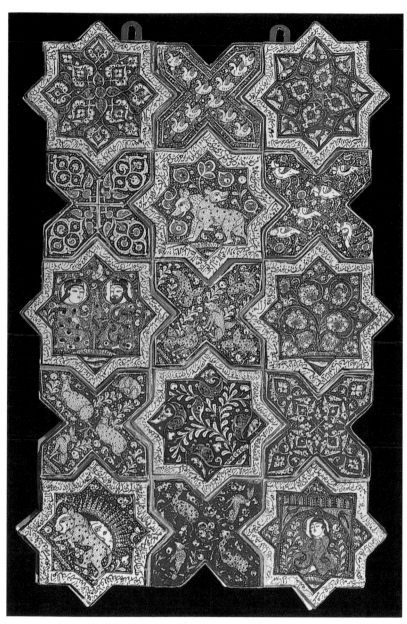

Tiles in the form of stars and
crosses (probably Kashan)
Islamic Republic of Iran
1267
Musée du Louvre, Paris

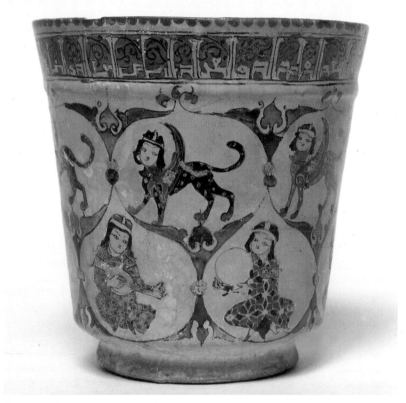

Beaker with enamel decoration
over a white glaze
(probably Kashan)
Islamic Republic of Iran
c. 1200
Musée du Louvre, Paris

Cast bronze door-knocker in the
form of two opposing dragons
from the Great Mosque at Cizre,
Eastern Turkey
c. 1200
David Collection, Copenhagen

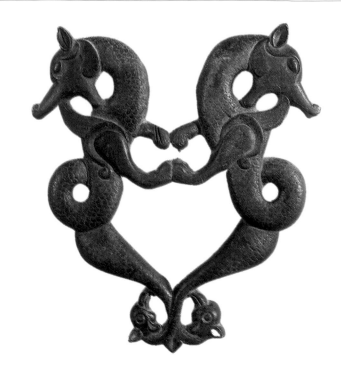

Cast bronze candelabra with
handles in the form
of stylized birds, inlaid with silver
and copper, Iran
Late 12th century
Walters Art Gallery, Baltimore

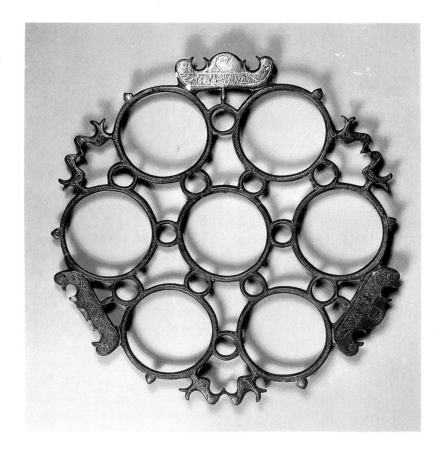

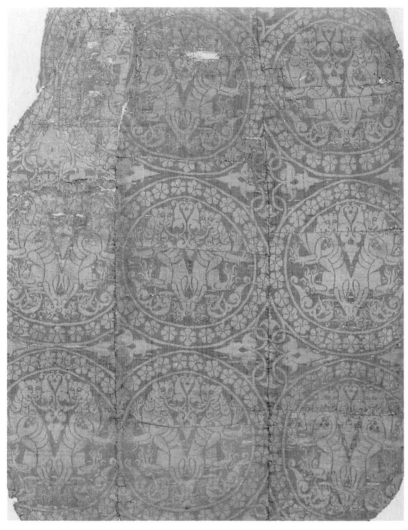

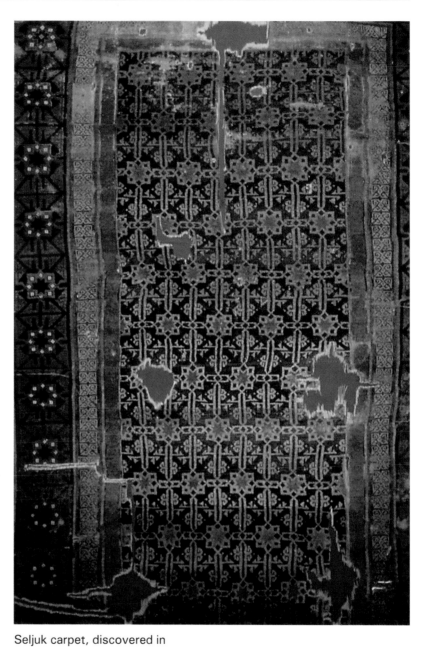

Silk decorated with eagles and
bearing the name of 'Alâ al-Dîn
Kayqubâad
Anatolia
Seljuk period, 13th century
Musée Historique des Tissus,
Lyons

Seljuk carpet, discovered in
the Alaeddin Mosque
Konya, Turkey
13th century

This is one of the oldest knotted
carpets extant.
Museum of Turkish and Islamic
Art, Istanbul

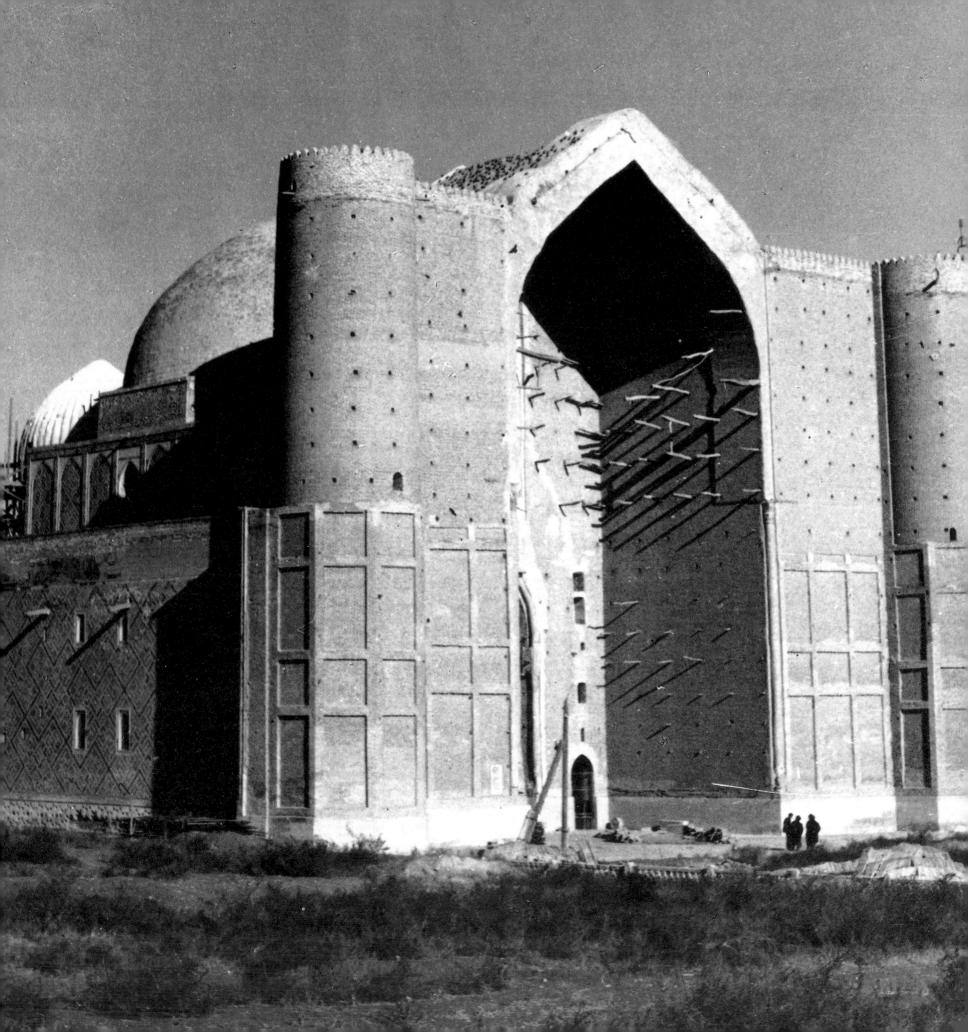

The Great Empires: Timurid, Ottoman, Safavid, Mughal

Mausoleum of Ahmad Yassavi,
Timurid restorations
Turkestan, USSR
1397

Ahmad Yassavi (died 1166)
was the founder of an important
Sufi order, and Tamerlane
honoured his memory with this
gigantic building comprising a
buttressed entrance *iwan,*
which heralded a massive
rectangular domed building
beyond which was the Saint's
tomb.

In 1370, Timur, or Tamerlane, a Barlas Turk, gained control of Samarkand. From this base he launched campaigns against Iran and the Near East, and then India, and was on his way to China when he died in 1405. These campaigns were overwhelmingly destructive, but his conquests were always followed by the deportation of craftsmen to develop Samarkand as his capital. Much of the architecture he ordered was built too fast, too high and is now in ruins, but his grandiose constructions inspired his son, Shah Rukh, and his grandson, Ulugh Beg, to build more permanently. The latter's buildings in Samarkand include a *madrasa* where the curriculum included mathematics, and an observatory which produced a new set of star-tables used later by the great European Renaissance astronomers. The power of Timur's successors was most firmly established in Central Asia in Samarkand and Bukhara, and in Herat in Afghanistan. The arts were particularly well patronized. Much of Iran remained disputed territory, and although Timur's descendants at Shiraz maintained a firm hold, they faced the growing power of two great Turkoman confederations: the Empire of the Black Sheep (Karakoyunlu) and that of the White Sheep (Akkoyunlu) who occupied both Baghdad and Tabriz. In 1500, Herat was faced with the threat of a new Turkic dynasty, the Uzbeks, who made Bukhara their capital, while Western Iran was threatened by the Safavids, militant Shiites, who originally were Sufis from Ardebil. In 1520 under Shah Ismâ'îl I, Iran was united and the capital was successively at Tabriz, Qazvin and Isfahan. Under

Shah 'Abbas I (died 1629) Isfahan was replanned entirely, with a palace, a great central square and grandstand for watching polo matches, a grand entrance to the bazaars, and two mosques, that of Sheik Lutfallâh and that of Shah 'Abbas. With its gorgeous tile revetments inside and out, the mosque of Shah 'Abbas enshrines one of the Islamic ideals of architecture as the art of surface decoration.

From the beginning, the Safavids came into violent conflict with the orthodox Sunni Ottomans. Originally from a small emirate in Western Turkey with a capital at Bursa, the Ottomans rapidly expanded, by marriage and conquest, into the Balkans and subdued their neighbours. Their defeat at Ankara by Timur in 1401 was only a minor set-back: in 1453 Constantinople fell to Mehmed the Conqueror, and by 1530 Egypt, Syria, Mesopotamia and the Balkans as far as Budapest were under their control. The empire remained an important European power until the 19th century and counts as one of the longest-lived of all Muslim states. Its greatest period, however, was probably from 1453 to 1600, when Constantinople (Istanbul) attracted craftsmen from all over Europe and the Islamic world. Splendid mosques were built by the famous architect Sinan at Edirne, Istanbul and all over the Ottoman empire; Korans and illustrated chronicles were executed in the palace workshops; and the potteries at Iznik and the court carpet and textile manufactures at Bursa, Uşak and Istanbul were in full production.

The Mughals traced their ancestry to Timur. Bâbur, the founder of the dynasty, was driven away from Samarkand and settled in India. His son, Humâyûn, spent most of his reign at the Safavid court, where, by good fortune, he attracted court painters into his service. Not until the 1570s did Akbar finally subdue the Muslim dynasties established on the sub-continent and the rest of the Northern Indian non-Muslim states. By the late 16th century the Mughals were supreme, with a newly founded capital at Fatehpur Sikri (now abandoned). Under Akbar's successors, Jâhangîr and Shah Jahân, the Mughal capitals of Lahore, Agra and Delhi were replanned and grand architectural ensembles like the Taj Mahal created.

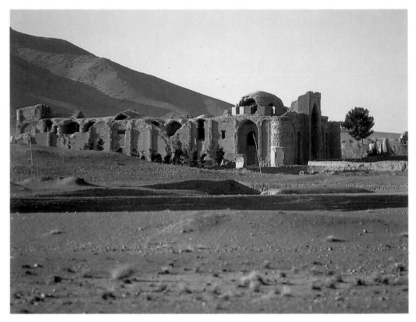

Madrasa Ghiyâthiyya
Khargird, Islamic Republic of Iran
Dated 1444

Founded by a vizier of Shah Rukh, the son of Tamerlane, the brick building has a grand entrance and four courtyard *iwans* while the lecture rooms and prayer chambers are at the corners. The tile mosaic decoration bears the signature of one of the most famous Timurid architects of the early 15th century, Qavan al-Din.

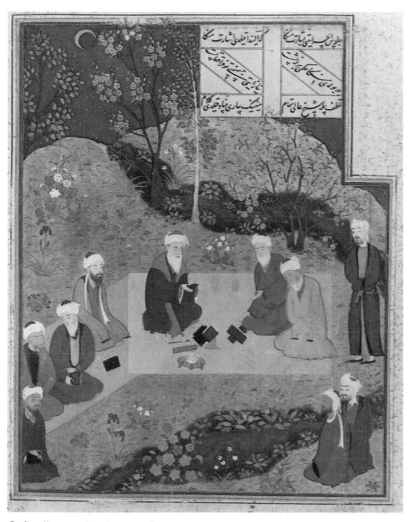

Sufis discoursing in a garden,
Khamsa of Mir ʿAlî Shîr Navâî
Herat, Afghanistan
1495
Bodleian Library, Oxford

Page of stylized calligraphy,
based on the name ʿAlî
repeated four times
Baghdad, Iraq
15th century
Istanbul, Topkapi Saray Library,
Album H. 2152

The polychrome calligraphy on
a brilliant red background
carries the angular tendencies
of Timurid stylized calligraphy
to its limits.

Nasta °liq calligraphy by Sultan
'Ali Mashhadî, taken from
an anthology (the Makhzan
al-Asrâr), Tabriz
Dated 1478
Spencer Collection, New York
Public Library

Executed in black ink on pale blue
Chinese paper with drawings of
architecture and landscapes in
gold.

Binding, inner cover, Divan
(collected poems)
Sultan Ahmad Jalāir, Baghdad
1406-07
Turkish and Islamic
Art Museum, Istanbul

Brown leather tooled and gilt
with filigree medallions
and corner-pieces on dark blue.
Such bindings were the
source of Renaissance Italian
bindings and very probably
of contemporary European
'arabesque' designs.

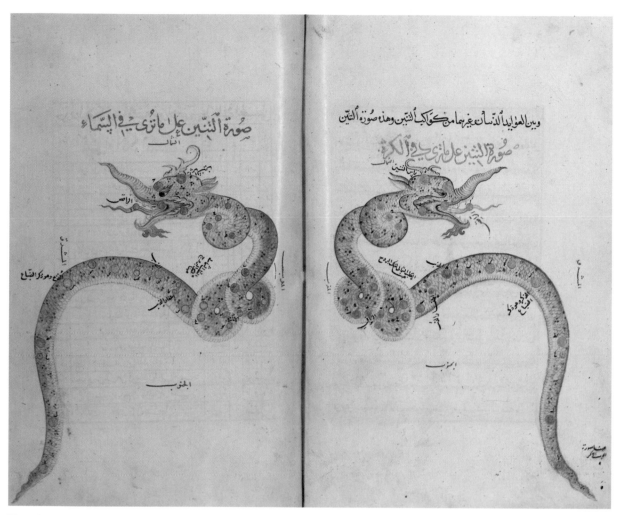

Treatise on the Fixed Stars
(Kitâb Suwar al-Kawâkib
al-Thâbita) copied for Ulugh Beg
and his observatory at
Samarkand, probably at Herat
c. 1430
Bibliothèque Nationale, Paris

The Constellation Draco is
depicted as it appears in the sky
and on a globe.

Silk
Iran or Central Asia
14th century
West Berlin, Staatliche Museen für
Preussischer Kulturbesitz,
Kunstgewerbemuseum

This silk, brocaded with gold
thread, is decorated with
medallions of opposing eagles
separated by dragons of Chinese
inspiration.

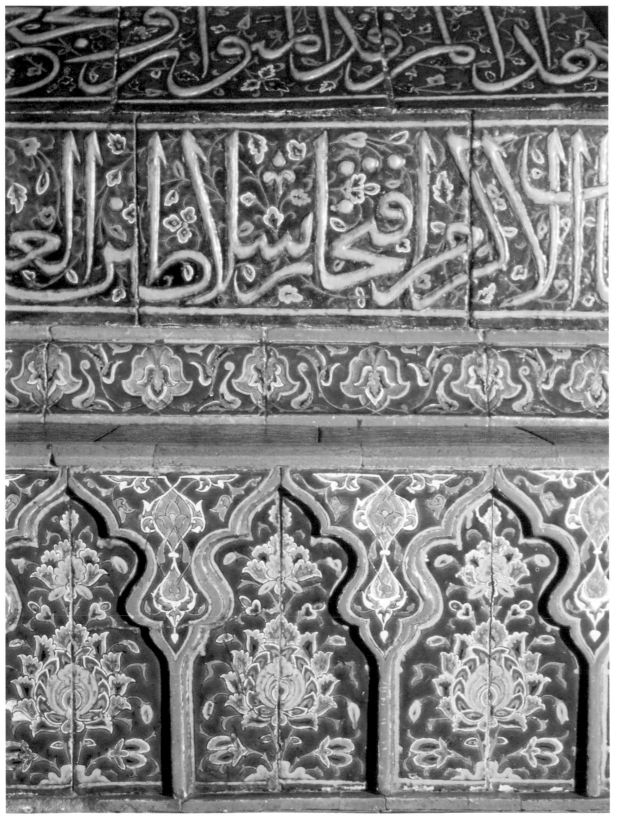

Tiled cenotaph of the Green
Mosque
Bursa, Turkey
1414-24

Founded in 1414 by Çelebi
Sultan Mehmed and completed
in 1424 by the Ottoman Sultan
Murad II, the mosque and tomb
are renowned for their superb
faience.

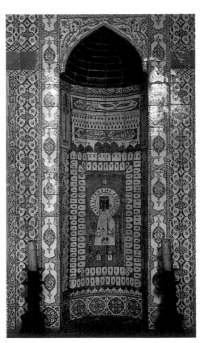

Mihrab with tiles representing the
Kaa 'ba
Istanbul, Turkey
Topkapi Saray Museum, Istanbul

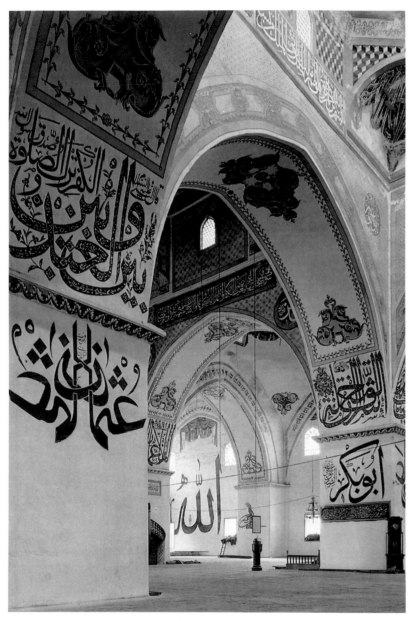

Ottoman monumental calligraphy,
Old Mosque (Eski Cami)
Edirne, Turkey
16th century

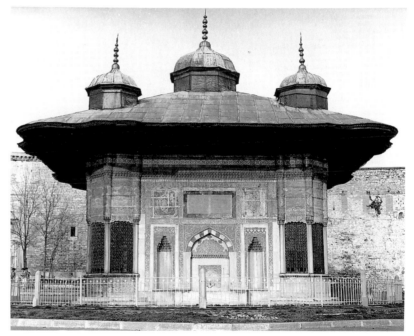

Fountain of Ahmed III
Istanbul, Turkey
1728

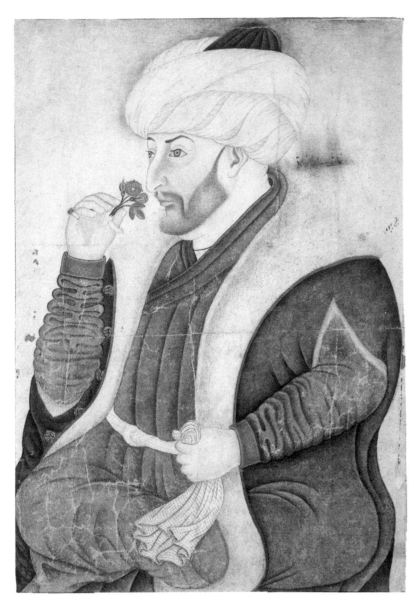

Portrait of Mehmed II, who
conquered Istanbul in 1453,
painted by Sinan Beg
Second half of the 15th century
Topkapi Saray Museum, Istanbul

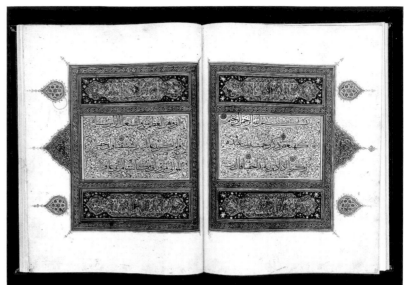

Koran fragment associated with
Bayazit II
1481-1512
Chester Beatty Library, Dublin

The text in the central panel is
in *naskhî* script and is
set on a background of
arabesques and foliate motifs.

Imperial monogram (*tuğra*) of the
Ottoman Sultan Süleyman the
Magnificent
1521-66
Museum of Turkish and Islamic
Art, Istanbul

Executed in blue and gold and
surrounded with a triangular
scroll.

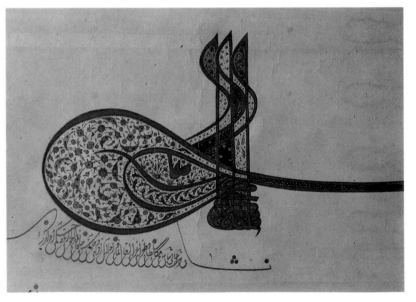

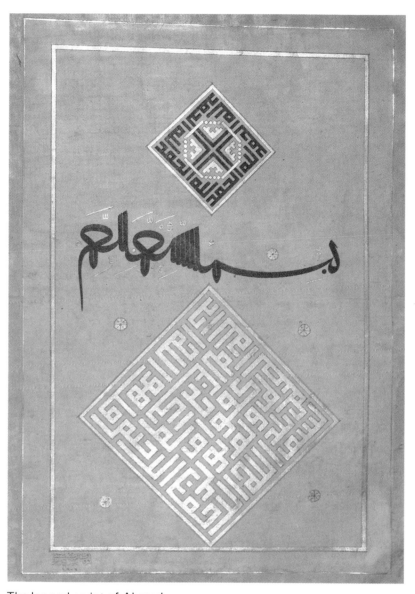

The looped script of Ahmed
Karahisarî
16th century
Museum of Turkish and Islamic
Art, Istanbul

Karahisarî's works include
sumptuously illuminated Korans,
like those consecrated in the
Mosque of Süleymaniye.

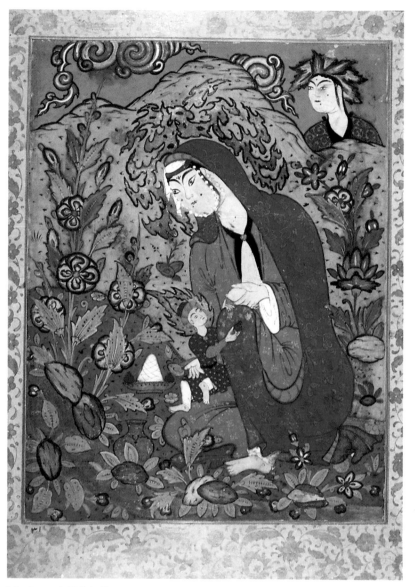

Virgin and Child, *Fâlnâme*
of Kalender Pasha
Istanbul, Turkey
Topkapi Saray Museum, Istanbul

The Virgin and Child are depicted
here with fiery haloes, according
to Muslim conventions.

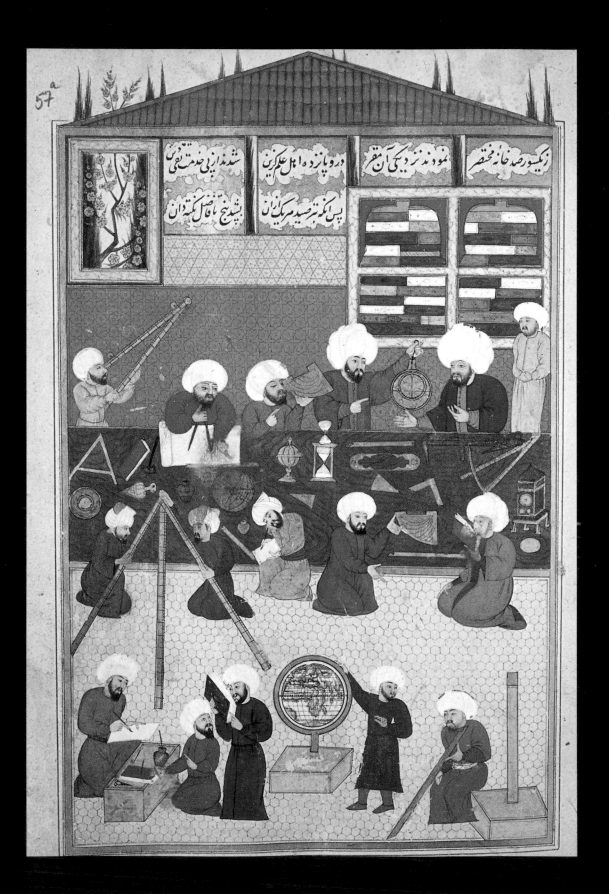

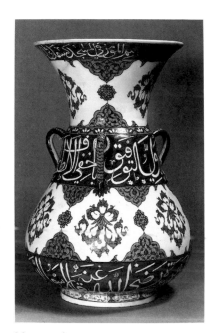

Observatory at Tophane
Shâhanshâhnâme (Book of the
King of Kings)
1580
University Library, Istanbul

Sultan Murad III founded an
observatory at Tophane in 1579.
Here we see the staff of the
observatory with globes and
other astronomical instruments.

Mosque lamp
Iznik, Turkey
1549
British Museum, London

This lamp is from the Dome of
the Rock in Jerusalem and
attests to the restoration projects
carried out in the
Holy Land under Süleyman the
Magnificent.

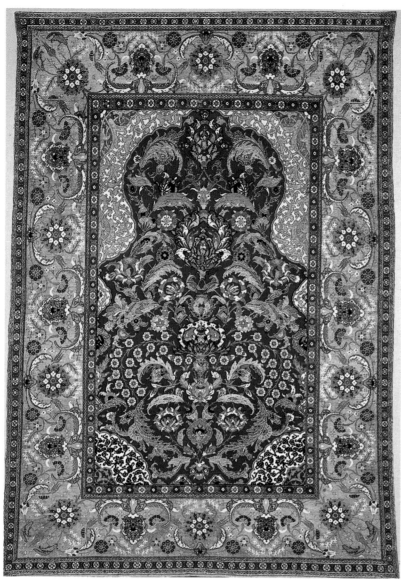

Ottoman Court Carpet
Istanbul, Turkey
Late 16th century
Museum für Angewandte Kunst,
Vienna

Patterns were made by the court
designers for carpets,
Ottoman illumination, book
bindings, textiles and tiles.

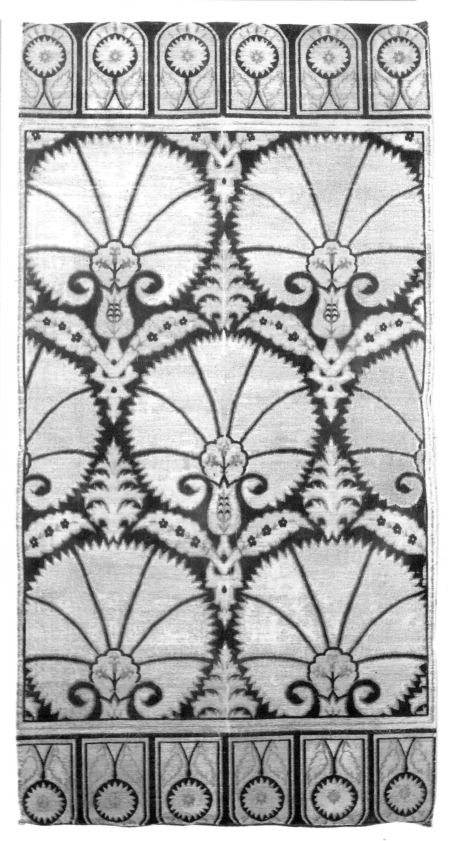

Velvet cushion cover,
Topkapi Saray Museum, Istanbul
Early 17th century

The cover was made of silk
and metal threads and is
decorated with stylized
carnations.

King Nûshîrwân and the Owls,
Khamsa (the five poems) of
Nizâmî,
Tabriz
c. 1540
British Library, London

The king learns from overhearing
the owls boast about the
destruction of his kingdom that
a wise ruler must also be just.

Koran, Suras I, 1-II, 4
1538-39
Topkapi Saray Museum, Istanbul

Page written by Shâh Mahmûd
al-Naysâbûrî, the favourite
calligrapher of the Safavid Shâh,
Tahmâsp.

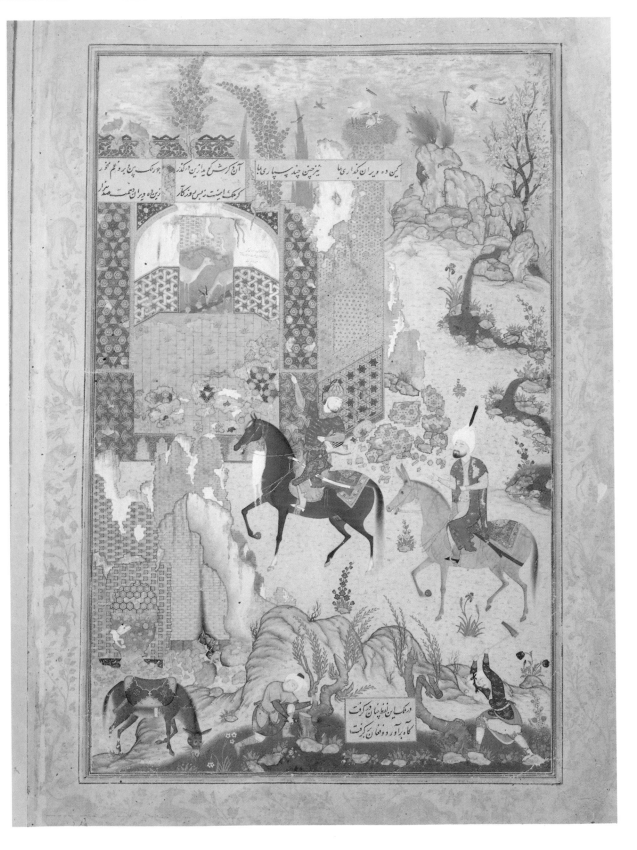

Bookbinding, stamped and gilt
leather with cut-out tracery over
patches of coloured paper
Islamic Republic of Iran
possibly Isfahan
17th century
Musée du Louvre, Paris

Drawing of a pheasant in ink
and gold wash with its head
in five positions
Islamic Republic of Iran
c. 1550
British Museum, London

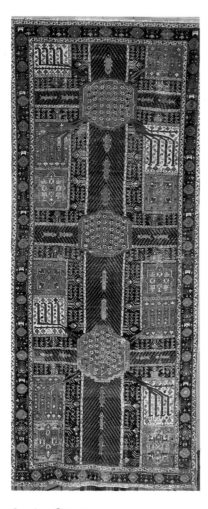

Wool carpet from the Shrine of Shaykh Safî at
Ardebil, Tabriz, Islamic Republic of Iran
1539-40
Victoria and Albert Museum, London

The deep blue field is dominated by a central sixteen-pointed medallion with smaller medallions arranged around it.

Garden Carpet
Western Iran
c. 1800 after 18th-century design
Metropolitan Museum of Art, New York

With a broad canal on the vertical axes, the water is indicated by diagonal lines and fishes. There are three horizontal canals: where they cross there are basins with peach trees. The rectangles are filled with star-shaped flower beds and stylized trees, the borders of the plots seem to be espalier-trained fruit trees.

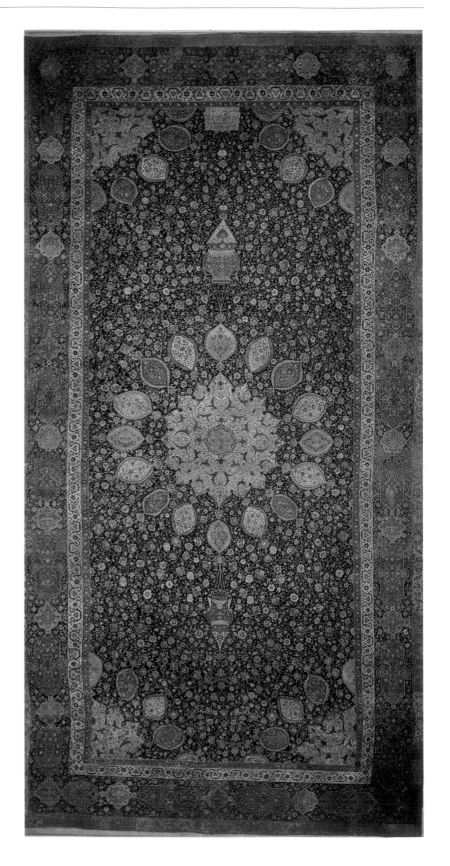

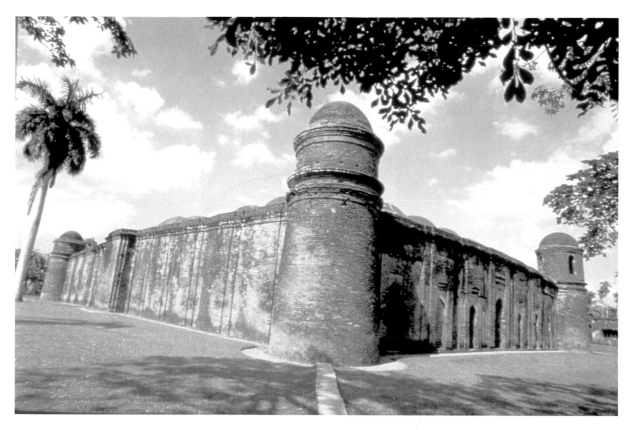

Shait Gumbad Mosque, exterior
Khalifatabad, near Bagerhat,
Bangladesh
15th century

Fortress-like in its appearance,
the mosque is roofed
with seventy-seven domed
bays. The *qibla* wall is set
with eleven richly decorated
mihrabs.

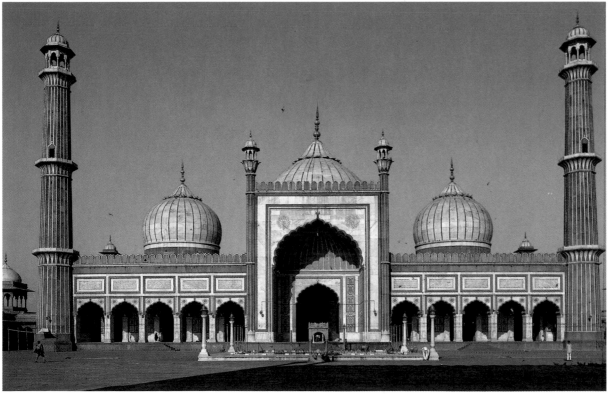

Jami Mosque
New Delhi, India
Completed *c.* 1650

Built in red sandstone and white
marble by Shâh Janân,
this was the main mosque of his
palace-city, Shâhjahanabad.
The main façade is composed
of open arcades with a
monumental entrance and
minarets at the corners.

Tomb of Muhammad 'Âdil Shâh
(Gul Gunbad)
Bijapur, India
1626-56

The building, a giant cube with
corner towers, supports a
single dome. The decoration
is unfinished.

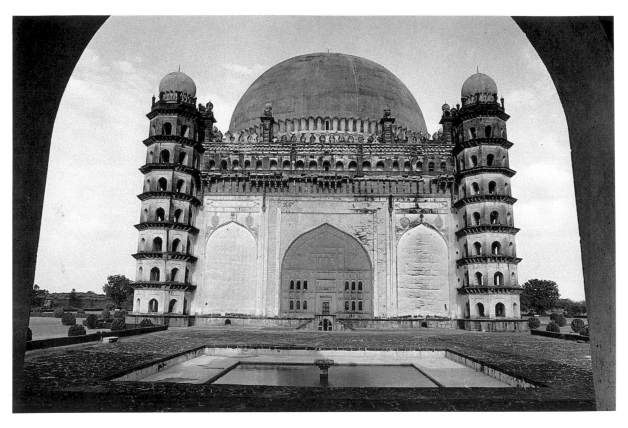

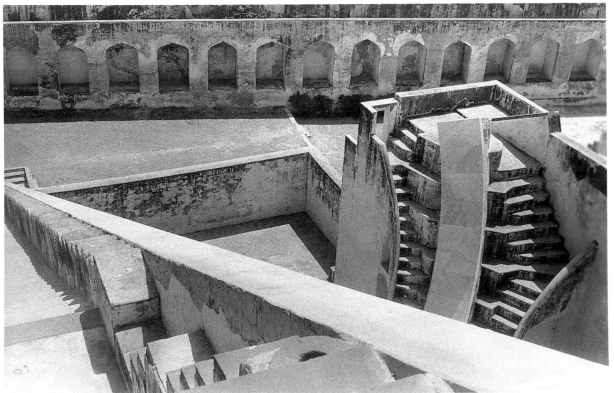

The Observatory of Jai Singh
Jaipur, India
c. 1734

Jai Singh had observatories
constructed in Delhi, Ujjain
and Jaipur. Their instruments
and layout drew upon
both Hindu and Muslim
astronomical traditions. The
standard architectural features
included sextants,
quadrants and terraces for
observing celestial bodies.
Set in circular enclosures, huge
gnomons were marked with
degrees so that the sunset could
be measured.

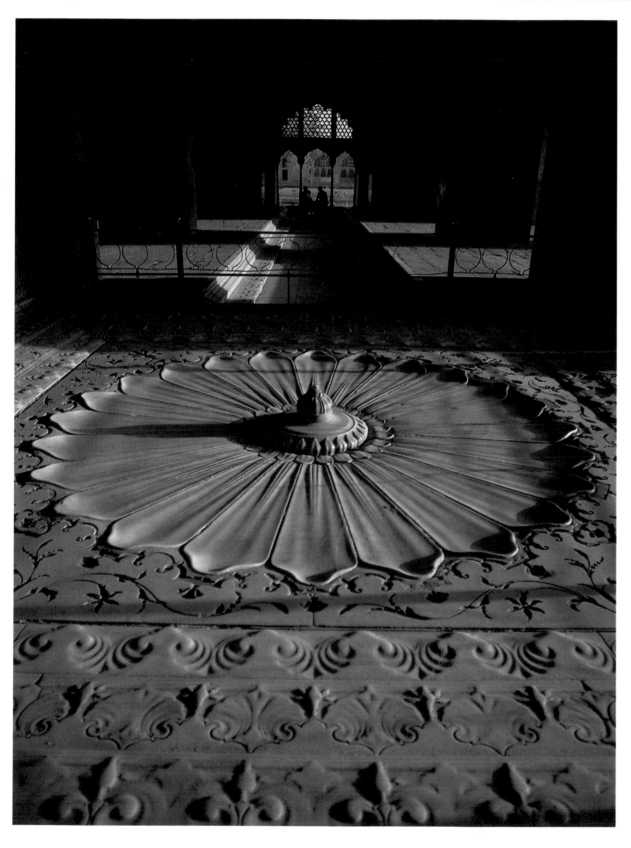

Red Fort
New Delhi, India
1638

This building is not a fort but
a palace of Shah Jahân,
and it consisted largely of
single-storeyed pavilions
linked by canals and fountain
pools. The lotus pool
of the Rang Mahal shown here
adapts one of the favourite
motifs of Mughal architecture
for a fountain and weir.

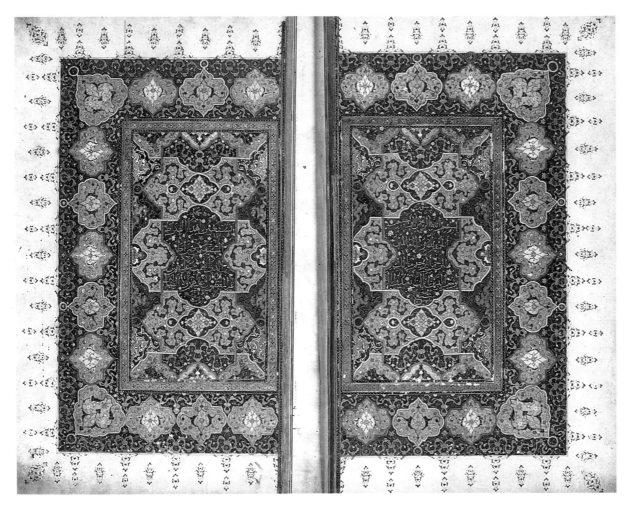

Koran
Fatiha, (Sura I) India
16th century
British Library, London

The text is written in gold on lapis-lazuli panels set against angular panels of contrasting blue and gold and in borders of lobed butterfly-like medallions. The background is liberally filled with various cloud-scrolls of Chinese inspiration.

Anonymous nasta°liq calligraphy, from an album dating to the end of Shah Jahân's reign
c. 1645
Los Angeles County Museum of Art: The Nasli and Alice Heeramaneck Collection

Muslim rulers from the 15th century on collected calligraphy as avidly as painting, mounting them together in albums with, as here, splendidly illuminated margins representing brilliant birds, animals and floral scrolls. Many of the rulers, moreover, prided themselves on their own calligraphic skill.

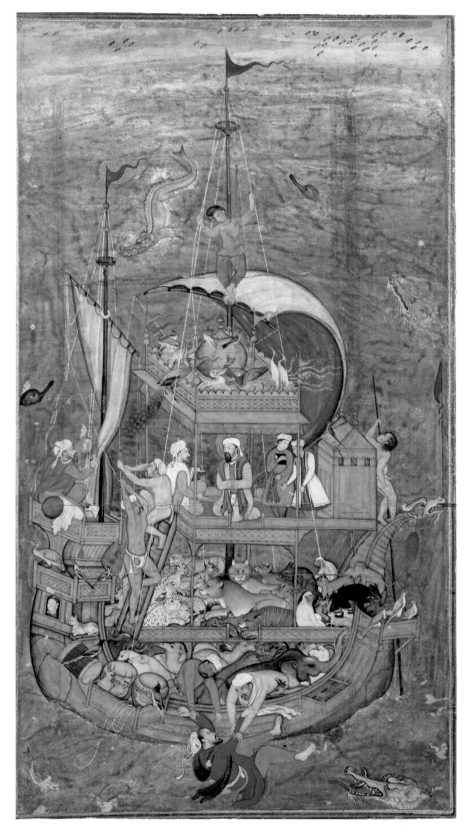

Noah's ark,
possibly from the *Divan* of Hâfiz
c. 1590
Freer Gallery of Art, Washington

The traditional theme of a man overboard and saved from drowning here has been adapted to illustrate the story of Noah and the animals. This work probably was not directly inspired from the Koranic verse which alludes to Noah as a Prophet, but instead from the later expanded accounts of his life found in collected biographies of the Prophets and Patriarchs of Islam.

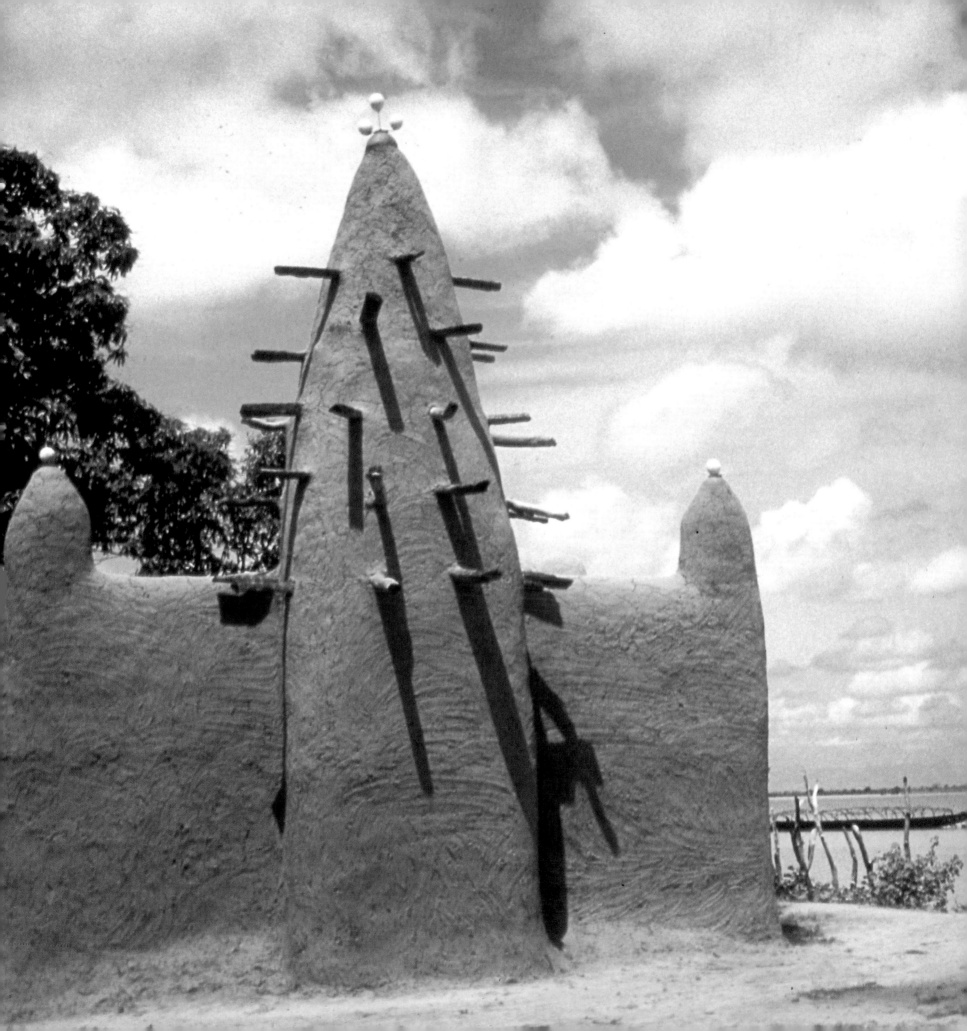

The Development of Islamic Art throughout the World: Sub-Sahara, China, South-East Asia

For centuries mud has been almost the only building material available in Sub-Saharan Africa. Wood and stone are scarce. The inhabitants of the area ingeniously adapted this material to their architecture and thus expressed their cultural individuality. Mud-brick gives remarkable architectural unity, from simple houses to impressive mosques; the climatic and ecological benefits it offers are increasingly appreciated by architects all over the world. The impressive verticality of the façades of the great mosques in Mali, Burkina Faso, Nigeria, Mauritania and Senegal, constructed with wooden framework, show how traditional Western and Central African architecture was shaped to the requirements and traditions of Islam. Similarly, Mauritanian domestic architecture offers a remarkable variety of architectural forms combined with impressively decorated façades.

Small Mosque
Ké Macina, Mali

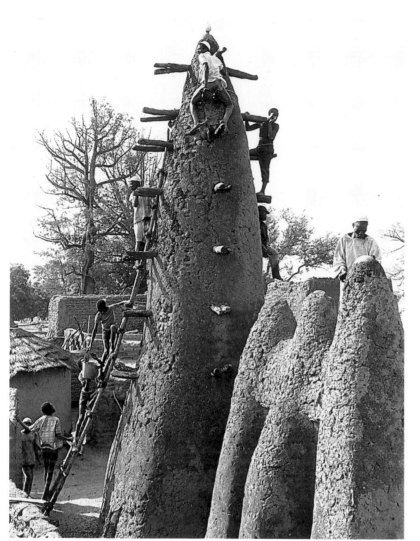

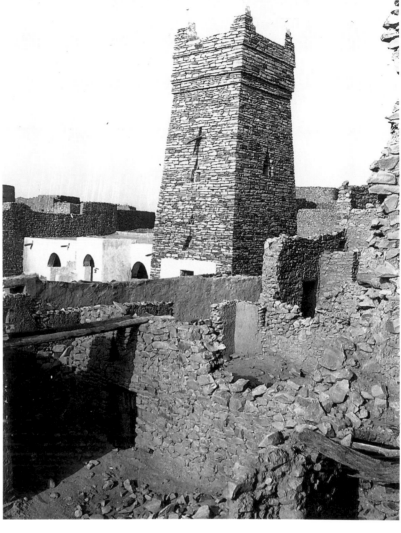

Mosque of Koudougou
Burkina Faso

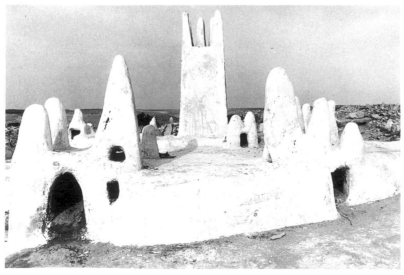

Minaret amongst ruins
Chinguetti, Mauritania

Tomb of Sidi Aissa
Ghardaia, Algeria

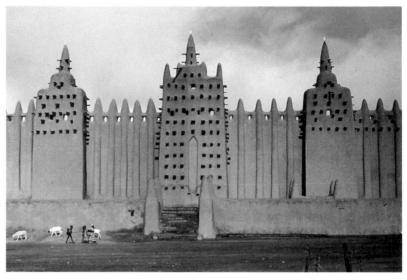

Wall decoration in plaster relief
Walata, Mauritania

Great Mosque
San, Mali

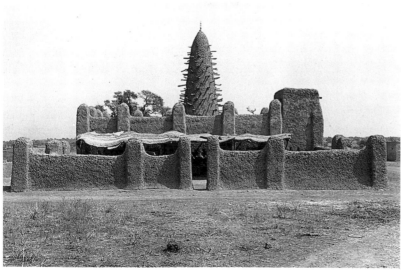

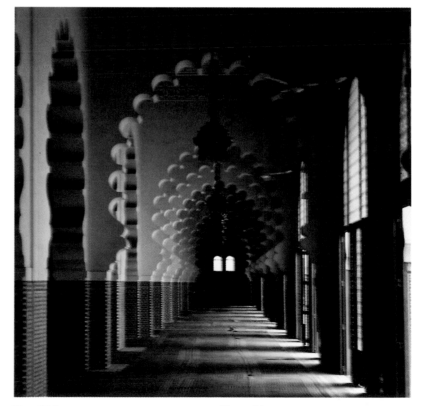

Small Mosque
Dano, Burkina Faso

Great Mosque
Dakar, Senegal

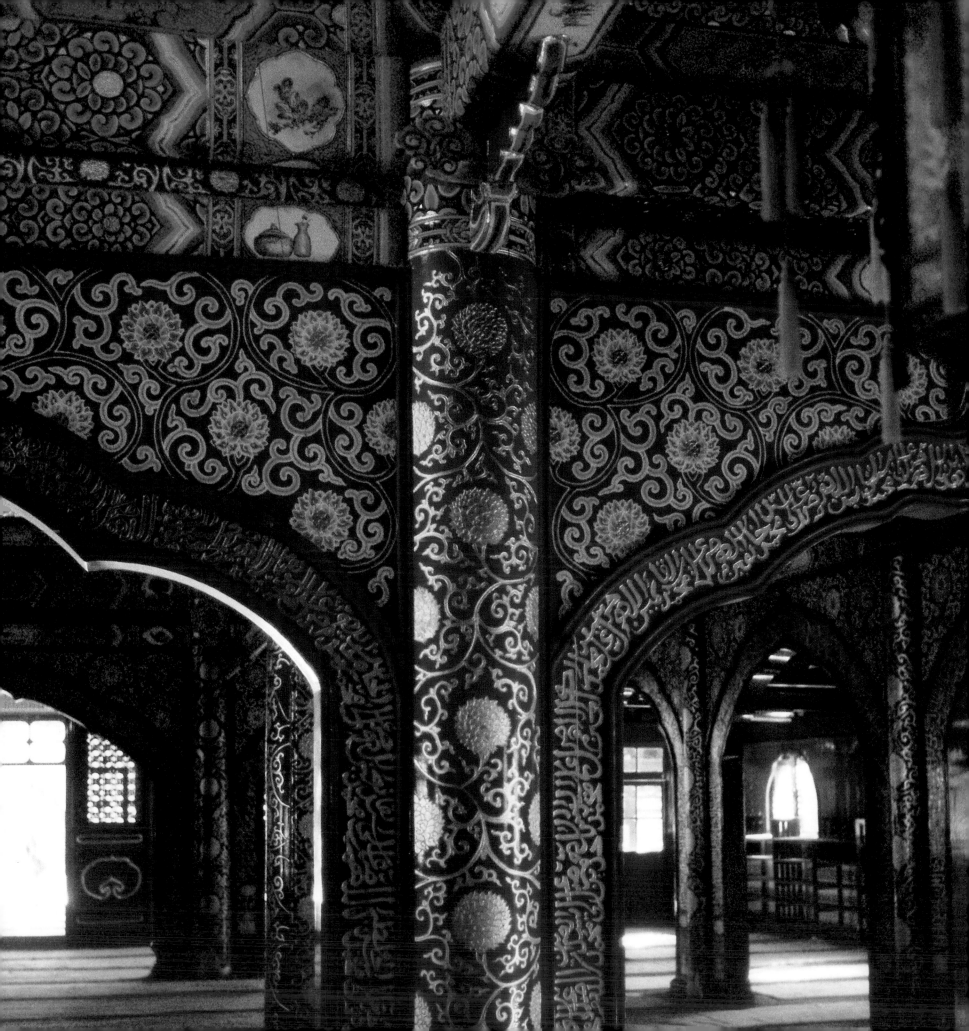

China

The appearance of Islam in China goes back to the 7th-century Arab traders who travelled through southern India, Sri Lanka, Malaysia and Thailand and reached Cathay. As early as 651, the Chinese Emperor received a visit from the Caliph's emissary who obtained the authorization to establish the first Muslim embassy at Xian, and in 742 the first mosque was built there.

The Silk Route that connected Xian, the ancient capital of the Chinese Empire, with the West in pre-Islamic and early Islamic times remained important for the transmission of culture and religion. Hence the particular influence of Islam in Western China, at Kashi (Kashgar) and at Turfan in the province of Xinjiang.

Mosque architecture shows noteworthy variations from province to province–Beijing (Peking), Xian and Xinjiang. The Niu Jie mosque in Beijing (begun 962) and the Great Mosque in Xian (begun in 1392), which represents one of the most remarkable Muslim complexes in China, incorporate design and decorative elements of traditional Chinese architecture in their construction. Characteristic of the influence of Chinese architecture is the use of wood and brilliantly painted decoration.

Although the mosques of Xinjiang, particularly the Amin mosque in Turfan and those of Aitika and Aba Khoja at Kashi, show local peculiarities, they also show the influence of neighbouring cultures in their architectural expression and construction techniques.

Entirely built of mud-brick, the Amin mosque has a spec-

Niu Jie Mosque
Beijing, China

Multi-foiled columns supporting arcades inspired by central Asian design form the structure of the prayer hall.

tacular minaret and grand entrance influenced by Persian or Central Asian Muslim architecture. Similar features characterize the Aitika mosque at Kashi, although its decoration and use of wood and columned halls is closer to Chinese traditions.

The mosque and mausoleum of Aba Khoja is the most important architectural complex in Kashi with two prayer halls, a school *madrasa*, a bath and living quarters and a cemetery. Although similar architecturally and structurally to the Aitika mosque, polychrome tile revetments play an important part here, especially in the mausoleum.

This complex strikingly attests to the importance of Islam in Western China.

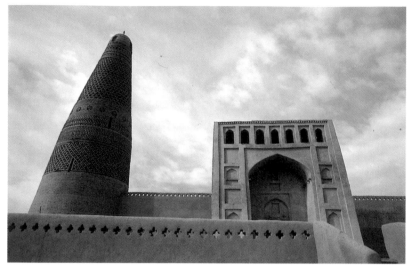

Amin Mosque, entrance. Turfan, China

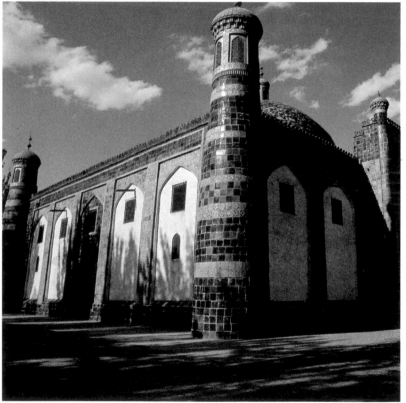

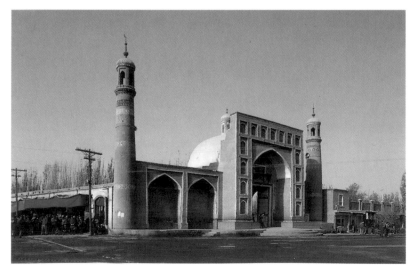

Aitika Mosque
Kashi, China

Square bay with traditional Islamic patterns painted in bright colours.
Entrance to the Mosque

Aba Khoja Mosque and Mausoleum
Kashi, China

South-East Asia

The Islamic culture of South-East Asia is tempered by non-Islamic values and cultures. The Muslims of Indonesia, for instance, are influenced by Hindu and Animist beliefs and the highly refined Javanese cultural tradition.

Similarly, the architecture of South-East Asia contains many indigenous traditions and forms. The impact of Islam on local architecture may be seen most vividly in the mosques. There appear to have been two styles in the design of the earliest mosques: the first, usually reserved for major mosques, imitated the Arab and Indian buildings with their gilded domes and arched openings. The second, based on indigenous forms, retained the traditional pitched roofs, the division of space and structure by means of timber columns placed according to older rituals, larger openings on the sides and the absence, usually, of an interior courtyard.

Since gaining independence, many South-East Asian countries with Muslim populations (among them Malaysia, Indonesia, Singapore and the Philippines), have been increasingly exposed to a 'Pan-Islamic' movement emanating from the Middle East. With it has come an architectural image of what a mosque should look like, with domes, arches, a minaret and a courtyard. Thus, older mosques often receive a dome in place of the traditional roof, while a minaret may be erected next to it, regardless of its appropriateness. In terms of contemporary design, the South-East Asian mosque has not yet satisfactorily solved the problem of simultaneously serving religious functions and expressing, in modern forms, both popular vision and national aspirations.

Zakat Fitrah Mosque
Singapore

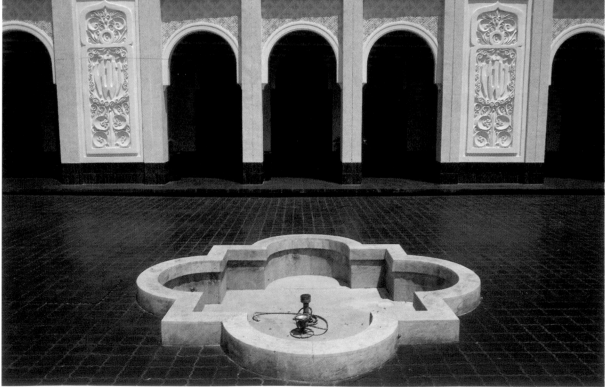

Village Mosque
Manila, Philippines

Solo Mosque
Solo, Indonesia
The mosque at Solo, one of
the major cultural centres of Java,
possesses an ancient *minbar*.

Pangumuman Mosque
Cirebon, Java, Indonesia

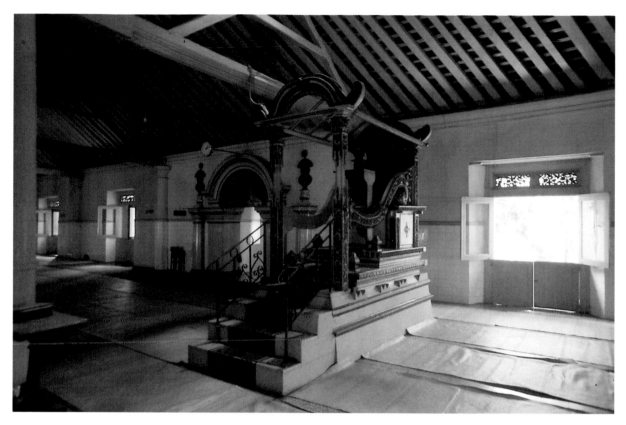

Bangumas Mosque
Java, Indonesia

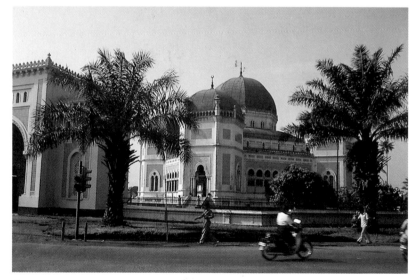

Great Mosque
Medan, West Sumatra, Indonesia

Situated in an area of the country
that was influenced
by early Arab traders and was
among the first to
be converted to Islam, this
mosque attests to the mixed
influence of Arab and Indian
architecture.

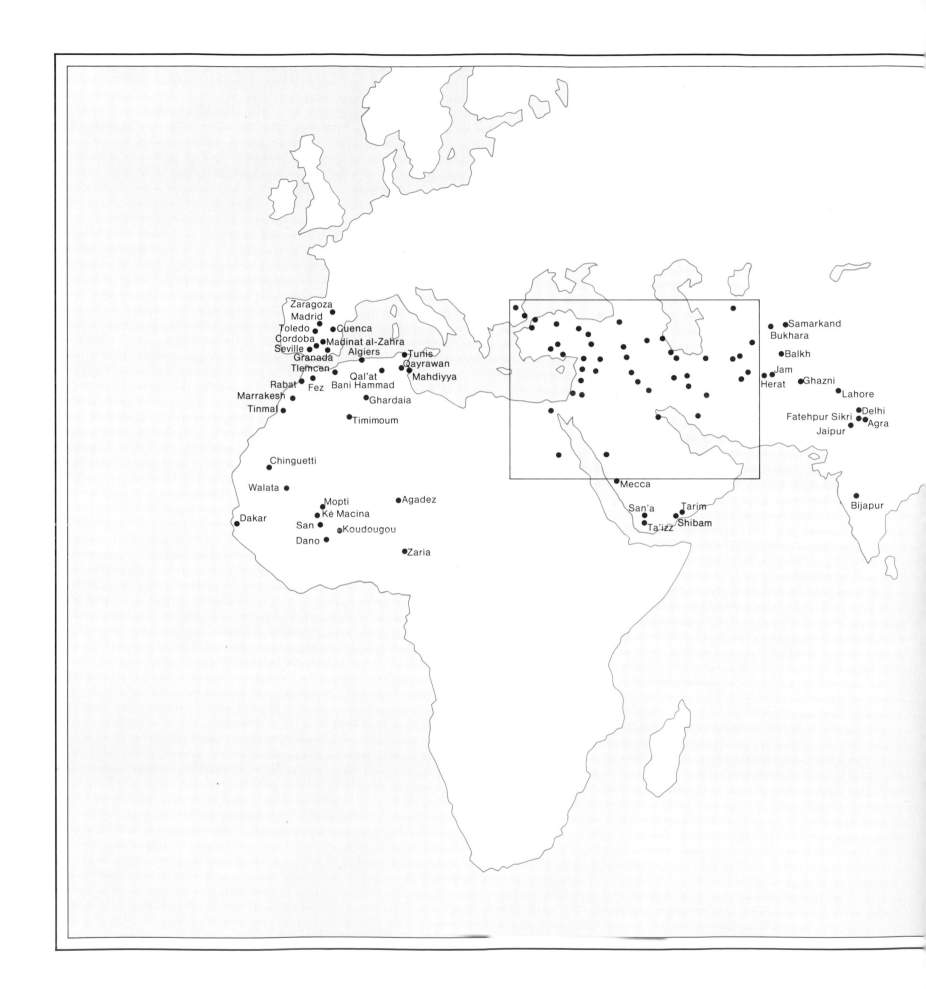

Zaragoza
Madrid
Toledo
Cuenca
Cordoba
Seville
Madinat al-Zahra
Granada Algiers
Tlemcen
Rabat Fez
Qal'at
Bani Hammad
Marrakesh
Tinmal

Tunis
Qayrawan
Mahdiyya

Ghardaia

Timimoum

Chinguetti

Walata

Mopti Agadez
Ké Macina
San
Dakar Koudougou
Dano

Zaria

Samarkand
Bukhara
Balkh
Jam
Herat Ghazni
Lahore
Fatehpur Sikri Delhi
Agra
Jaipur

Mecca

San'a Tarim
Ta'izz Shibam

Bijapur

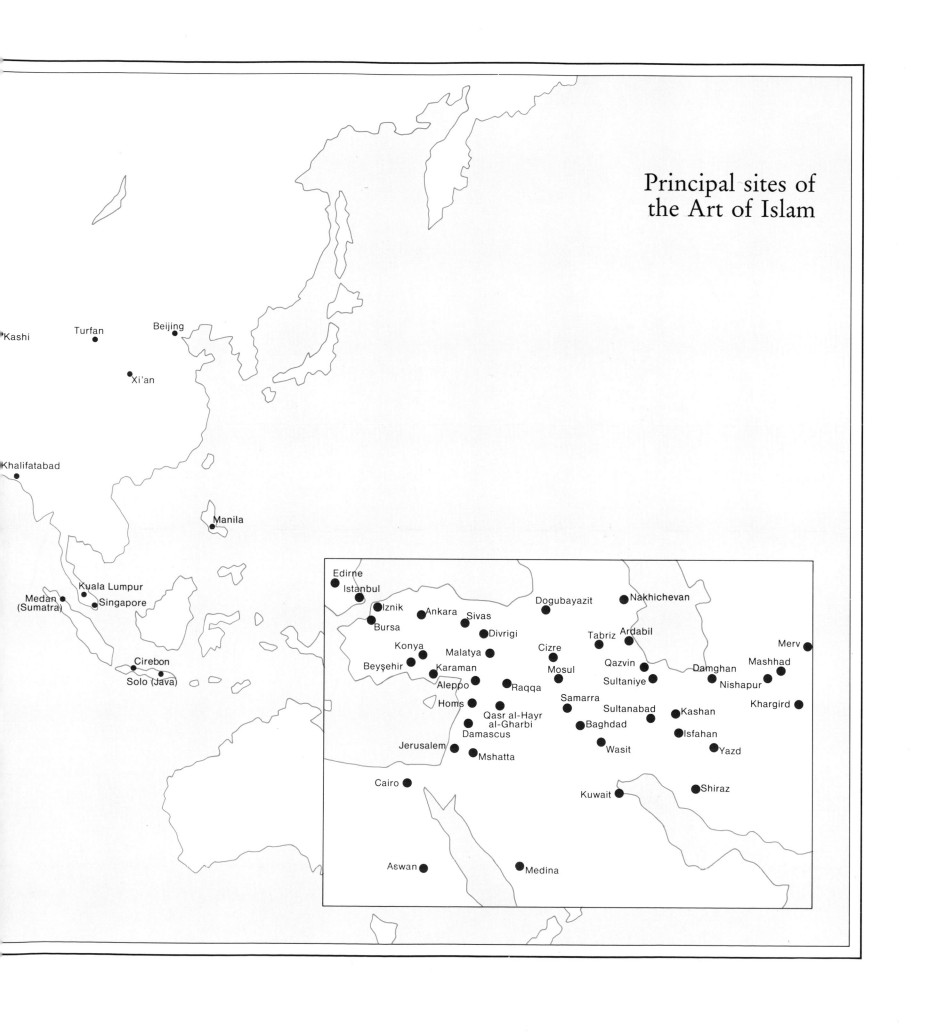

Principal sites of
the Art of Islam

Kashi

Turfan

Beijing

Xi'an

Khalifatabad

Manila

Kuala Lumpur

Medan
(Sumatra)

Singapore

Cirebon

Solo (Java)

Edirne

Istanbul

Iznik

Ankara

Sivas

Dogubayazit

Nakhichevan

Bursa

Divrigi

Tabriz

Ardabil

Merv

Konya

Malatya

Cizre

Qazvin

Damghan

Mashhad

Beyşehir

Karaman

Mosul

Sultaniye

Nishapur

Aleppo

Raqqa

Khargird

Homs

Samarra

Sultanabad

Kashan

Qasr al-Hayr
al-Gharbi

Baghdad

Isfahan

Damascus

Wasit

Yazd

Jerusalem

Mshatta

Cairo

Kuwait

Shiraz

Aswan

Medina

DATES ISLAMIC ERA	DATES CHRISTIAN ERA	DYNASTIES	CAPITALS	PRINCIPAL MONUMENTS
30	650	Umayyads 661-750	Damascus	Dome of the Rock, Jerusalem al-Aqsâ Mosque, Jerusalem Great Mosque, Damascus Qasr al-Khayr al-Gharbî Palace
81	700			
133	750	Abbasids 750-940	Baghdad	Great Mosque, Samarra Mosque of al-Mutawakkil, Samarra Palace of Jawsaq al-Khaqani, Samarra Nô Gunbad, Balkh
		Umayyads 755-1031	Cordoba	Great Mosque, Cordoba Palace of Madînat al-Zahra, Cordoba Aljafería Palace, Zaragoza
		Irisids 788-975	Fez	Foundation of the city of Fez
184	800	Aghlabids 800-909	Qayrawan	Great Mosque, Qayrawan al-Zaytuna Mosque, Tunis Great Mosque, Sfax
236	850	Tulunids 868-905	Cairo	Mosque of Ahmad ibn Tûlûn, Cairo
		Samanids 874-1001	Bukhara Nishapur	Mausoleum of Ismâ'îl the Samanid, Bukhara
287	900	Buyids 932-1001	Baghdad Shiraz	Great Mosque, Nayin
339	950	Ghaznavids 962-1186	Ghazni Nishapur	Mosque and minarets, Ghazni Mausoleum-tower, Gunbad-i Qâbûs
		Fatimids 969-1171	Cairo	Great Mosque, Mahdiyya Mosque of al-Azhar, Cairo Mosque of al-Hâkim, Cairo
		Zirids 990-1150	Qayrawan	Restoration of the Great Mosque of Sfax Qal'a of the Banu Hammâd
391	1000	Seljuks 1038-1194	Baghdad	Restoration of the Great Mosque of Isfahan Restoration of the Great Mosque Aleppo Mausoleum of Sultan Sanjar, Merv
442	1050	Almoravids 1056-1147	Marrakesh Seville	Great Mosque (the Kutubiyya), Marrakesh Great Mosque, Seville
		Seljuks of Rum (Anatolia) 1077-1307	Konya	Mosque Alâeddîn, Konya Gök Medrese, Sivas Çifte Minare Medrese, Erzurum
495	1100	Zangids 1127-1211	Aleppo Mosul Damascus	Mosque of Nûr al-Dîn, Mosul Minaret of the Great Mosque, Irbil Maristan al-Nûrî, Damascus
		Almohads 1145-1269	Seville Marrakesh	Great Mosque, Tinmâl Great Mosque, Seville Giralda, Seville
545	1150	Ghurids 1148-1215	Herat	Minaret, Jâm

DATES ISLAMIC ERA	DATES CHRISTIAN ERA	DYNASTIES	CAPITALS	PRINCIPAL MONUMENTS
545	1150	Ayyubids 1171-1250	Cairo Damascus Aleppo	Citadel, Aleppo Madrasat al-Firdaws, Aleppo Citadel, Damascus Madrasa of al-Malik al-Sâlih Najm al-Dîn Ayyûb, Cairo
597	1200	Delhi Sultanates 1215-1526	Delhi	Quwwat al-Islam Mosque, Delhi Qutb Minar, Delhi Moth-ki Mosque, Delhi
		Ilkhans/Mongols 1256-1353	Tabriz Sultaniyye	Tomb of Öljeytü, Sultaniyye Restoration of the Great Mosque of Isfahan Great Mosque, Varamin
		Merinids 1216-1470	Fez	Madrasat al-Attârîn, Fez Madrasat Bû-Inâniyya, Fez Mosque of al-Mânsur, Tlemcen Chella Necropolis, Rabat
		Hafsids 1228-1575	Tunis	Porches over the entrance and arcades of the Great Mosque of Qayrawan
		Nasrids 1232-1490	Granada	Gardens of the Generalife, Granada Alhambra, Granada
648	1250	Mamluks 1250-1517	Cairo	So-called Cemetery "of the Caliphs", Cairo Mosque of Sultan Baybars I, Cairo Mosque and Mausoleum of Sultan Hasan, Cairo
		Ottomans 1290-1922	Bursa Edirne Istanbul	Green Mosque, Bursa Mosque of Bayazit II, Edirne Mosque Selimiye, Edirne Mosque of Sultan Ahmed, Istanbul Fountain of Ahmed III, Istanbul
700	1300	Emirates c. 1300-1500	Anatolia	
751	1350	Bahmanids 1347-1526	Gulbarga Bidâr	
		Turkmans Karakoyunlu and Akkoyunlu 1378-1506	Baghdad Tabriz	Mosque of Jahânshâh Karakoyunlu (Blue Mosque), Tabriz
		Timurids 1378-1506	Samarkand Herat	Tomb of Timur (Gûr-i Mîr), Samarkand Madrasa of Ulugh Beg, Samarkand Mosque of Bîbî Khanum, Samarkand Shah-i Zinde, Samarkand Gazur Gah, Herat Mausoleum of Gawhar Shâd, Herat
803	1400			
854	1450	Khanate Uzbek 1470-1800	Bukhara	
906	1500	Safavids 1506-1722	Tabriz Qazvîn Isfahan	Mosque of Shaykh Lutfallâh, Isfahan Mosque of Imam (Mosque of Shah Abbâs Ist), Isfahan
		Mughals 1526-1858	Delhi Agra	Jami Mosque, Delhi Tomb of Humâyûn, Delhi Taj Mahal and Red Fort, Agra Tomb of Jahângîr, Lahore
1112	1700	Qajars c. 1740-1800	Tehran	

Index

Photographic Acknowledgements

Page 6: Jean-Louis Nou, Livry-Gargan; 8: D. R. Serageldin, World Bank; 10 top: British Library, London; 10 bottom: Jean Mazenod, Paris; 11: Henri Stierlin, Geneva; 12: Jean-Louis Nou, Livry-Gargan; 13: Banri Namikawa, Tokyo; 14: Henri Stierlin, Geneva; 15: Nurhan Atasoy; 16: Roland and Sabrina Michaud, Paris; 17: Jean-Louis Nou, Livry-Gargan; 18: Ch. Bastin and J. Evrard, Brussels; 19: Jean-Louis Nou, Livry-Gargan; 20: Gérard Degeorge, Paris; 22: Banri Namikawa, Tokyo; 23: USSR Archives; 24 left: Roland Michaud/Rapho, Paris; 24 right: Banri Namikawa, Tokyo; 25: University of Pennsylvania; 26 left: R. Napier; 26 right: Afif Bahnassi; 27: Banri Namikawa, Tokyo; 28 left: Ch. Bastin and J. Evrard, Brussels; 28 right: Roland and Sabrina Michaud, Paris; 29: Christopher Little/The Aga Khan Award for Architecture; 30: Jean Mazenod, Paris; 32 left: Henri Stierlin, Geneva; 32 right: Jean Mazenod, Paris; 33: Henri Stierlin, Geneva; 34: USSR Archives; 35: Roland and Sabrina Michaud, Paris; 36 top left: Roland Michaud/Rapho; 36 top right: Henri Stierlin, Geneva; 36 bottom: Ch. Bastin and J. Evrard, Brussels; 38: Jean-Louis Nou, Livry-Gargan; 40: Banri Namikawa, Tokyo; 41 left: Lewcock; 41 right, 42, 43: Christopher Little; 44-45: Henri Stierlin, Geneva; 46: Lewcock; 47 left: Roumi; 47 right: Marc and Evelyne Bernheim/Rapho, Paris; 48: Jean Mazenod, Paris; 50 top: Ersin Alok, Istanbul; 50 bottom, 51: Henri Stierlin, Geneva; 52: Roland and Sabrina Michaud, Paris; 53: The Aga Khan Award for Architecture; 54 left: Afif Bahnassi; 54 right: Henri Stierlin, Geneva; 55: Jean-Louis Nou, Livry-Gargan; 56: Henri Stierlin, Geneva; 57: Roland and Sabrina Michaud, Paris; 58: Henri Stierlin, Geneva; 59 top: Christopher Little/The Aga Khan Award for Architecture;

59 bottom: Gérard Degeorge, Paris; 60 top: Ch. Bastin and J. Evrard, Brussels; 60 bottom: Ersin Alok, Istanbul; 61: Henri Stierlin, Geneva; 62: Banri Namikawa, Tokyo; 64 top: Roland and Sabrina Michaud, Paris; 64 bottom: Ersin Alok, Istanbul; 65 top: Roland Michaud/Rapho, Paris; 65 bottom: Roland Michaud, Paris; 66 top left: Henri Stierlin, Geneva; 66 top right: Peter Willi, Paris; 66 bottom: Roland and Sabrina Michaud, Paris; 67: Banri Namikawa, Tokyo; 68: Henri Stierlin, Geneva; 70 left: Roumi; 70 right: Henri Stierlin, Geneva; 71: Gérard Degeorge, Paris; 72 top and bottom left: Henri Stierlin, Geneva; 72 bottom right: USSR Archives; 73: Ersin Alok, Istanbul; 74: Roland and Sabrina Michaud, 76: Henri Stierlin, Geneva; 77 left: Roumi; 77 right, 78: Henri Stierlin, Geneva; 79: Nurhan Atasoy; 80: Reha Günay; 82 top left: Roland and Sabrina Michaud/Rapho, Paris; 82 top right: Jean Mazenod, Paris; 82 bottom: Bildarchiv, Marburg; 83 left: USSR Archives; 83 right: Reha Günay; 84: Henri Stierlin, Geneva; 86: Roger-Viollet, Paris; 87: Henri Stierlin, Geneva; 88 left: USSR Archives; 88 right: Jean Mazenod, Paris; 89: Adle; 90: Ersin Alok, Istanbul; 91: Reha Günay; 92: USSR Archives; 94 top: Lewcock; 94 bottom: Henri Stierlin, Geneva; 95: Ersin Alok, Istanbul; 96 top: Gérard Degeorge, Paris; 96 bottom: Jean Mazenod, Paris; 97: USSR Archives; 98: Jean Louis Nou, Livry-Gargan; 100: Banri Namikawa, Tokyo; 101, 102: Jean-Louis Nou, Livry-Gargan; 103 top: British Museum, London; 103 bottom: Afif Bahnassi; 104 left: Museum für Islamische Kunst, Staatliche Museen für Preussischer Kulturbesitz, Berlin; 104 right: Bodleian Library, Oxford; 105: Chester Beatty Library, Dublin, photo Pieterse-Davison International Ltd; 106: Henri Stierlin, Geneva; 108: Banri

Namikawa, Tokyo; 109 left: Archaeological Museum, Madrid; 109 right: Jean Mazenod, Paris; 110: J.-L. Michon; 111: Everts/Rapho, Paris; 112 left: Peter Willi, Paris; 113 left: Staatliche Kunstsammlungen, Kassel, photo Gabriele Bössert; 113 right: Victoria and Albert Museum, London; 114: Jean Mazenod, Paris; 116-117: Ch. Bastin and J. Evrard, Brussels; 118 top: Musée Benaki, Athens; 118 bottom: Hermitage Museum, Leningrad; 119: British Museum, London; 120, 121, 122 left: Bibliothèque nationale, Paris; 122 right: Bayerische Staatsbibliothek, Munich; 123 left: Bibliothèque nationale, Paris; 123 right: Staatliches Museum für Völkerkunde, Munich; 124 left: Jean Mazenod, Paris; 124 right: Jean-Louis Nou, Livry-Gargan; 125 left: Lewcock; 125 right: Gérard Degeorge, Paris; 126 top: Afif Bahnassi; 126 bottom: Chester Beatty Library, Dublin, photo Pieterse-Davison International Ltd; 127: Metropolitan Museum of Art, Bequest of Cora Timken Burnett, 1956, Corna Timken Burnett Collection of Persian Miniatures and Other Persian Art Objects; 128: Peter Willi, Paris; 129 left: Peter Willi, Paris; 129 right: Österreichisches Museum für Angewandte Kunst, Vienna; 130: USSR Archives; 132: Reha Güney; 133 left: Henri Stierlin, Geneva; 133 top right: Ersin Alok, Istanbul; 133 bottom right: Adle; 134 left and centre: Nurhan Atasoy; 134 right: Chester Beatty Library, London, photo Pieterse-Davison International Ltd; 135: Freer Gallery of Art, Washington; 136 left: Peter Willi, Paris; 136 right: Collection David, Copenhagen; 137 left: Peter Willi, Paris; 137 right: Peter Willi, Paris; 138 top: Collection David, Copenhagen; 138 bottom: Walters Art Gallery, Baltimore; 139 left: Musée historique des Tissus, Lyons, photo studio René Basset; 139 right: Reha Güney; 140: USSR Archives; 142:

Roland and Sabrina Michaud, Paris; 143 left: Bodleian Library, Oxford; 143 right: Nurhan Atasoy; 144 top: New York Public Library, photo O. E. Nelson; 144 bottom: Reha Güney; 145 left: Peter Willi, Paris; 145 right: Kunstgewerbemuseum, Staatliche Museen für Preussischer Kulturbesitz, Berlin; 146 left: Reha Günay; 146 right: Banri Namikawa, Tokyo; 147: Reha Günay; 148 top left: Nurhan Atasoy; 148 top right: Chester Beatty Library, Dublin, photo Pieterse-Davison International Ltd; 148 bottom, 149, 150 left: Nurhan Atasoy; 150 right: British Museum, London; 151 left: Österreichisches Museum für Angewandte Kunst, Vienna; 151 right: Reha Güney; 152 left: Nurhan Atasoy; 152 right: British Museum, London; 153 left: Peter Willi, Paris; 153 right: British Museum, London; 154 left: Metropolitan Museum of Art, New York, gift of William R. Pickering; 154 right: Victoria and Albert Museum, London; 155 top: Accu-Tokyo; 155 bottom: Roland and Sabrina Michaud, Paris; 156: R. Napier; 157: Roland and Sabrina Michaud, Paris; 158 top: British Library, London; 158 bottom: Los Angeles County Museum of Art, The Nasli and Alice Heeramaneck Collection; 159: Freer Gallery of Art, Washington; 160: Adaua; 162 top left: Ch. Bastin and J. Evrard, Brussels; 162 top right: Mauritanian Institute for Scientific Research; 162 bottom: Ch. Bastin and J. Evrard, Brussels; 163 top left: Mauritanian Institute for Scientific Research; 163 top right: Adaua; 163 bottom left: Ch. Bastin and J. Evrard, Brussels; 163 bottom right: The Agan Khan Award for Architecture; 164, 166 top and bottom left: Christopher Little/The Aga Khan Award for Architecture; 166 bottom right: Banri Namikawa, Tokyo; 168, 169: The Aga Khan Award for Architecture.